Sep 2018

P9-DFR-792

Celestial Bodies

Celestial Bodies

HOW TO LOOK AT BALLET

Laura Jacobs

Illustrations by Jessica Roux

BASIC BOOKS
New York

Basic Books
Hachette Book Group
1290 Avenue of the Americas
New York, NY 10104
www.basicbooks.com

Printed in the United States of America
First Edition: May 2018
Published by Basic Books, an imprint of Perseus Books, LLC, a subsidiary of Hachette Book Group, Inc. The Basic Books name and logo is a trademark of the Hachette Book Group.

The publisher is not responsible for websites (or their content) that are not owned by the publisher.

Illustrations by Jessica Roux
Print book interior design by Linda Mark

Library of Congress Cataloging-in-Publication Data
Names: Jacobs, Laura, author.
Title: Celestial bodies: how to look at ballet / Laura Jacobs; illustrations by Jessica Roux.
Description: First edition. | New York: Basic Books, 2018. | Includes bibliographical references and index.
Identifiers: LCCN 2017051470| ISBN 9780465098477 (hardback) | ISBN 9780465098484 (ebook)
Subjects: LCSH: Ballet. | Ballet—History. | BISAC: PERFORMING ARTS / Dance / Classical & Ballet. | MUSIC / Genres & Styles / Ballet. | ART / Performance. | ART / General.
Classification: LCC GV1787 .J36 2018 | DDC 792.8—dc23
LC record available at https://lccn.loc.gov/2017051470

ISBNs: 978-0-465-09847-7 (hardcover), 978-0-465-09848-4 (ebook)

LSC-C

10 9 8 7 6 5 4 3 2 1

To my sister
Caryn

Perhaps the roses really want to grow,
The vision seriously intends to stay . . .

—W. H. Auden

CONTENTS

Contents

INTRODUCTION

*H*OW TO LOOK AT BALLET? WHILE WRITING THIS book, there were moments when I felt it could have been subtitled "How to *Think* About Ballet." We assume that "how to look" and "how to think" are two different things. Yet when it comes to ballet—to all dance, actually—looking and thinking, separate faculties at first, eventually begin to work as one faculty. Looking becomes a form of thinking.

We know that dancers develop their bodies to a point of exquisite coordination. But we in the audience do the same with our seeing, so much so that the dance is actually happening on both sides of the footlights. We begin to place our trust in visual echoes, references, and metaphors—glimpses and images that we assume everyone sees but that, as we learn later when talking to others, sometimes only we have seen. That's the way this art is. And while there is often

consensus on what a gesture, a step, an entire ballet may mean, interpretations can also vary widely. We all bring our own history to the ballet, each of us with his or her own interpretative framework, and these too inform a performance.

Through aural memory, which is stored in the brain's auditory cortex, humans have the capacity to retain whole songs, symphonies, and scores seemingly forever. Sight is different. We remember what we've seen in snapshots or, at best, in seconds of "live capture." Most of us can't replay in our mind's eye long skeins of movement from past performances. And anyway, on a big stage there is no way to take in every inch of what's happening. This means that no matter how many times we see a ballet there will always be something new to wonder at, to puzzle over, to see for the first time. With a change in cast, there will be dancers who emphasize different aspects of a role and bring different meanings to a work. Because we can't ever completely possess a ballet, it continues to surprise.

This freedom from finality is why companies can keep the greatest ballets perpetually in repertory, where they circle around and back, year after year, bringing new insights and deepening discovery. Paradoxically, this rhythm of cyclical or eventual return, of ballets never gone for long, also brings a reassuring stability, a steady heartbeat, to the art form. Ballets can be delicious meringues, old friends, vintage wines, great loves, grand banquets, spiritual sustenance, long-standing enigmas. Some ballets (we each have our own list of these) are like difficult relatives at a family gathering: here they come again, oh well, can't hurt to

catch up and see how they are doing. Other ballets loom large. What would December be without *The Nutcracker*? It is as loved and leaned upon as Handel's *Messiah* and Dickens's *A Christmas Carol*.

As we become more comfortable with our own cognitive leaps and turns, our own wanderings within a work, we will bring new spins to a ballet we thought we knew. The greatest ballets reward endless looking. They are glass-bottom boats, Proust's madeleine, C. S. Lewis's wardrobe, Bluebeard's castle, Freud's couch, Dr. Caligari's cabinet, Kubrickian space odysseys, and superkinetic PlayStations. They take you places you never dreamed of going.

Ballet is energy and energy is life. As with any foreign territory, we can approach an evening at the ballet with a fear of the unknown or with an open heart, a belief that success is in the seeing. The way to go is with an open heart.

NOTE TO THE READER

*T*HIS BOOK IS NOT A HISTORY OF BALLET AND DOESN'T need to be. There are many fine histories already published, and there will undoubtedly be many more. Still, I have organized my chapters so that themes emerge in a chronological way that roughly coincides with the art's development through the last three-plus centuries. Along the way I have quoted from some of the fundamental books on classical dance, as well as more recent books on the subject. If I have quoted from a book, a critic, or an artist of the ballet, it is an implicit recommendation of a voice I respect. Certain names will turn up again and again. All quotes from the vivacious Théophile Gautier come from *The Romantic Ballet as Seen by Théophile Gautier, 1837–1848*, a collection of his reviews and articles translated by Cyril W. Beaumont. All quotes from Akim Volynsky come from *Ballet's Magic*

Kingdom, the first English translation of Volynsky's work, including his shining treatise of 1925, "The Book of Exaltations: The ABCs of Classical Dance." And all quotes from Agnes de Mille come from her terrific memoir of 1951, *Dance to the Piper*. The learned writing of both Cyril Beaumont and Lincoln Kirstein is pulled from many of their books. Gail Grant's *Technical Manual and Dictionary of Classical Ballet* is a classic, and I've quoted from this book liberally.

When it comes to the classical vocabulary, I have defined steps and terms wherever I think it is necessary, and as succinctly as possible. When I have chosen to mention a step without a definition, it's because I think context will make things clear. I also trust that readers can jump onto the internet and pull up either a dictionary definition or a YouTube demonstration. Many of the ballets discussed in this book can be viewed for free on YouTube, but I've mostly refrained from making recommendations because what's online today may, due to copyright laws, be gone tomorrow. Finally, when using the word *pointe*, I am referring to the pointed foot of a person wearing pointe shoes; when a dancer is "on pointe," it means that they are dancing or balancing on the toe of the pointe shoe.

Regarding the ballets mentioned within these chapters, the works I have written about illustrate an issue in classical dance or embody an idea I am developing. I have chosen ballets that are performed regularly by most companies: the full-length classics and the shorter repertory pieces that have become staples around the world. While I have discussed

the history of some core ballets—*La Sylphide, Giselle, Swan Lake*—I have not gone into the choreographic revisions triggered by evolving technique and the changing tastes of different eras. Again, many wonderful books already address these subjects, and my hope is that you will move from this book to those.

FIRST POSITION FIRST:
THE FOUNDATIONS OF BALLET

ALLET BEGINS WITH A DARE. Can you, standing with feet parallel and insteps touching, fan each foot outward by ninety degrees so that your toes are directed to the right and to the left—think Charlie Chaplin!—and can you do this without falling?

Try it now.

You probably felt a tug under the buttocks and down the back of your thighs, for you've engaged muscles that a normal bipedal stance—toes forward, like your nose—does not. Instead of the usual four-cornered footing of two feet aimed forward—north, let's say—your feet, with heels touching, are aimed east and west on a single straight line. Perhaps it seemed as if a strong wind would blow you over and you

compensated by stiffening backwards or teetering forward, as Lucille Ball does in episode nineteen of *I Love Lucy*, titled "The Ballet." These are no-nos. Knees must be "stretched" (straight), the rear pulled in, the breastbone lifted, the neck long, and the head like a flower on its stem, drawing light and life from the sun high above.

This is first position.

Classical ballet is based on five positions of the feet. In "The Book of Exaltations: The ABCs of Classical Dance," the great Russian dance critic Akim Volynsky calls them "the five embryos of all future movements," and first, while seemingly simple and as easily drawn as an upside-down T, constitutes a radical departure from everyday deportment. It removes us from our evolutionary destiny, the hunter-gatherer locomotion of feet parallel, in line with our eyes and the path in front of us. And it resets the legs and feet for emancipation—limitless movement in limitless space. All of classical dance flows from first position. All ballet classes begin in first position. And the first lesson learned by all students of ballet is first position.[1]

"It is part of the inviolable ritual of ballet dancing," writes the American choreographer Agnes de Mille in her memoir *Dance to the Piper*. "Every ballet student that has ever trained in the classic technique in any part of the world begins just this way."[2]

We too have begun just this way. In this chapter we will look at the birth of ballet in the French court, where the spatial reorientation exacted by first position—and reiterated by the other four positions—is a conceptual Big Bang

with spiritual, political, and theatrical ramifications. We will then, through first position, enter into the first great ballet made on American soil, George Balanchine's *Serenade*. Created with the intention of lifting student dancers from the classroom to the stage, dramatizing the very positions they were diligently perfecting in daily class, *Serenade* has also taught and lifted generations of balletgoers. Free of meaning yet full of meaning, it draws us into the world of ballet a little deeper with every viewing.

"IN THE FIRST POSITION THE LEGS ARE STRAIGHT, THE TWO heels one against the other, and the feet turned out equally." This description comes to us from Pierre Rameau, author of *The Dancing Master*, a seminal text published in Paris in 1725. Although the book is primarily focused on the social dancing of its time, such dancing shared the positions and precepts practiced and advanced by France's Royal Academy of Dance, the West's first dance institution. The academy was founded in 1661, marking the start of ballet as we know it today.

Rameau writes admiringly of Pierre Beauchamps, who was appointed director of the academy in 1671, for it was he who established as absolute the five positions and, in so doing, gave "a definite foundation to the art." Rameau has even greater admiration for Beauchamps's employer—Louis XIV, the king of France, who reigned from 1643 to 1715 and was the founder of the Royal Academy of Dance. "That

prince," Rameau writes of Louis XIV, "endowed by nature with a noble and majestic bearing, loved from his cradle all manner of bodily exercises, and to his natural gifts added all those that can be acquired. His passion for dancing induced him, during periods of peace, to give magnificent ballets, in which this sovereign himself did not disdain to appear with the princes and nobles of his realm."[3]

So much is contained in these two sentences. Rameau's reference to the king's "noble and majestic bearing" reminds us that an aristocratic comportment is expected of every ballet dancer—never mind that young hopefuls would eventually come from all classes and races. And his mention of the king's cradle is symbolic. Ballet traces back to the marriage, in 1533, of the Florentine noblewoman Catherine de Medici to the French king Henry II. Through this union Italy's love of outrageous spectacle was joined to French ideas about the perfectibility of man, and court celebrations that included all manner of physical prowess—acrobatics, pantomime, magic, theatrical horse ballets—in time gained a cerebral underpinning. One hundred years and three French kings later, the court of Louis XIV was indeed the golden cradle of classical dance. During his reign the art form was coddled, codified, nourished, and nurtured by a king who danced for both pleasure and power.[4]

In this he followed in the footsteps of his father, Louis XIII, who not only had a hand in the creation of ballets but used these ballets as a kind of political public relations. It is important to remember that in seventeenth-century France the upper body and head were thought to be the

site of nobility, while the body below the waist (and under skirts) was considered ignoble. Extreme verticality was built into the clothing of aristocrats, with padding in men's jackets forcing a lift in the chest and the V-shaped corsets of women creating an erect posture so extreme that their shoulder blades sometimes crossed. The king was accepted as the embodiment of France, his own flesh as sacred as a saint's (after death, as with the saints, pieces of his corpse were apportioned into reliquaries). How better to express the king's supremacy than in movement that ennobled the legs and feet, thus drawing the lower half of the body into high-minded wholeness with the upper half? When Louis XIII danced the role of Apollo—the god who governs the hours of the day—it further enhanced his aura of godlike divine right.[5]

Louis XIV was even more adept at mixing dance and politics. He first performed at age thirteen. Two years later, in 1653, in a bolt of metaphorical—and somewhat Machiavellian—brilliance, he assumed the lead role in a thirteen-hour work called *Le Ballet de la Nuit* (The Ballet of the Night). Performed through the night, this ballet centered on themes of darkness and chaos—fetes, Fates, the Moon in love with the shepherd Endymion, and a flaming witches' sabbath—all of which were dispelled by the approach of dawn, or rather, of young Louis, the people's savior dressed in gold as the Rising Sun. It is this role that earned Louis XIV the sobriquet of *Roi-Soleil,* or "Sun King," and it is to this sun that young dancers the world over, lined in rows at the ballet barre, lift their heads.

As befit the sun, the golden-haired Louis XIV reorganized his court so that it revolved around his person and his passions. When Rameau writes that "this sovereign himself did not disdain to appear with the princes and nobles of his realm," he is alluding to the fact that female roles were at that time danced by men, and he is also putting a gracious spin on an ingenious power play. As a way of controlling and containing divisive nobles, Louis insisted on their continuing presence at his palaces, where strict protocols of etiquette—including a refined sense of movement and the ability to dance—governed all. To stay in the king's good graces, the aristocracy itself had to practice grace. Classical dance was a man's pursuit of real consequence. (Although noblewomen sometimes appeared in Louis's ballets, professional female dancers did not officially take the stage until 1681.)[6]

As for the way Rameau links the king's pursuit of classical dance to "periods of peace," there is here the implication that ballet is the opposite of battle, which is, in a sense, true. Classical dance is grueling to master, and aspiring dancers often feel they are at war with their bodies. But the end result of daily training by endless rote, of technique pushed and perfected year after year, is the appearance of effortlessness, the banishment of strain—energy coherently and peacefully channeled. It is often said, "Ballet never becomes easy; it becomes possible."

The possible in love with the impossible!

Finally, when Rameau writes of first position that "the feet [are] turned out equally," he is not only showing us the symmetry that distinguishes this position—the strangely

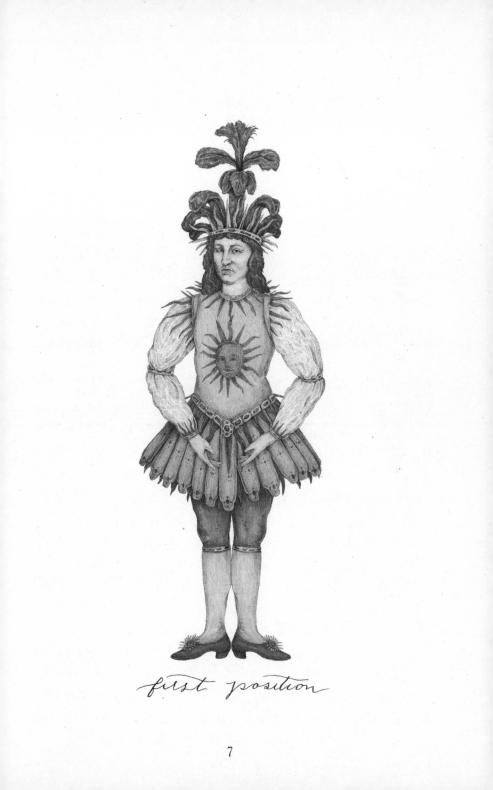

first position

serene (or serenely strange) balance from which ballet begins—he is describing the hallowed threshold into ballet's kingdom. For contained within first position is a concept that is indivisible from ballet: turnout.

"IN ORDER TO DANCE WELL, SIR," WROTE THE EIGHTEENTH-century ballet master Jean-George Noverre, who for a time taught Marie Antoinette, "nothing is so important as the turning outwards of the thigh, and nothing is so natural to men as the contrary position." This is why first attempts at first position catch us under the buttock and leave us flailing like Lucille Ball. Turnout is not natural.[7]

Done correctly, turnout is generated in the pelvis—as is all human life—and specifically in the hips, where the ball at the top of the femur must rotate outward in its socket. This doozy of a sentence, found in Anatole Chujoy and P. W. Manchester's *The Dance Encyclopedia*, explains it anatomically: "If the leg is turned out, the big trochanter recedes and the brim of the acetabulum meets the flat side-surface of the hip-neck." By extension, the top of the knee, ankle, and metatarsals also turn outward, resulting in a smooth linear channel that allows power to flow freely and elegantly all the way down through the toes. In Rameau's time, the turned-out feet of first position looked like a V opened to 90 degrees. Today, dancers work toward the more extreme ideal of feet turned out to 180 degrees. Muscles in the hip, haunch, and groin must adjust to support this acute rotation

of the femurs in their sockets, a process of years that can't be forced or faked.

But why move in this artificial way?

We could ask the same question of the equestrians who practice dressage, which dates back to ancient Greece, became a classical art during the Renaissance, and has its own array of pirouettes and fancy footwork. The answer has to do with the concept of "collection." When horses in the wild collect, whether for play, courtship, or competition, they lift in the chest, arch the neck (which draws in the head), and pull in their hindquarters. This concentration not only makes them appear larger, it allows them to move instantly in any direction, especially upward, in rears and bucks. In the art of dressage, horse and rider collect together, performing harmonious moves of poised precision and technical bravura. The mantra of dressage is "maximum performance with minimum effort."

Turnout is the basis of theatrical dancing, and when it is employed, Rameau tells us, "the body appears more erect." This means taller, but also, as John Milton put it in Book IV of *Paradise Lost,* more marvelously human. Describing Adam and Eve in Eden, he writes: "Two of far nobler shape, erect and tall, God-like erect . . . seemed lords of all." Turnout's symmetrical torque in the hips engages energy and concentrates it, so that the dancer is *always collected.*

Tadasana, the feet-parallel Mountain Pose of yoga, is a solemnly rooted position, a grounding that feels for the heart of the earth through the soles of the feet, drawing primal power up into the body. It is worshipful and

weighted. Turnout, which finds five different expressions in the five positions, has more in common with the double helix—life dynamically coiled and ready to leap. In a split second the ballet dancer can shoot, skip, step, or slide in any direction. Turnout also meant that at court one could glide forward, backward, or sideways while continuing to face the king. Life in the stratosphere of Louis XIV was itself a form of theater.

It just so happens that turnout is also beautiful. During the reign of Louis XIV women's legs were still hidden under long skirts, but for men, a shapely or "well-turned" leg was such a source of pride that men with thin calves might fill out their stockings with lamb's wool. When the feet are turned outward into first position, the legs come suddenly into profile, the curves and volumes of the muscles are more fully dimensional, and the inner plane of the thigh, usually hidden from view, is presented with panache. The dancer's body becomes an open book and his turned-out legs offer more for the audience to read. There's the shape of the foot and the slimness of the ankle. There's the silhouetted S line of the leg: the relationship of swell to swell as the line curves over the thigh and under the calf. We expect classical proportions from classical dancers, and turnout lets us see the sculpted musculature of our species displayed without self-consciousness.

"I wasn't naked," the stripper Gypsy Rose Lee, arrested in a police raid at Minsky's, once claimed. "I was completely covered by a blue spotlight." Even in the scantiest costume

the ballet dancer isn't naked: he or she is completely covered by the classical technique, which means turnout.

So turnout is the key. When a dancer assumes first position, it's as if two doors swing open on a kingdom with its own forms, symbols, and senses, an alternate universe where movement itself has been restructured. The feet, once blinkered like eyes, are now like ears, able to "hear" what is all around, a sweep of 360 degrees. Feet can't hear, of course, but in assuming first position the toes, the feet, the legs—the whole body—become more listening, more responsive, more sensitive to space.

"Turnout makes the difference," we read in Chujoy and Manchester, "between a limited number of steps on one plane and the possibility of control of all dance movements in space." One plane versus all space! Where before turnout a person stands on a path, after turnout a dancer exists in a sphere. Within that sphere the dancer trains daily on curves and circuits. Like the legs of a compass, the supporting turned-out leg is stationary while the working turned-out leg reaches from the hip socket to draw circles and semicircles on the floor, ringlets and upwellings in the air. These are *ronds de jambe*, "rounds of the leg."

Volynsky, eloquent on the subject, sees turnout in music, poetry, and painting. "The principle of turnout prevails where human creation is present," he writes. "The creative act is by its very nature an act of turnout." And so we turn to George Balanchine and his first creative act in America.[8]

"SERENADE WAS MY FIRST BALLET IN THE UNITED STATES," Balanchine, the greatest choreographer of the twentieth century, tells us in *Balanchine's Complete Stories of the Great Ballets*. "Soon after my arrival in America, Lincoln Kirstein, Edward M. M. Warburg, and I opened the School of American Ballet in New York. As part of the school curriculum, I started an evening ballet class in stage technique, to give students some idea of how dancing on stage differs from classwork. *Serenade* evolved from the lessons I gave."

The year was 1934 and Balanchine was thirty. Born in St. Petersburg in 1904, a graduate of the czar's Imperial Theater School, Balanchine left Russia in 1924. He soon joined Sergei Diaghilev's legendary company, the Ballets Russes, and there he made his first masterpieces, *Apollo* in 1928 and *The Prodigal Son* in 1929. When Diaghilev died three months after the premiere of *Prodigal*, Balanchine began freelancing, moving between Paris, London, Copenhagen, and Monte Carlo. In 1933, a young American named Lincoln Kirstein—Harvard-educated, wealthy, and mad for ballet—made Balanchine an intriguing offer: come to America and start a ballet company. "Yes, but first a school," Balanchine famously replied. He knew he was not just starting fresh in America, he was starting from scratch—from first position. In 1934, when Balanchine began work on *Serenade*, his American students were not yet artists; they were hardly dancers.[9]

The curtain comes up on a stage containing seventeen young women, because that's how many girls were in class the day Balanchine began. They are wearing long tutus of palest blue—the lighting onstage is the milky blue of

moonlight—and they are arranged in a pattern of two dia-monds linked in the center by one girl. Perfectly symmet-rical, this pattern suggests a pair of wings (the downstage edge forms a W, the upstage edge an M). Poems in which the line lengths take the form of their subject are called "pattern," "shape," or "concrete" poems, and there is some-thing of pattern poetry in this opening image. In "Easter Wings," George Herbert's poem of 1633, words are arranged in line lengths that look like two wings on the page. Ballet is an art of pattern poetry, especially in the arrangements contrived for the corps de ballet.

The young women are standing normally, their feet par-allel and close together, insteps touching. Their right arms are raised on an angle, and their right hands, fingers to-gether, seem to salute the moon. One's thoughts run back to 1653 and *Le Ballet de la Nuit.*

In unison, on a swell in the music—Tchaikovsky's Sere-nade for Strings, op. 48—the women turn their faces away from the moon and pull the top of that raised hand in toward the right temple, a gesture that unites them in emotion. But what emotion? World-weariness? A lapse into dream? The right hand then lowers to meet the left, both arms curved downward to form parentheses around the hips, the site of turnout. On a cue in the music that only these women hear, their feet snap open into first position.

In this moment we realize that Balanchine's floor pat-tern, his semblance of wings, is also an enlarged expression of first position: symmetrical, serene, yet ready to fly. Each girl slides her right foot out to the side, toes pointed—a step

13

called *tendu*—and then slides it back so that it is fully in front of the left foot: fifth position. Opening their arms to the audience and letting their heads fall back in shared rapture, they look like gulls gliding into mist.

"You start in parallel," says Deborah Wingert, a Balanchine dancer who has taught *Serenade* countless times, "and you're standing as a human being. As you turn out into first position you've entered the world of ballet. Then you breathe and do the first, best tendu ever. And then close into fifth, which is home base for ballet. As you open the face, the arms, the chest, it's like you're saying, *I'm ready to dance now, I'm beginning to dance*. So that sense of opening in the arms and in the heart allows for the art to come through. All the mechanics, all of the vocabulary are there."[10]

Serenade's snap into first position is a lock springing on a secret society, a sylvan sorority whose members move in this special way. They whirl like the wind and flow forth in waves. They gather into groupings reminiscent of the sculptures that surround royal fountains; they form sisterly cliques and Old World allées. Everything they do has a point of reference in one of the five positions, for as the ballet teacher Muriel Stuart writes, "All leg movements proceed from these five basic positions and have their logical termination in them." When Lincoln Kirstein writes that the five positions "are a kind of net or comb through which dance movement must accommodate itself in a ceaseless shift," he could be describing the ceaseless ebb and flow of *Serenade*.[11]

LET'S TAKE A CLOSER LOOK AT THESE FOUNDATIONAL FIVE positions. In every one of them both feet are flat on the ground, the body is centered over them, and weight is held mostly in the balls of the feet. These positions, which are architectural in their strict plumb line and unchanging sense of measure, support a system of spatial verities. All exercises in daily class begin, end, and constantly move into, out of, or through one or more of these positions, which means that there is a constant circling back—a dynamic of eternal return—that is built into ballet's movement language and that gives the art its sensation of high-vaulted yet airtight enclosure. If you mapped out the paths through which a classical dancer's legs must always travel—on the ground (*à terre*) and in the air (*en l'air*)—you would see movement corridors that are akin to the orbital paths of celestial bodies: demilunes, ovals, and ecliptic rings. The dancer's solar plexus is like the center of an armillary sphere.

In fact, as the art developed during the hundred years preceding the reign of Louis XIV—a period characterized as *ballet de cour*, or "court ballet"—celestial aspiration was actively engraved into its forms, with steps and positions modeled on the geometries of mathematics and astronomy, disciplines that engage infinity and touch the divine. The art form was thus elevated, its stress on perfect proportions established, and the groundwork laid for its claim to classicism. You could say that ballet is the human embodiment of *musica universalis*—"harmony of the spheres"—an ancient philosophical concept that found in the sun, moon,

and planets, in the constancy of their movement patterns, a state of music. Such heavenly harmony implicitly supported the ascendant authority of Louis XIV—the Sun King. Even today, more than three hundred years after his death, the art of ballet is a living reliquary for this king's body.

First position, for all its generative power—its incarnation of "In the beginning . . ."—doesn't appear that often onstage. We see it in ballets that celebrate classical vocabulary by evoking the centuries-old rote of the classroom, works like August Bournonville's *Konservatoriet* (1849) and Harald Lander's *Études* (1948), or in a ballet like *Serenade*, where first is the doorway into classical dance. Mostly, first position is present onstage as a narrow passageway that dancers brush through on their way to bigger movements fore and aft. Walking, running, and leaping, dancers are moving through first.

In second position the feet remain turned out on the same east-west line as in first, but with a distance of one foot between the heels (not twelve inches but rather the length of the dancer's own foot), so that the shape of second is like a capital A. Some schools of thought allow a wider second, and choreographers take liberties with the position, but to widen the spacing of second is to lose collection, the coiled spring beneath. In temperament, second is unguarded, the position most free from the tension of artifice. Where first is quiet and correct, a ritual beginning, second is openly athletic and gung ho. As Rameau tells us, second "is used in open steps which are employed for traveling sideways." It is frequently seen onstage: on pointe in a snapped-open A

shape called *échappé* (escaping), up in the air in a sideways skimming step called *glissade* (gliding). In modern or avant-garde choreography, where classical ambiance and courtly manners are stripped away, the exposed groin of second position can suddenly, when the dancer bends both knees in a *plié*, seem defiantly sexual or even bawdy. It all depends on context.

Third position, which in Rameau's time was a place of repose, is not in use today. Achieved by bringing the heel of one foot to the middle of the other, so that heels overlap while the toes remain visible on their east-west continuum, third has come to seem neither here nor there, an unnecessary stop on the way to fifth position, which is here and everywhere!

Supremely concentrated, fifth sees one foot pulled completely in front of the other, so that the heel in front hides the toes in back (and the toes in front hide the heel in back). Though pressed tightly against each other, the feet in fifth have the feeling of a figure eight. At the same time the silhouette of the legs in fifth is an hourglass: hip-wide at the top, thinning to one visible knee (the other knee, crossed behind, is hidden), then widening out again to the width of the foot. The mini infinity that adheres in both the eight and the hourglass adheres as well in fifth, the most collected of the five positions. When the Russian dancer Mikhail Baryshnikov, not tall at five feet six, took fifth position on the stage of the Metropolitan Opera House, his heightened presence flooded the place.

Fifth is the center of ballet's universe, and from fifth a dancer can move to any point within the spherical surround.

In her book *On Balanchine Technique*, the former New York City Ballet ballerina Suki Schorer writes that for Balanchine, fifth had "an almost mystical significance." In his last days, she continues, when one of his dancers visited him in the hospital, Balanchine "made fifth position with his hands and rotated his arms to the right and to the left. He said, 'This is where it all is.' Even close to death, he was still pondering it."

Fourth position is perhaps the most complicated of the five positions. It is strikingly eloquent. Just as second is first position widened east-west by the length of the dancer's own foot, fourth is fifth position opened forward or back—north-south—again by the length of the dancer's own foot. When the left foot is forward, the floor pattern of fourth is something like a Z (the pattern flips when the right foot is forward). There's a lot of air in fourth and thus built-in uncertainty, more searching for centeredness over the legs. (Second is automatically centered—no searching.)

"It's open but closed," the Balanchine dancer Deborah Wingert says of fourth position. "Open but crossed. The interconnection of the inner thighs is profound; you are choosing to coordinate your legs in opposition to one another. There's always a spiral going on. If your right foot's in front, your right hip has to be pulling back and your left hip coming forward. They'll never actually align, but you are always striving for that—striving for the impossible."

Fourth, then, is the star-crossed position, the most romantic of the five. In the middle decades of the twentieth century it was the ballerina's position of choice, held on pointe, for the studio photographs of the time, her legs

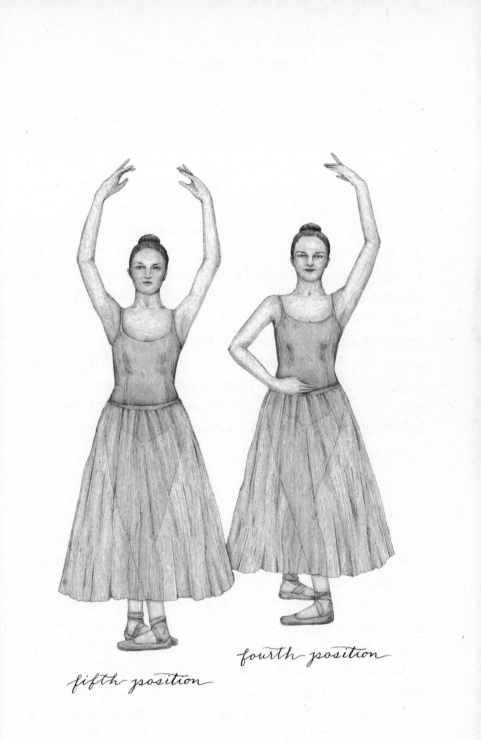

fourth position

fifth position

energized by fourth's torsion in the hips and caressed by light and shadow. Fourth is a position of suspension. With knees bent in plié, the most common preparation for pirouettes, fourth is like an intake of breath before a tempest. On pointe, fourth is a rising fairy bridge, a sigh of longing. In the air, it's *grand jeté*—a spiral straightening to the stars.

After ten years of study, the size and shape of each step, its prescribed path on the ground and the slipstreams in the air into which it is drawn, become second nature. And still, work on turnout never stops. Some dancers will get to 180 degrees without tears. Others, because of their anatomy, will never get there and must compensate with adjustments that approximate perfect turnout. The art form of ballet is not very forgiving of flaws physical or technical, but it is understood that only a few can attain full turnout in both legs. Many great dancers have had less-than-great turnout.

WHEN BALANCHINE MADE *SERENADE* FOR HIS FIRST AMERican students, novices in the transfigured world of ballet, he was attempting to give them wings. There is no evidence that Balanchine knew Herbert's poem, but the Russian artists and intelligentsia of his generation were well read in the poetry of other countries, so he could have known it. "Easter Wings" is about man's fall from grace and his flight to salvation. *Serenade*, too, contains a fall—actually, a few falls. The first came to the ballet by accident, when one of the students fell during work on *Serenade*. Balanchine wove

the event into his choreographic design, where it took on its own life. He let it recur, and it became a motif. This first fall is not Herbert's fall, that of Eve and Adam in the garden, but the second fall, which happens to a different girl—she is called "the Waltz Girl"—is more ambiguous, touched with turbulence . . . fallible. In the end, she is lifted above the others and borne into a darkling beyond that may represent the grace of God.

There are many ways to interpret *Serenade*. As Balanchine said, the ballet was meant to give his students a sense of the stage, to bring their technique to the next level. So it's a dance academy in Arcadia. "The five academic positions," Kirstein writes of *Serenade*, "are successively assumed in the initial twenty measures of the music." The ballet has also been viewed as an updated, hair-loosened expression of Mikhail Fokine's ballet of 1909, *Les Sylphides*, a study of winged wood sprites set to the music of Chopin. Fokine himself was referencing the groundbreaking ballet of 1832, *La Sylphide*, in which a sylph dies because of her love for a man. Her wings drop off and she leaves the world floating upward on a bier. (It is worth noting that the first sylphides, like their descendants in *Serenade*, were costumed in long bluish tutus.)[12]

Historians have pointed to Isadora Duncan, the barefoot American art dancer who took Europe and then America by storm in the early twentieth century, as an influence on both Fokine's *Les Sylphides* and Balanchine's *Serenade*. She was mistress of the earthen gesture, of unadorned flow and an unmediated response to music. Unschooled in classical

technique, unafraid to dance solo to large scores by Chopin and Tchaikovsky and Wagner, the free-form Duncan showed the way to modern dance and was as much the inheritance of Balanchine's new students as were the classical commandments he was teaching them. In *Serenade* we see the beginning of an American classicism, ballet dancing more unadorned, unmediated, and free in its responses.

Unwilling to impose on his work by explicating it, Balanchine writes, "The only story is the music's story, a serenade, a dance, if you like, in the light of the moon." And yet, what to make of *Serenade*'s tragic undertone and elegiac ending? What to make of the descriptions from dancers who speak of forces disturbed and whirling, who liken the ballet to an ocean turbulent with currents, the dancers swept from calm pools to rushing vortexes?[13]

In a book called *Balanchine and the Lost Muse: Revolution and the Making of a Choreographer*, the historian Elizabeth Kendall writes of Balanchine's relationship with a classmate, Lidia Ivanova, who died by drowning in 1924, just weeks before she was to leave Russia with a small troupe of dancers that included Balanchine. They were young, close, and had grown up together in the Imperial Theater School. Lidia's death—poorly investigated and possibly a political murder—was traumatizing. Here was a dancer who was pulling the art form into the future, whose abandon onstage was revolutionary but whose abandon offstage left her dangerously unprotected in a time and place—St. Petersburg, Russia, post-revolution—that was itself disturbed and whirling. In *Serenade*, when the Waltz Girl falls for the final time,

she does so turning in the arms of a male dancer, as if rolling in a watery vortex. This man, whom one might view as a surrogate for Balanchine, stands over the fallen girl while another woman, positioned behind him, wings her arms like a great angel. Or is she Fate? It is an image that speaks of "time's wingèd chariot" and of the obligation to accept loss and move on.

"Affliction shall advance the flight in me." This is the last line of Herbert's poem, and it is one way to read the last image of Balanchine's *Serenade*, which seems to show us a death and resurrection. How did we get to this interpretation? By seeing an image of wings in the ballet's opening floor pattern and seeing wings again in first position. By feeling in these wings the foreshadowing of a flight. And then by locating, in a flight that is preceded by a fall, theistic implications.

It is often one moment, one pattern, or one step that opens meaning in a ballet. Will everyone who sees *Serenade* see this particular meaning? No. Do we need to know for sure that Balanchine knew Herbert's poem? No. For a scholar developing a thesis on *Serenade* some documentation is required, but the rest of us are free to let our imaginations dance with the dancers.

"It means what you see," Balanchine once said when asked to explain one of his ballets. Think about that. It means what *you* see.[14]

Go to any single ballet again and again and what you see will change, depending on how your own frame of reference expands through travel, film, books, music, art, and

life. Is *Serenade*'s opening arrangement of young women a pair of wings, or girls standing where the brook and river meet, or an ancient grove in which a strange initiation is about to take place? Do these dancers embody the elemental energies of the earth—the rushes, pools, winds, currents, and tides that answer to the laws of physics just as a ballet's poetic energy answers to the laws of classical technique? Or do we witness a chapter from Balanchine's personal history, his memory of a lost girl retold in the language of classical dance? Meanings appear and disappear, just as the dancers do, on the wing.

THE POINT OF THE POINTE

*A*T THE THEATER, BEFORE YOU EVEN TAKE YOUR SEAT, the peculiar nature of ballet is calling out from a table in the lobby or from a glass case where souvenirs are sold. I am speaking of a siren song that is soundless, a seduction that is like no other on earth. I am speaking of pointe shoes, or, as they're often called, toe shoes.

There they are, arranged in pairs, in shades from Wedgwood pink to palest peach, the used pointe shoes of reigning ballerinas and rising stars. They look like half a shoe, really. The satin back and sides are folded inward so that only the box—a reinforced cylinder that sheathes the toes—is three-dimensional. On the top of the box, a surface called the "vamp," the dancer has signed her name in ballpoint or felt-tip pen. Who will buy these shoes? Girls who idolize a ballerina and aspire to dance as she does; admiring fans who

wish to come closer to a dancer they find dazzling; collectors who see history in the feet that have worn these shoes.

"I wanted to have something of you, until I see you again," says George Sanders, having stolen Gene Tierney's handkerchief in *The Ghost and Mrs. Muir*, a movie that is balletic in its acceptance of impermanence.

In all the performing arts, there is no memento like the satin pointe shoe, no other artifact so uniquely fitted to the stress of a living hour onstage and at the same time unfit to last much longer than that hour—or two or three hours (longevity depends on the rigor of the role). For girls, it is often the pointe shoe alone that draws them to ballet, its mysterious magnetism something like a religious vision or Cupid's arrow, tantamount to a calling or a high romance and promising an intensity, purity, and purpose outside the tread of ordinary existence. In that glorious postwar movie of 1948, Michael Powell and Emeric Pressburger's *The Red Shoes*, based on a story by Hans Christian Andersen, the beckoning pointes symbolize the obsessional imperatives of a life in art, the sacrifice of the everyday for the spiking ecstasy of performance. Red like the apple in Eden, possessed of a secret knowledge, these shoes are a matter of life and death. "We had all been told for ten years to go out and die for freedom and democracy," said Powell, the director. "*The Red Shoes* told us to go and die for art."[1]

Just as indelible is a scene in the 1952 movie *Hans Christian Andersen*, a Hollywood musical about Denmark's famous writer of fairy tales, many of them the basis for ballets. Andersen was the son of a cobbler, but in the movie he

himself is the cobbler—a cobbler who writes. When Andersen, played by Danny Kaye, goes to see the premiere of *The Little Mermaid*, a ballet sourced from another of his stories, he carries in his arms an offering for the ballerina, a bouquet of pointe shoes made in satins of sapphire, cerulean, fuchsia, and Paris green. Fabergé shades, confectionary colors, spring plumages—these pointes are classical eye candy, a rainbow path leading to another plane of existence.

What goes into the making and wearing of these magical slippers? How did the art of French kings find its way to a shoe worn only by women? Who was the first person to go up on pointe, and what did it mean for ballet in historical and aesthetic terms? Like Cinderella with her glass slippers, let us put on the pointe and see what happens.

THE SHOE ITSELF, THOUGH REFINED OVER TIME, HASN'T changed much in the last hundred years. Made by master cobblers who serve lengthy apprenticeships, these special slippers come from specialized companies with famous names: Capezio, Freed, Repetto, Grishko, and newcomer Gaynor Minden. When dancers find the brand and model that suits them best, they remain loyal to it for years or for life. The leather sole of a pointe shoe does not run the full length of the foot but is cut well short of toes and heel, all the better to support the arch when the dancer is up on pointe—it is more the memory of a sole. The shoe's sides and back are simple cloth, satin lined with cotton. The box, meanwhile, is

built from approximately seven layers of various fabrics (jute, linen, calico, flax—each company has its own combination), with glue between each layer. Grishko claims its glue is almost edible, composed of flour and corn dextrose, and bakes its pointe shoes in drying kilns as if they were little loaves of bread, all of which points to the organic properties of the pointe shoe and its life cycle.

Little loaves of pink bread, I should say, for the pale-pink pointe, when worn with similarly pale-pink tights, becomes a seraphic skin that lifts dancers out of the corporeal present and into a world of illusion. Why pale pink? This shade was the closest that early dyes could come to a flesh tone, and while complexions above the waist may vary greatly, the art seeks uniformity in the legs and feet. Pale pink became ballet's foundation color by default. When the Dance Theater of Harlem, founded in 1969 and one of America's most innovative ballet companies, affirmed its African American heritage and matched both tights and pointe shoes to the dancers' skin tones, the effect proved to be subtle and lovely.

New, the pointe shoe is a virgin vessel, a satin rocket to other worlds. Each dancer prepares her shoe for the trip, customizing it to her needs without sacrificing too much of its support. For better flexibility she might pull out the inner sole (the shank), and for better grip she scores the leather outer sole with a file. To soften and quiet the box she may slam it in a door or knock it against the wall. She sews on pink ribbons and secures a loop of elastic at the heel, always with adjustments that speak to the anatomy of her own

arch, instep, and ankle. The English ballerina Dame Alicia Markova glued her slippers to her feet at the heels and sewed the ankle ribbons fast. "She had to be cut out of her shoes," writes Agnes de Mille. Today, the internet is full of videos in which dancers show what they do to make their pointe shoes performance ready.

Once the shoe is put on, it awakens. The moist heat of the dancer's foot warms the layers of glue that stiffen the box and the shoe becomes one with the foot. In lighting that is dim or if you're seated far from the stage, the silhouette of a particular pointe can often be more easily identified than a dancer's face. We learn from the Goncourt brothers, in a *Journal des Goncourt* entry of 1868, that even the fluff of lamb's wool laid over the toes for padding engaged the fan's idolatry. "An expert could tell you," they write, "from a glance at the wadding, the name of the dancer." As a ballet-besotted teenager, my doodle of choice was a female foot in a pointe shoe. As if practicing a signature, I drew endless variations of high insteps curving into a sensitive vamp, the ankles crisscrossed with ribbons. If it all sounds rather erotic, truth be told, there *is* a sexual reverse that is latent in the pointe, a phallic vibe in the soft foot suddenly hard.[2]

Used up or "dead," as dancers call a pointe shoe gone soft, these scuffed relics have the poignancy of the dying sylph's dropped wings. The Russian dancer Vadim Strukov was always aghast that James, the man who mistakenly kills the thing he loves in *La Sylphide*, didn't gather those fallen wings to his heart. A footnote: the sides of a pointe shoe's box are called "side wings."

WHILE TODAY IT IS IMPOSSIBLE TO IMAGINE BALLET WITH-out pointe work, the art form did very well without it, thank you, for more than one hundred years after the death of Louis XIV. "To a number of people ballet means toe danc-ing," Edwin Denby, one of America's most important dance critics, wrote in 1943. "But toe steps are not what ballet is about. They are just one of the devices of choreography." Classical dance pre-pointe was so expressive, Denby adds, that both David Garrick, the eighteenth-century actor and impresario, and Stendhal, the nineteenth-century French novelist, "compared dance scenes they saw to scenes of Shakespeare."[3]

From the start, no matter the shoe, an articulate foot was the quick of classical dancing. "The action of the instep," writes Rameau in *The Dancing Master,* "supports the whole weight of the body in its equilibrium." He goes on to say that in jumps, it is a strong instep that "enables you to alight *sur la demi-pointe* [on the half point]. The more steps you per-form *sur les demi-pointes* the lighter you will appear to dance." Lightness—pussycat landings and a butterfly's buoyancy—is impossible without a strong and pliant foot.

Gail Grant, author of the invaluable *Technical Manual and Dictionary of Classical Ballet,* describes *sur les demi-pointes* as "to stand high on the balls of the feet and under part of the toes." This is another way of saying "on tiptoe."

The rise to *demi-pointe,* or tiptoe, which is called *relevé* (raised), is part of ballet's daily ritual at the barre. It can be performed slowly or quickly, rolling up through the foot or employing a little spring, and from any of the five positions

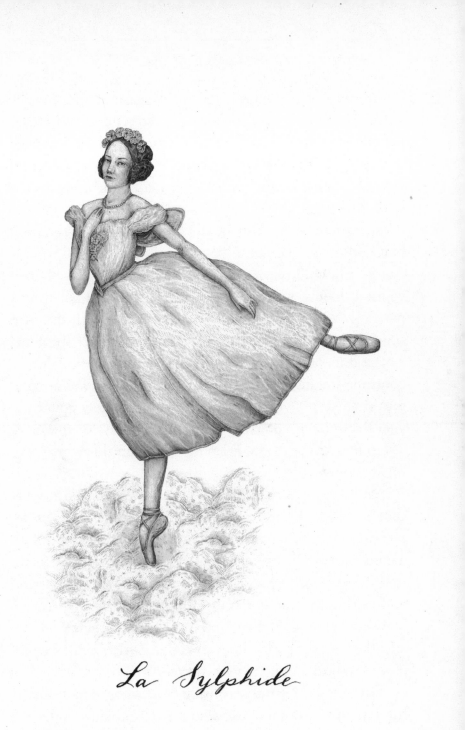

La Sylphide

or on one foot at a time. The counterpoint of relevé is plié (bent, bending), the dancer's daily exercise of deep knee bends, performed in all five positions except third. But even in plié the spirit of relevé remains, for at no time in classical dancing should weight ever settle, hard and heavy, in the heel. The life of the foot resides in the toes and instep, and every exercise at the barre maintains this fealty to the front of the foot.

Try plié and relevé yourself. Stand facing the kitchen counter, hands on the counter and feet turned out in first position. Very slowly bend the knees in line with the toes, sinking down until the heels want to come off the floor. This is *demi-plié*. Now let the heels come off the floor as you continue sinking. When you can go no further, you've completed *grand plié*. *Don't dwell here!* Immediately command your heels to push down, for this initiates the rise upward to a standing first position. From here you can slowly relevé to highest tiptoe.

Well, one can see that the feet are landlocked in plié, caught in a sonority, an earthbound feeling of Orpheus descending, squeezing down into lower octaves, not free to fly. There is no ballet without plié, but it is usually not an end in itself. (This is where modern dance, oriented to the ground and in thrall to its subterranean pull, takes over.) Instead, plié is the engine for elevation in jumps and leaps, and also a feather bed for all landings. As Grant writes, "All steps of elevation begin and end with a *demi-plié*."

But relevé. The raised steps of ballet, not to mention its hops, jumps, leaps, and the avian trills known as *batterie*—

in which the calves quickly "beat" fore and aft in flight—possess the entire celestial sphere above, an infinite space in which to explore.

AND EXPLORE BALLET DID, BUT NOT YET WITH THE FREE-dom that was in its future. Court ballet of the 1600s was a ceremonious, symmetrical, and mostly à terre spectacle—"successions of entries," in the words of Lincoln Kirstein, "formal or fantastic in design, that decorated a general scheme, but barely linked loose narrative." In the latter decades of the 1600s, under the influence of Molière and the Italians, court ballet opened into *comédie-ballet* and narratives tightened, numbers were faster and more acrobatic, and satire was introduced. At this juncture the aristocratic amateurs of Louis XIV gave way to professional dancers—no surprise, the rich do not like satire. In the 1700s, with Jean-Philippe Rameau the predominant musical architect (just as Jean-Baptiste Lully was in the 1600s), the era of *opéra-ballet* commenced. Absorbed into opera, classical dance evolved into something freer, more asymmetrical and melodramatic, its technique more sophisticated and its storytelling more nuanced and true.[4]

In all this time, the footwear of dancers did not change.

"Dancers performed in street shoes, which were generally made of ornamented silk, velvet, felt, or leather," writes Jennifer Homans in her celebrated history of ballet, *Apollo's Angels*. "Shoes were squared at the front with a thick, low

heel attached at the back for men, and more pointed at the toe with a higher and narrower heel stemming from the instep for women. Men thus moved with greater ease and balance than women could ever hope to achieve."

So women were dancing on a foot fixed in a position halfway to tiptoe, on top of which they were still tightly corseted (a silhouette that lives on in the traditional tutu, with its V-shaped bodice, intricately seamed and sometimes boned). While a slim foot in a spotless satin pump is fetching, in such a shoe there is no way to get a proper plié and hence no great spring for big jumps. Should the sole be flexible enough to achieve a fully pointed foot, that highish heel continues to be an impediment that can catch on the floor or in footwork en l'air.

If we were to pave the way from heels to pointe in a series of cameos, we could begin with Marie Camargo, who debuted in Paris in 1726 and was the first female star of classical dance to liberate herself from heels. Instead, she wore flat shoes that flattered her pretty feet and granted her more aerial brilliance—the virtuosity, some observed, of a man. She also shortened her skirts to show off her flashy *petite batterie* (small beating steps in the air) and is said to have perfected the *entrechat quatre*—a tight upward trill, legs straight, the lower calves and pointed toes crisscrossing twice in the air.

Next we would see the one-act ballet *Flore et Zephyre*, in which the wings of the inconstant Breeze are stolen by a nymph. Produced in 1796, in London, by the Frenchman Charles-Louis Didelot, the ballet stunned audiences with

the effects of its "flying machine"—counterweighted wires that let a female dancer pose weightlessly on the tip of her toes before zipping her up and around the stage. A simulated pointe!

Next, a new shoe. In the early 1800s dancers adopted the fashionable footwear of the neoclassically inclined Regency era: heelless slippers that were secured by ribbons around the ankles. Such soft footing allowed female dancers a fully integrated plié and the property of *ballon* (bounce) that comes with it. The bound and rebound of ballon was described by Carlo Blasis, the nineteenth-century Italian ballet master, as "scarcely touching the ground, and seeming at every moment on the point of flying into the air." The ballerina was now in the air, without wires.[5]

Finally, in 1832, Marie Taglioni ascends to pointe in the premiere of *La Sylphide*.

Certainly the lift built into classical placement—the high head and breast, the heels resting on the floor yet aloof from it, as if lightly kissing it goodbye—begged the question of liftoff. Add to this the desire to transcend physical limitation, a striving inherent in all athletic endeavors, and you have a neuromuscular logic urging ballerinas upward. Before 1832 female dancers had now and then lurched to their toes, but it was a trick, nothing artful about it. In *La Sylphide*, with Taglioni's rise to pointe, neuromuscular logic became aesthetic breakthrough and expansion. When she rose, the art form rose with her.

La Sylphide was custom-made for Marie by her father, the Italian choreographer Filippo Taglioni, and it takes place

in the Scotland of lore. A gentleman farmer named James, engaged to be married, is increasingly infatuated with a woodland sprite that only he can see, the Sylphide. When the ballet begins, James is dozing in a fireside chair, the sylph at his feet, watching him sleep. All through act 1, dancing with a delicacy that culminates in poses on pointe, she threads her way through his preparations for marriage—entering through the window, disappearing up the chimney, distracting him. The act ends as he runs out the door to pursue her into the woods, leaving hearth and sweetheart behind. In act 2, James finds the Sylphide among her sister sylphs and dances with them in a clearing. But the Sylphide still keeps disappearing. Looking for her, James comes upon a witch whom he has previously insulted. She takes her revenge by offering him a magic shawl that will make the Sylphide his. The shawl kills the sylph—this is when her wings drop off—and she is borne into the sky by her sisters. James is left in limbo.

For the first time in history the pointe was used sensitively, expressively, as an agent of illusion in a choreographic fantasia. It offered another way into the air, far more sustained and introspective than a jump or leap, and far more atmospheric. In short, the pointe changed the matrix of ballet. It's as if the longitudinal arch, normally a small curving cave along the inside length of the foot, suddenly released, in its spring to the vertical, an airborne bestiary of hybrid spirits. "After *La Sylphide*," the French critic Théophile Gautier would write in 1844, "the [ballet] was given over to gnomes, undines, salamanders, elves, nixies, wilis, peris—to

all that strange and mysterious folk who lend themselves so marvelously to the fantasies of the *maître de ballet*."[6]

It was also given over, decisively and definitively, to the female.

"Her Airiness," Taglioni was crowned by the French critic Jules Janin.

"An allusion to something inexpressible in words," mused Gautier.

"The Sylphide had enlarged the sphere of ballet by her conquest of the land of dreams," writes the Russian critic André Levinson in his glittering monograph of 1930, *Marie Taglioni*. "The ballet was an entertainment," he states, but now "it became a mystery."

Much ink has been spilled on the subject of Taglioni's physical instrument: her plain face, slight stoop, abnormally long limbs, her thinness. At a time when a small foot was the fashion, Taglioni's feet were long and narrow. It was her genius, led by her father's foresight and the intense strengthening regimen she undertook with him—she could hold a position for one hundred counts—that turned her deficits into avenues of illumination. The forward reach of her sloping shoulders and the lowered carriage of her long arms produced a newly attenuated silhouette, one that seemed to lead from a sunlit place into a crepuscular void. Her ballon, or bounce, sprang seamlessly and silently. And the relevé sheathed in her long foot—think iron hand in velvet glove.

Not only were form and content provocatively one in the dancing of Taglioni, but here, arguably, was the first

ballerina to hold within herself those contradictions unique to ballet. Her mighty technique was used to express the ineffable. Her *danse ballonné* style of long lines and lightness en l'air was as spiritual as it was sensational. Her body sought disembodiment: Levinson describes a "human frame impelled toward its most abstract expression, its mass reduced to the play of straight lines and pure curves."

And then there was her use of pointe. If the foot is the quick of classical dance, the development of pointe work was the quickening. In religion, quickening—or "ensoulment"—is the moment when a human being gains a soul. It is not a stretch to say that Taglioni ensouled her art form (though we might want to spell it "ensolement"). Wearing the very slippers fashionable women were wearing but reinforced with a leather sole and darning along the side wings, her time on pointe was transient, probably not fully over the toes, yet enough of a hush, a breath, a glimpse of transport to captivate audiences, especially women in the audience, so that *sylphide*, a noun, came to be used as an adjective. In the decades that followed, as portrayed in so many impressionist paintings, women's daywear fashioned in froths of white fabric were extremely "sylphide," ethereal apparel for that Victorian ideal of womanhood, "the angel in the house." It's hard not to see a nascent impressionism in *La Sylphide*, especially in its act 2 setting *en plein air*, evocative of moonrise and lunar plays of perception. The sylph was the angel *outside* the house—pure yet errant energy.

Consciousness and the subconscious, reality and dream, duty versus desire, society versus the self (and sylph!)—

Taglioni's pointes, by creating an alternative plane for movement, brought these zeitgeist polarities into the mindscape of classical dance.

The romantic ballet was born.

ALMOST OVERNIGHT POINTE WORK BECAME THE NEW NORmal, but that doesn't mean its logic was apparent to all. The reason the pointe has been compared, wrongheadedly, to the now-forbidden practice of foot-binding is because both defy common sense. "In ballet women usually dance on the tips of their toes," writes Akim Volynsky, "and at first blush this posture may seem unnatural and nonsensical. In order to elucidate this issue, which is so essential for ballet, we need to examine the nature and significance of verticality in everyday life."[7]

Volynsky believed that the vertical inspires an involuntary and emotional surge skyward. "Soaring cathedrals, obelisks, columns, mountains," he rhapsodizes, "all of these draw the soul upward." He goes on to speak of early man in a rather winning pocket version of evolution. "At one point man crawled on all fours and lived in trees the way monkeys now do; he lived then horizontally, without raising his eyes to the stars, and he also thought horizontally. . . . But in the course of development . . . man climbed down from the trees, stood firmly on his two feet, and freed up his arms to engage in a conscious struggle with his surroundings." Volynsky then reprises that Miltonian thunderbolt ("God-like erect"):

"With verticality begins the history of human culture and the slow conquest of heaven and earth."[8]

Though fancifully written, Volynsky's summation of human evolution is accurate. In search of new food sources, early man did descend from the trees to the plains. His survival there depended on what paleontologist's call a "habitual bipedal foot"—a foot that could support an upright stance, thus allowing man to see both prey and predators while also freeing his hands to carry tools of the hunt. So abstract thought—the brain—was developing too. What distinguished the habitual bipedal foot from that of our closest primate relative, the African ape, was an ankle with a narrower range of motion, a big toe aligned with the other toes, and a robust and stabilizing baby toe. An arch was detectable along the inner underside of this protohuman foot. There are other opposable thumbs in nature. No other creature has an arch.[9]

So the foot, the hand, and the brain evolved in concert. But it was the foot, and more specifically the longitudinal arch, that was the bridge. Builders would one day understand the arch to be the greatest yet simplest of all weight-bearing structures, capable of creating immense interior spaces. And while many may think of feet as low on the totem pole, classical dance bestowed grace upon the foot. Its secret pocket of interior space—the longitudinal arch, which holds the quest in every step—is the foundation of our inward seeing: imagination.

When was the last time you looked, really looked, at the moon? When was the last time you stared into its sharp light

of rebounded gold, a heavenly ballon? The crescent moon sheaving the centuries like a scythe. The full moon commanding tides and migrating birds, its light a glowworm-bore into the brains of poets. The moon goddess Selene in love with the shepherd Endymion. The moon spotlighting sylphs in a silvered glade, completing the art of classical dance, telling females to claim it, to unsettle those golden boys rocked in gilded cradles.

When was the last time you looked, really looked, at a human footprint on the beach? There's the imprint of five graduated toes, and the ball of the foot, and a bough that marks the outer length of the foot, and a gouge where the heel sinks in. Classical dance lives on the toes, the ball, and the bough, the heel just touching the earth. The sand under the longitudinal arch is untouched, a hemisphere like the sun and the moon.

In his essay "About Toe Dancing," Edwin Denby writes, "Toe steps are an application of an older ballet device, the rigid stretch of knee, ankle, and instep to form a single straight line. During the eighteenth century this special expression of the leg was emphasized more and more, though used only when the leg was in the air."

With the rise to pointe, the "single straight line" of which Denby speaks could be expressed by the leg that was *not* in the air—the supporting leg. Trading the lever of demi-pointe for the tensile suspension of full pointe, the straight

line of the supporting leg was now charged, like a needle pulled to true north.

And it possessed an Olympian power that elevated and intensified any step. The dynamics of classical dancing were blown open, answering a different set of pressures and achieving new vectors and velocities because of the way this taut vertical line could bank and sheer, could whip like a top, could veer with a force made possible by the small surface under the toe—called the "platform"—a pivot as freewheeling as a ball bearing. A fierce new energy was released upward into the art form. Pirouettes on pointe spun faster, which meant more revolutions. Balances on pointe were more thrilling, a high-wire act without a net. The pointe brought an exactitude to ballet technique that was literally pointier, as if the steel burin of intaglio engraving had been applied to the art. It gave greater punctuation to footwork, more finish to the line, and, when a phrase ended with a pose *sur la pointe* (on the point), the loft of a held note.

Pointe amplified the celestial fantasy of classical dance. The ballerina's legs, ending in pointes, worked like an astronomer's compass, tracing arcs and ascensions, boundaries physical and metaphorical, thus bringing still another sensation of cartography, containment, to the art form. Like the open compass legs in William Blake's drawings "Newton" and "The Ancient of Days"—a shape that is the same as second position on pointe or the step échappé (/\)—the space measured by these pointes can seem everyday or epic. When Blake writes in his poem "Auguries of Innocence," "To see a World in a Grain of Sand / And a Heaven in a

Wild Flower / Hold Infinity in the palm of your hand / And Eternity in an hour," he could be describing the metaphysics at play in ballet, its ability to hold infinity in the arch of a foot, and eternity in a pointe.

The pointe itself is poetic. The leg that ends in a pointe is a lance, a sword, a wand—an Arthurian appendage. (Alfred, Lord Tennyson's *Idylls of the King* was published between 1859 and 1885. Written in blank verse, it is a romantic ballet in words.) Simply walking on her toes, the ballerina, with the omnipotence born of pointe, can be a sylph, a specter, a swan, a sixteen-year-old celebrating her birthday, the Cluny unicorn, Yeats's long-legged fly on water, a supermodel in the highest of heels, a Machine Age automaton, a feminist marking her territory with her toes, even *la morte* (death personified). The pointe in profile—the curve of the instep swan-diving into the toes—is an eagle's talon, a tiger's claw, a quill pen, a dove's breast, an upholsterer's needle, an arrow shot from its own bow, an echo of the crescent moon. A pointe with an extremely full instep and arch is thought to be baroque and verging on decadence and tends to be a "softer" foot, harder to control. A pointe with an arch less pronounced—straighter to the point—is more classically restrained, pulled up, and usually stronger.

After a ballet, when discussing it with friends or family, pay attention to the words or images you use to describe its pointe work. The tender hand stitches of the sewing sampler? Or the smart up-down of a sewing machine? Or aggressive stabs? Each of these analogies is already, implicitly, a form

of analysis. If you feel a dancer had a spidery way with her pointe work, this may be because the choreographer spun a web of relationships onstage. And if a dancer seemed to draw herself high up on pointe, as if into an impregnable tower, this is a clue to the character she was building. And note whether the temperature of pointe work is cool, as it is in most classical ballets (their geometric floor patterns akin to snowflakes), or hot-blooded and sizzling, as in a fiery role like Kitri in *Don Quixote*.

Hardwired into pointe work is the position—or perch—called *sous-sus*, which means "under-over." This is the position of those tiny ballerinas that pop up in the jewel boxes of little girls. It is a fifth position (the tightly crossed position), but one that is up on both pointes, the legs and feet so crossed, one in front of the other, and so close together that we see little of the ballerina's back leg and foot (the "under"). Though the ballerina in the jewel box spins effortlessly in sous-sus—an impossibility, actually, because you can't spin with two pointes on the ground—to balance in sous-sus is not as simple as it looks. The position is still but not static, for the dancer is making innumerable microadjustments: pulling up-up-up out of her toes, out of her hips, while keeping her weight centered. In the ballet *La Bayadère* (1877), in the famous act called "The Kingdom of the Shades"—an opium dream—a corps of thirty-two wraiths in white tutus position themselves in four rows of eight and rise into sous-sus as one, holding the position for seven unearthly seconds. In so doing they create a pointillist field of energy, a stillness that is not really still.

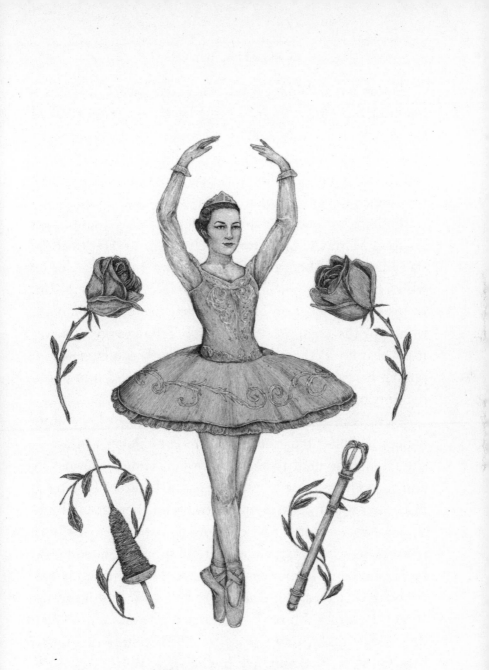

sous - sus

When a female dancer lets the inner energy of sous-sus manifest outwardly, then sous-sus becomes the step called *pas de bourrée:* a very tight back-and-forth flurry between both pointes. Humming just above the earth, pas de bourrée can travel in any direction, or it can hover in one spot like the single note of a string instrument played tremolo.

Perhaps no choreographer understood the pointe better than Marius Petipa, the Frenchman who directed Russia's Mariinsky Theatre from 1871 to 1904, decades during which he built a repertory of inimitable depth and breadth. In his 1890 production of *The Sleeping Beauty,* a collaboration with the composer Pyotr Ilyich Tchaikovsky that was itself beatific, Petipa's lyric precision with the language of pointe, his genius for visual homonyms, allowed him to tell his story on many levels.

Here's an example. When sixteen-year-old Aurora dances with her four suitors in the Rose Adagio of act 1, she takes a moment to show her joy by coming downstage and unspooling a slowly spinning pas de bourrée. Turning in place, her upper body dipping down and then lifting high, she's a long-stemmed rose opening its petals. But she also, unknowingly, foreshadows the fateful spindle that will soon be her undoing. Two meanings are fused in this animated, decorated sous-sus. But wait, there will be a third meaning. In act 3, during Aurora's wedding, the royal couple's first duet is crowned with a vertical surge of exaltation: Aurora, in sous-sus, is lifted and held high by her prince.

Rose—spindle—scepter!

Such is the alchemy of ballet, empowered by the pointe.

READING THE PROGRAM: A GLOSSARY

*T*HE USHER WHO DIRECTS YOU TO YOUR SEAT AT THE theater will invariably hand you a program for the evening's performance. It is usually small in size, but it is no small thing. Ballet programs fall into that realm of printed memorabilia called ephemera, but they are also handfuls of history that contain the ongoing life of a company. In these pages, printed the day before the performance so as to accommodate last-minute cast changes (the result of strains and sprains), we have a record of *who's* running the company and *who* is in it, *what* ballets are in repertory or in fashion, *where* a dancer is perched on the roster, *which* contemporary choreographers are on the scene, and *how* talent is rising through the ranks. Some balletomanes save every

47

single program to form an archive of their passion. "Ballet-omane," by the way, is pronounced with a hard *t*. The term joins "ballet" to "mania" and refers to avid fans of the art form, who are sometimes just called "manes."

My first job after college was at *Stagebill*, the national program magazine that served theaters, opera houses, performing arts centers, and symphony orchestras. I was an assistant editor in the Chicago office, and I haven't forgotten how exciting it was when a ballet company came to town. There were the annual tours of the American Ballet Theatre (ABT), the Joffrey Ballet (now resident in Chicago), and the Dance Theatre of Harlem, along with international visitors like the Bolshoi Ballet, the Stuttgart Ballet, and the Royal Danish Ballet. I grabbed the chance to edit those programs, even though it meant proofreading a lot of names. There was a company roster—always the first or title page—followed by the ballet or ballets to be performed, complete with credits, casting, and sometimes a synopsis. These pages would be followed by lists: members of the orchestra, the company's staff and board, and the donors who kept the company financially afloat.

All these names add up to an expensive enterprise. Classical dance is in deep debt to the kings and queens, the czars and czarinas, who had the time, space, and treasury to maintain an art form that was as organic as it was ornamental, slow to grow yet panoramic, its poetry a Homeric act of muscle memory stretched over centuries. Income from ticket sales can't begin to cover a ballet company's operating expenses, so in many countries ballet is still state supported and en-

joys the patronage, and title, of existing monarchies—Great Britain's Royal Ballet comes to mind. In America, companies have development departments that pursue corporate grants, government endowments, and private giving. The budget, always ballooning, includes salaries onstage, offstage, and in the pit; costumes and scenery; home-base upkeep; and the cost of endless rehearsal on union time—not to mention, if the company travels, gargantuan touring expenses. In recent years companies have defrayed costs through sponsorships—a strategy that sees a board member, wealthy fan, or corporation paying the salary of an individual dancer—but the practice raises eyebrows (will a dancer with big sponsorship be favored over a better dancer with less backing?). Add it all up and the care and feeding of a ballet company is commensurate with a king's ransom.

The company itself is a kind of kingdom, with a tiered structure of rank, only this kingdom is more romantically moated and shares themes with the fairy tale: competition between exquisitely ambitious women ("Mirror, mirror on the wall, who's the fairest of us all?") and overnight transformations brought about with the wave of a wand (or at least a cast change). Take a look at the program's title page; printed there is a clear hierarchy that represents levels of achievement not unlike those in the military and based similarly on performance under pressure—the same guts, grace, and imagination that sends war historians into raptures of debate.

Modern dance of the twentieth century slapped back at ballet's strict order, its companies more communes or

collectives and its dancers more or less equals, level with the horizon line. In ballet, with its hew to the vertical, lifting ever upward, equality doesn't hold much sway. The truth is that every first-year ballet student can identify the pick of the class, just as every kid in the third grade knows who runs the fastest fifty-yard dash. Ballet dancers are trying to transcend equality.

But the title page. There it is, from the top down: principals, soloists, corps de ballet. These tiers—the building blocks of older ballets—make for a wedding-cake world: the commoners on the bottom, the gentry in the middle, the aristocrats on top, and the cake invisibly crowned with a royal couple. This title-page hierarchy is also a stairway to stardom, in which the corps dancer hopes to prove his or her way upward to soloist and from there to principal.

Dancers are already prepared for this tiered climb, having moved level by level up through the ballet academy, often in color-coded leotards, and having watched fellow students fall away for any number of reasons: puberty changed their proportions, or they were not advancing technically, or they lost their commitment, the joy and the drive. Admittance into a company is a triumph for graduating students, but it lands them at a new beginning—the corps de ballet—which is base camp for a whole new climb. France, the birthplace of ballet, is a country of critics with a habit of implicit judgment (good, better, best) that today makes Americans uncomfortable. A woman who worked for the Paris fashion house Agnes B once said to me, explaining the hypercritical French, "I'm Parisian, I hate everything." So it's not sur-

prising that the hierarchy at the Paris Opera has more gradations than most. According to Gail Grant, and starting at the base, it goes from: "(1) *Élèves* (apprentice dancers; also known as "les petits rats"). (2) *Premiers quadrilles, seconds quadrilles* (corps de ballet). (3) *Coryphées* (leaders of the corps de ballet). (4) *Grands sujets, petits sujets* (soloists). (5) *Premières danseuses* (ballerinas). (6) *Premières danseuses étoiles* (prima ballerinas). Each 'cadre' (framework or division) has its corresponding number of male dancers also."

These fine French capillaries of status give us a sense of arduous ascent, the many tests to be passed before a dancer can be trusted with starring roles. In America, there are just three tiers, though there is also much more willingness to stretch soloists and even corps dancers in roles that are above their status, sometimes even lead roles, which irks the principals. Ballet doesn't have understudies; it has a premiere or opening-night cast and then second, third, and maybe fourth casts. But even if there were only one cast, ballet companies brim with Peggy Sawyers and Eve Harringtons, young women ready in the wings, eager to go out a youngster and come back a star.

Following is a glossary of terms you will encounter in the program. Knowing what these terms mean will help ready *you* for the performance.

CORPS DE BALLET. BOTH MEN AND WOMEN ARE LISTED in the corps de ballet, and when they dance together it is

usually as townspeople, peasants, or partygoers of one caste or another. If the ballet lacks a narrative then they are cogs in its machinery, or the live matter of a metaphor, or simply dancers in a dance, people who share a distinct community or temporality. The abstraction we refer to as "the corps" is another thing altogether, and it is entirely female, made up of the women in the corps de ballet. The female corps dances as a unit—as flowers, phantoms, shades, sylphs, swans, sprites, and so on. This, too, is a distinct community, but a community of souls, communicating as one. Many balletgoers think of the corps as the body and breath of a company.

The corps is not quite a Greek chorus commenting on the action (though there's no reason it can't be used that way) but more of a sympathetic surround—a Sensurround. Its lines and formations create architectural spaces and decorative framings for the duets and solos that take place within it. Scenery may "set the stage," but if you were to pretend that the scenery wasn't there and just focus on the ever-changing patterns of the corps, you would see that the corps is a ballet's true beams and backdrops—a set that can move and mutate. In non-narrative ballets, which are also referred to as "plotless" or "abstract," corps patterns offer up important information. Ask yourself, what do these patterns suggest? Do they approximate designs from nature or history, from the latest video game or technological advance? The corps is continually, if subtly, sparking collective retinal memories that charge the space with meaning.

The corps is a fabric. It is no accident that two works central to ballet, *The Sleeping Beauty* (1890) and *Raymonda* (1898), share a theme of weaving. The spindle in *Beauty*, the tapestry in *Raymonda*, these symbols nod to the affinity between ballet and the ancient art of the loom. The corps is presented in grand damask-like patterns, a nap of light and dark, while the soloists and principals are single strands that thread through this fabric, embroider upon it, or pull away from it. They may also dance as part of the pattern, disappearing into it. We see this in *Serenade*, where Balanchine weaves to great effect, lifting soloists out of the nap and tucking them back in, pulling taut drama from a single thread (the Waltz Girl), here drawn long, there snagged.

The corps is also verse. It can work like the end rhymes in a sonnet or the refrain of a song—a visual echo that reiterates, embellishes, enlarges. There is frequently a feeling of drill to the corps, but if the dancers have a Stepford-wife sameness they become wooden, without breath. Better to think of the corps as a garden, a flock, a living landscape. Whether windblown or sun-kissed or storm-tossed or spellbound, the corps possesses an alien omniscience.

And it is often wearing white. The historian Jennifer Homans tells us that during the French Revolution, women who wore "simple white tunics became powerful symbols of a nation cleansed of corruption and greed. . . . The corps de ballet as a group of women (never men) in white thus took its cue from the Revolution: they represented the claims of the community (and the nation) over those of the individual."[1]

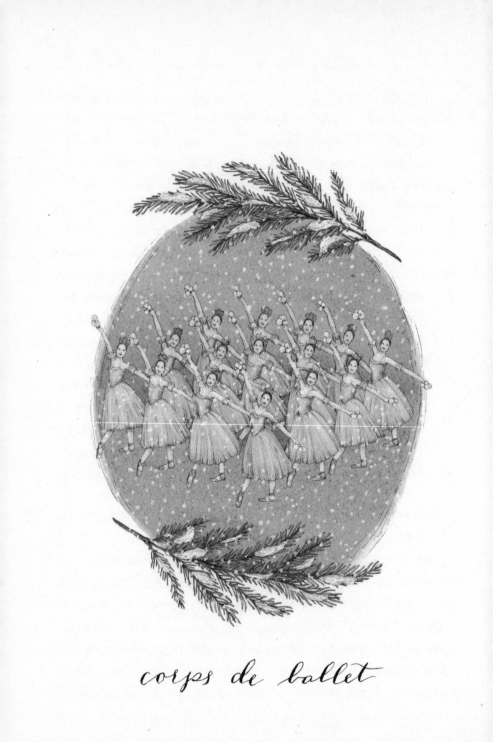

corps de ballet

I sometimes think *corps de soeurs* or *soeurs de ballet* would be a better name for this group, dressed alike and like-minded. These sisters, like the sets of sisters in Greek mythology, know what they're about. They dispense beneficence, or hold grudges, or open and close like a kaleidoscope trained on one emotional color. The humming chorus in the opera *Madama Butterfly* captures something of the corps's hive-state synchronicity, its wordless perpetuity. Soloists and principals come and go, but the corps—like the honeyed hive that supports an endless succession of queens, or the classic French cassoulet kept simmering on the stove, still tasting of that first batch of beans—is forever.

Such endurance makes the corps a much-admired keeper of company style. For even though we don't want to see a machinelike corps, we do want one that is coherent, a corps that reflects the "core" values of the company and its pedagogy. This means that its members should move as if raised together, bent by the same breezes, casting shadows at the same angle, energized by the same kinetic intelligence that fuses a murmuration of starlings or a flashing school of fish. The corps is nurtured until it becomes a thing of nature.

Yet even as its members work en masse, we are still reminded that the corps is made up of individuals. A face, a figure, a foot will beguile us from within the maze of faces, figures, and feet, and we will have a new favorite, someone to watch and wonder about. A single performer in a choir or an orchestra can similarly catch our attention, but they tend not to be singly heard, whereas a corps dancer, webbed

in her world, bound in its patterns, shines forth fully seen. We ask, "Why has this one—so appealing and with such a wonderful arabesque—not risen out of the corps?" Maybe she will rise, or maybe her strength, stamina, or nerves are an issue. Then, too, "this one" may shine best among her sisters. The corps is full of such questions.

SOLOIST. POSITIONED ON THE ROSTER BETWEEN THE corps de ballet and the principals, the soloist is regularly cast in short solos and supporting roles. Soloists don't necessarily spend that much time in the corps before moving to this middle tier, because many have been earmarked for the spotlight while still in ballet school. Teachers at the last levels before graduation may not detect the late bloomer who comes into her own once in the company, but it's hard to miss the precocious early blooms—the power ingenues—and they will be tested in solos right from the start. Stamina and star quality must still be determined, because what thrills in class may not translate to the stage. So soloist status can be short or long: a one-year holding pen for dancer A; a two- to three-year tempering for dancer B; a longer proving ground for dancer C.

Many soloists will go no further and shouldn't. They bring great pleasure in supporting roles or as spritzers and appetizers, their charms most potent in short bursts. Of the soloists who go on to be promoted, a few will bear out the Peter Principle, finding themselves technically over-

mounted in principal roles or not quite up to them artistically. (A person at a party can be fabulous for ten minutes, then strangely repetitive for longer.) This is discouraging, as it means that a principal position will be unavailable to a more deserving talent.

PRINCIPAL DANCER. THE TOP OF THE ROSTER. THESE ARE the most accomplished dancers in a company, the standard-bearers who perform the leading roles. Principals can and should be homegrown. When they are, they are testament to the vision and health of a company, its management, and the ballet academy that feeds into it. Companies that don't have a feeder academy, and hence gather dancers from various backgrounds, must work that much harder to forge cohesion of style, which is, after all, an expression of company ideals. Should management rely on guest artists to amp up the ranks of principal dancers, these guests may bring foreign performance values to the stage, confusing the soloists and corps dancers who look to them for inspiration. On the positive side, these same guests may rattle the status quo, raising the bar for everyone, as the Russian ballerina Natalia Makarova did when she defected from the Soviet Union in 1970 and joined the American Ballet Theatre.

The status of principal dancer is assumed to be the equivalent of "star" or "artist." In the best of all possible worlds, principals would always be both. But as you become comfortable judging a performance, you may begin to question

whether a given principal is more of a star than an artist: a whiz technically, say, with an intense connection to the audience, but not a particularly interesting connection to the role. Or is he or she more of an artist than a star: one who takes a role into new territory, charisma concentrated inward rather than directed out past the footlights. These are questions of lively debate in classical dance. Finding your favorites and then explaining why they move, excite, or delight you is an exercise we in the audience are expected to do.

It can be elusive, actually, this pinning down what attracts you. Perhaps there is something of an adored film actor or actress about a dancer, or they fit an archetype for which you have a weakness—the romantic, the spitfire, the rebel, the soubrette. Perhaps you see a quality of character in the way a dancer deploys classical technique, a quality you admire in others or strive for in yourself—honesty, or fearlessness, or a largeness of spirit, or a sensitivity that is involving. Sometimes it's simply a crush ("That man is a hunk!") or a fascination with a splendid face and figure. Nothing wrong with that, though if the dancer doesn't deliver artistically your eye may soon roam, on the lookout for splendor with more levels. It's an intimate business, understanding one's own heart.

ARTISTIC DIRECTOR. THE TITLE PAGE, USUALLY UP AT the top, will list an artistic director, though some compa-

nies still use the old-fashioned terms *ballet master* or *premier maître de ballet*. What does this person do? He or she makes all the decisions that pertain to repertory (the ballets performed in a season) and to casting (who dances what). This is a complex job, and it requires a knowledge of ballet history and of dance history in general, an understanding of the company's strengths and weaknesses, and a vision for the company, what its values are. Sensitive stewardship of the classics and the commissioning of new ballets from choreographers both proven and on the rise are front and center in the job description. Is it time for a fresh production of *Swan Lake*, and if so, should it be a traditional treatment or something experimental? Is there a midcentury masterpiece that's been out of repertory for too long? If it's a work by Antony Tudor, for example, a genius who weighted ballet technique with a Freudian plumb and pitch (the weight of the couch), is there the time and money to rehearse company dancers in Tudor style? What about a commission from the latest choreographic phenom, even though that phenom happens to be postmodern and a little hostile to classical dance? It could be cutting-edge classicism . . . or an insult. And our rising stars, on whom artistic and financial hopes are pinned—what's the best way to grow their talent?

That's the other responsibility: the hiring, cultivation, and casting of dancers. A company needs all kinds of personalities and artistic profiles because there's such a wide variety of ballets, each with its own casting requirements. It is the artistic director's taste in dancers and dancing that

rules who gets the leads, the solos, the breaks—and who doesn't—which is why stalled dancers may move from one company to another, hoping a different director will give them more chances. All of us, advocating for our favorites, will question the taste of the artistic director: *Why isn't he or she casting my darling in that role?!*

But here's another question. Would you want to be in control of forty (small company) to one hundred (large company) artistic egos—the hungry-to-succeed performers who see you every day and are not shy about letting you know what they want and why they are unhappy? These are short careers and the clock is ticking. Dancers are elite athletes, and the physical demands of today's classical technique are typically too crushing to sustain past the age of thirty-five or forty. Injuries end many careers sooner than that. So time is of the essence and the roles need to come *now*. The point is this: the artistic director stands between each dancer and destiny, which makes it an almost impossible job because no artistic director can make everyone in the company—or in the audience—happy.

What can we reasonably ask of the men and women in this role? That they love and respect ballet's history while being wholly invested in the present. That they have an eye. That they are clear about the uses of cheap sensation, which has its place in the theater, and that they know when it's a threat to integrity. That they support dancers who are as talented as they are difficult. That they put art before money. That they never ever say to themselves, "The audience won't notice."

CHOREOGRAPHY. NEWCOMERS TO BALLET ARE OFTEN UN-sure how fixed and fast is the spectacle before them. What is set in stone, what isn't, what liberties, if any, is the dancer allowed to take? In his book *Prelude to Ballet*, the English dance critic Arnold Haskell writes of how a lady seated next to him at the ballet "expressed her amazement that the dancers were making the same movements that night as they had the night before. She had imagined the whole thing to be a brilliant improvisation."

A ballet is most definitely *not* an improvisation.

Once a ballet has been premiered, it exists. Every performance puts it again before us, embodied and breathing, palpable and visible, so vital we can take its pulse and its temperature and give a fair analysis of its mood. Glowing with health? Sensually fulfilled? Or a little distracted, depressed? All cylinders firing or a touch manic tonight? Dancers are human and the company is a complicated organism, so performances can be prey to biorhythmic ups and downs.

Between performances a ballet is immaterial—a memory, a mirage, the floating smile of the Cheshire Cat. Like the music that accompanies it, a ballet is alive only in measures of time. And like a building, it must inhabit open space, with its footing on the ground and its expansion, expression, in the air.

A ballet consists of (1) classical steps linked into flowing phrases (a balletic phrase is called an *enchaînement*, which means "sequence, series, chain"), (2) mime and gesture, (3) visual similes and echoes, (4) spatial arrangements, and (5) stillnesses. The ballet's score or story (if it has one) will

prompt decisions regarding dance forms; the more solos, duets, and group dances there are in a ballet, the more complex it is. And the longer the ballet, the more overarching and underknit must be its movement motifs and metaphors; otherwise it will be lax.

The structure unique to each ballet—to any dance, for that matter—is called "choreography." I have spent whole afternoons in front of the video monitor, going phrase by phrase through a ballet on film—stop, rewind, play; stop, rewind, play—charting out the ever-shifting floor patterns, noting the artful entrances and exits, discovering reiterations of steps that escape the eye in performance but register subconsciously, and detecting references (to other ballets, or to other works of art or pop culture, or to the creative world around the music) that add layers of meaning. The artist who devises this time-space exploration is the choreographer. Some choreographers are also the artistic director of a company, but not all artistic directors are choreographers.

"A ballet," Théophile Gautier wrote in 1839, "is much more difficult to construct than would be believed. It is not easy to write for legs. . . . Thus a good ballet is the rarest thing in the world; tragedies, operas, and dramas are nothing in comparison with it."

If you look at the forces gathered into the choreographer's work—musicianship, architecture, and sculpture; an inborn sense of pattern and an aptitude for intelligible imagery (I haven't even touched on theatrical know-how and an instinct for showbiz)—you begin to understand why choreographers

are few and why great ones are national treasures. In every generation there are only a handful of viable classical chore-ographers. This is why you will see the same names headlined in companies across the land and overseas. Today, when a new talent emerges, every company wants a piece of the action, even if it means this new talent is stretched thin, robbed of the apprentice pace and slow-growing sentience that comes with a long gestation and that mature artistry requires.

The term "choreographer" was first used as a credit when George Balanchine made dances for a Broadway show called *On Your Toes*, in 1936. Before that the term was applied not to one who created a dance but to the person who recorded its steps, a stenographer of movement. With *On Your Toes* the word stuck, though clearly some found it pretentious. In the 1954 movie musical *White Christmas*, Irving Berlin spoofs the term in a hilarious song called "Choreography," sung by Danny Kaye. It begins, "Chaps / Who did taps / Aren't tapping anymore / They're doing choreography. / Chicks / Who did kicks / Aren't kicking anymore / They're doing choreography."

But why don't we let Balanchine himself tell us how the choreographer works with dancers. In an interview with *Dance Journal*, excerpted by the English writer and photog-rapher Cecil Beaton in his book of 1951, *Ballet*, Balanchine made clear that dancers improvise nowhere and that the choreographer's intent is everywhere.

I expect them to do exactly what I show them and as I wish it to be done. I must make them see a movement

as I see it, as if they saw it through my eyes. I do not tell them what they have to portray in their roles, because that would prejudice their conception of them. I make them drop naturally into their parts, so that they gradually come to live them. Nothing is left either to principals or corps de ballet to do for themselves; I show them every tiny movement and the least mimetic action; and I count their every step.

This is not to say that improvisation doesn't occur in the studio during the creation of a ballet, or that dancers don't bring their own perfume and personal style to a role, or even that choreographers don't make changes later on. They sometimes make small alterations because later dancers are uncomfortable in the original steps or would look better in different ones. And sometimes the choreographer has grown past the first version of a ballet, or maybe was never wholly happy with it and is still trying to get it right, and makes a change.

So which is the urtext? When it comes to classics like the great romantic ballets, or the Tchaikovsky trilogy, or modern masterpieces that received tinkering over time, this question pits scholars against dancers against coaches against critics. Choreographers are sometimes like mad scientists in a laboratory, pushing the boundaries of their own older ballets, dropping in a young dancer with wider technical horizons to see how he or she will explode space. Which is the touchstone—the original or the experiment? With the choreographer gone, there is no decisive answer.

As to music, choreographers have either the entire say or the largest say in the music they use for a new ballet. They can draw from the past or the present, and from any genre—classical, jazz, pop, avant-garde, folk, hip-hop, electronic. They can also create their own sound environment by piecing together various selections of music, as the choreographer Twyla Tharp did with such success in 1976's *Push Comes to Shove*, which swings between the ragtime of Joseph Lamb and the classical brio of Franz Joseph Haydn. Choreographers want to use music that moves them but that also triggers movement. Praising the scores composed by his frequent collaborator Leonard Bernstein, the choreographer Jerome Robbins said, "There always was a kinetic motor which had a need to be demonstrated by dance." Robbins, who liked to set himself musical tests, once made a ballet to no music. When a score commissioned from Aaron Copland was delayed, he started choreographing without it and thought, "This is very interesting without any music." Titled *Moves* (1959), the ballet is danced to silence but takes rhythmic impetus from the sounds of movement—footfalls, slides, and stamps.[2]

The commissioning of a score means that a composer has been asked to write original music for a new ballet, taking guidance on subject, length, and form. Although the choreographer usually has ideas about the composer with whom he or she would like to collaborate, the artistic director of the company will also have his or her two cents, especially if it is to be an evening-length work. In centuries past, when ballets told long stories, the choreographer and

composer, perhaps with help from the artistic director or a librettist, worked closely on the scenario, shaping the ballet in terms of dramatic arc, theatrical effects, pacing, and the placement of solos and pas de deux. The choreographer might also have given the composer a more detailed outline of what was needed musically, with indications of time spans, tempos, tone, and dynamics, just as Marius Petipa did with Pyotr Ilyich Tchaikovsky. ("The Christmas tree becomes huge," Petipa instructs Tchaikovsky in the scenario for *The Nutcracker*. "48 bars of fantastic music with a grandiose *crescendo*.") Today, commissioned scores range widely—from a decided-upon narrative to the barest of instructions.[3]

PRODUCTION. WHEN BALLETGOERS SPEAK OF A FULL-length classic, whether it's as early as the eighteenth-century comedy *La Fille Mal Gardée* (The Poorly Guarded Girl) or a more recent mid-twentieth-century work like *Romeo and Juliet*, they generally start by identifying the production. If they are referring to the original production, they mean the ballet as it was presented at its first birth into the world— same score, choreography, costumes, and sets. Most original productions have been lost for a long time, though choreographic pieces of them remain more or less intact (historians continue to grapple with the authenticity of this material). When we see an "original" production today, it tends to be a restoration, pieced together from old notations, photo-

graphs, memories, written accounts, the reading of tea leaves, and inventive channeling of the past.

The original production is not necessarily the best version of a ballet. The original *La Sylphide*, choreographed by Filippo Taglioni for his daughter Marie in 1832, is historic, a ballet garlanded with graces. But only four years later, in 1836, August Bournonville, the visionary director and choreographer of the Royal Danish Ballet, having seen Taglioni's original in Paris, commissioned a new score and restaged *La Sylphide* with his own choreography. This version—a more exuberant interweaving of tartan plaids and white tulle, human warmth and haunted moors—is the masterpiece. As for *Swan Lake*, its 1877 world premiere at the Bolshoi Ballet in Moscow was a big feathered flop. It took the Mariinsky Theatre of St. Petersburg, led by Marius Petipa and his lyrical lieutenant, choreographer Lev Ivanov, to see Tchaikovsky's Manichaean tragedy into flight, in a new production of 1895.

Because sets and costumes wear out and even the most wonderful productions begin to look dated, companies must regularly renew a classic. They can simply refresh the production by redesigning the sets and costumes or do a wholesale reinterpretation, which means new staging and choreography in part or in full. The change may be conceptual as well. We've seen classics recast as a story within a story, seen nineteenth-century narratives transplanted into twenty-first-century settings. A company sometimes attempts its own version of the "original" production, which means we can end up with competing "original" productions of a ballet.

Bottom line: a whole new production is a big deal financially and involves extensive fundraising. If money is tight, the company may rent a production from another company or two companies may share the cost of a new production that they both use. Some productions are dearly loved, others loathed. New productions are usually referred to by the year they debuted (the Royal Ballet's *Sleeping Beauty* of 1946) or by the choreographer and the company that paid for the restaging (Ratmansky's *Sleeping Beauty* for ABT).

SYNOPSIS. AFTER THE CAST LIST OF A BALLET, THE PROgram will sometimes include a synopsis. Full-length story ballets always include a description of what's happening onstage, act by act. This synopsis is especially helpful to newcomers for it lets them concentrate on the dancing, free of worry about the plot. With more confidence in your seeing, you may decide not to read the synopsis. I often don't, for the simple reason that I want to find out what the ballet itself—its imagery, structure, and movement motifs—is telling me. If the choreographer can't get the story across through movement and mime, then the choreography isn't successful. In a story ballet we should not have to ask, "What's happening?"

Sometimes the credits for a non-narrative work will include a short text. It can be a quotation, like the epigraph at the beginning of a novel; or a few sentences that make a connection or cite an inspiration; or a comment on the

music and what it means to the choreographer. These clues to content or context can open a window on the work. Some choreographers are given to overexplanation, and you may find yourself facing text that goes on and on. This rarely helps. I remember a ballet in the 1990s that was accompanied by two program pages of pretentious jargon. It was an added irritation to an incomprehensible evening. Antony Tudor once said, speaking for all choreographers, that at his best he had "expressed in movement something that says to an audience more than could be said to that audience by the spoken word."[4]

Or the written word! A lengthy explanatory note suggests that a choreographer doesn't have faith in the movement he or she has arranged.

VARIATION. THE TERM "VARIATION" IS TAKEN FROM classical music, where it refers to the restatement, in varied form or forms, of a theme. In ballet, "variation" refers to any solo dance within the entirety of a work. In a classical ballet the variations can come in eventful clusters, such as when each of the six fairies in *The Sleeping Beauty*—Tenderness, Vivacity, Generosity, Eloquence, Courage, and Lilac—performs her own solo, an evocation of the particular gift she is bestowing upon the newborn Princess Aurora. Variations are cherished for both their charms and their challenges (some are notoriously difficult). Devotees in the audience have seen variations performed countless times, and there is

a long tradition of performance against which a dancer will be measured.

PAS DE DEUX. THE LITERAL MEANING OF PAS IS "STEP," but in ballet it most commonly refers to a dance: *pas seul* is a dance for one; *pas de deux*, for two; *pas de trois*, for three; *pas de quatre*, for four. The term "pas de deux," no longer italicized, can be applied to any duet, but it's usually a shortened reference to the "grand pas de deux," which is a formal statement of love, passion, or camaraderie danced by a man and a woman. If the all-male Les Ballets Trockadero de Monte Carlo is in town, the pas de deux can be danced, and quite well, too, by a man and a man in drag.

The grand pas de deux—also called "grand pas"—has a long-established structure that divides into five parts, though the first, the *entrée* (entrance), consists of little more than the couple taking the stage. This is followed by an adagio, a slowly paced duet of close-in, hands-on, and somewhat ceremonial partnering. The adagio is followed by a variation for each dancer, and these two solos work like a pair of portraits. The pas de deux finds completion in an upbeat coda in which the pair again dance together. While a grand pas de deux can move through a progression of moods, the adagio tends to be of serious demeanor.

Whether framed as a public display or a private tryst or a dream or an abstraction, the grand pas de deux is self-contained and concentrated, poetry versus prose, which is

why these pas de deux are often plucked out of a ballet and used as stand-alone showpieces. Comparable to a temple or a bower—even something of a little Eden of enchaînements— this airy enclosure is designed to hold a relationship of two. The grand pas is the high point of a ballet, the crest of its momentum, and it is here that great partnerships are made manifest.

Such partnerships bring a special excitement to classical dance. Why? Because the pas de deux is a form of close-up, the theatrical equivalent of the camera's lavish gaze—those long seconds lingering on golden-era pairs like Colbert and Gable, Bergman and Bogart, Dunne and Grant, the rest of the world falling away. For the duration of a pas de deux, we are focused on the synergetic flow of two dancers: the way he touches her, the care with which he supports her, his intuitive reading of where she is going, her growing stronger because she trusts him, her abandon in the space between them, her fulfillment in his hands. Their attendance to each other, the heat they generate, the risks they take—big swooping moves that pull them apart and swing them back together, breast to breast—when you have dancers of escalating rapport, physically finishing each other's sentences, the pas de deux is a consummate pleasure of classical dance.

Tamara Karsavina and Vaslav Nijinsky. Antoinette Sibley and Anthony Dowell. Suzanne Farrell and Peter Martins. You can go to the history books to find out more about ballet's great partnerships, but please note: these coupledoms are not about hot-to-trot sex. They are imbued with eros but also beyond it, as if intimacy has been translated into

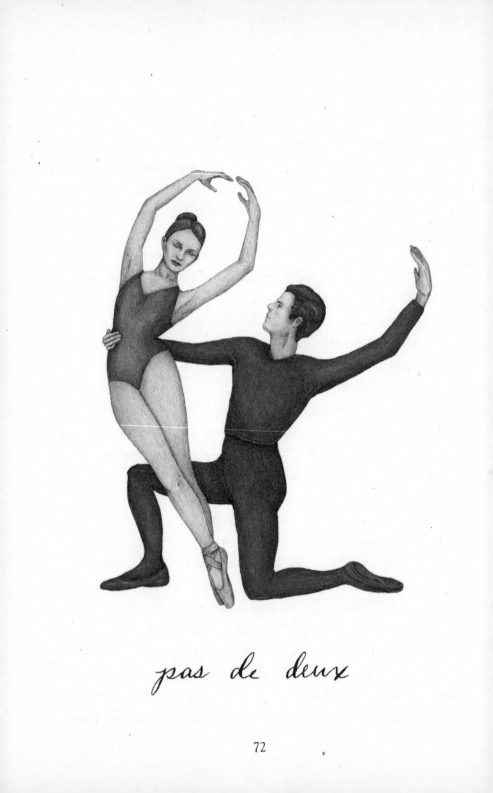

pas de deux

a whole new language of reach-and-response. The early-sixties partnership of the Royal Ballet's Margot Fonteyn and the recent Soviet defector Rudolf Nureyev was a surprise supernova that no one could have foreseen. Fonteyn was old enough to be his mother, her tea-with-the-queen air in stark contrast to his back-alley allure. So the pair was unlikely, their chemistry complex, and yet audiences responded with delirium. Here was a political paradigm that saw Western gentility calming, or at least containing, aggressive sensuality from the East. Her classical technique was pristine, his was "dirty" (meaning rough and unfinished). Then, too, there was something of Colette's *Chéri* about them, as if only an older woman could negotiate the flagrant beauty and wary psyche of this younger man.

The question of whether they were actual lovers remains unanswered. He sometimes said yes, sometimes no. She said no. "Rapture has a realm beyond the bedroom," writes Meredith Daneman in *Margot Fonteyn: A Life*. Daneman feels the right answer to the question is that "whatever took place behind closed doors, out of our sight, was as *nothing* compared to what happened on the stage, in front of our eyes." Nureyev himself said, when asked what it was like when he danced with Fonteyn, "It's not her, it's not me, it's the sameness of the goal."[5]

In the seventies and eighties, when Natalia Makarova danced with Mikhail Baryshnikov, a fellow defector from the Soviet Union, their shared training at Leningrad's Vaganova Academy gave them complicity, as if they were aristocratic children who'd suckled from the same wet nurse,

both of them understanding—and exemplifying—exactly how things *should be done*. Their partnership was an aesthetic consummation.

Baryshnikov also danced with the American ballerina Gelsey Kirkland, a "defector" from the New York City Ballet to American Ballet Theatre. She came to ABT expressly to dance with Baryshnikov, and, as one insider said, he needed her more than she needed him. Because for Baryshnikov, where Makarova was the past, Kirkland was the future. Her sparrow-like body and arrowy technique were scaled to order for his plush musculature, its puppyish proportions perfectly Herculean. The Russian archer had found his American arrow. They were a sensation.

We eventually learned, thanks to Kirkland's controversial first memoir, *Dancing on My Grave*, how fraught the partnership was and how out of sync they were offstage, her need to analyze a role and prepare carefully for a performance hitting up against his blithe brilliance and male prerogative. It was love-hate! It was seventies feminism and male chauvinism! They both took the stage in technical purity, but hers was hot out of the fire while his was ice-cap cool. We see this in the video record. We see Baryshnikov breezing through, never ruffled, a geometric proof of a man, and then there is Kirkland, her hummingbird heart beating fast in the glass castle of her technique, hovering, darting, looking for sugar water from the reigning god of classical dance.

As you may have noticed, my writing about these three partnerships—performances I saw on film or was privileged to see live—has sent me on trajectories, flying into my own

interpretive riffs. Everything one learns after the fact about a partnership, whether through written memoirs, documentaries, or inside scuttlebutt, is annexed into our remembered experience of a couple and their pas de deux (especially those we can return to on film) and keeps it breathing fresh air. This is the immortality of the great ballet partnerships, borne in the pas de deux. Our thinking about what we saw, and what it means, never ends.

TCHAIKOVSKY, GODFATHER OF BALLET

*M*Y FIRST BALLET HAS HELD FAST IN MY MEMORY for over fifty years, though not a step or gesture is retained. I was with my father, mother, and younger sister, Caryn, and we were up in a balcony. What theater was it? What ballet company? No one is sure, though my mother thinks the performance was at Chicago's Civic Opera House. She felt that Caryn and I, six and eight, were too young to appreciate ballet, but our father wanted us to know the arts early. When I ask Caryn what she remembers of the night, she says, "We were in the balcony and the stage was far away and it was a bluish color. Blue with a white dot of light at the center. Maybe the white dot was the spotlight."

I too remember a faraway stage, but the color was lavender. A glowing hearth of lavender in a huge dark space. The ballet was *The Sleeping Beauty*, and that purple glow undoubtedly belonged to the Lilac Fairy, the supernatural being who softens the mortal curse of the pricked finger, decreed by the embittered Fairy Carabosse. Transmuting a sentence of death into a mere hundred-year sleep, the Lilac Fairy is nothing less than light in the darkness. Her promise of rebirth fills the stage the way lilac blossoms fill springtime. That a performance full of bodies can become disembodied, can live on as light, color, mass, and mood, speaks to something wondrous in this art form.

"The whole world, as we experience it visually, comes to us through the mystic realm of color," writes the abstract painter Hans Hofmann in his essay "The Search for the Real in the Visual Arts." It is in this "mystic realm of color" that the composer Pyotr Ilyich Tchaikovsky built his incomparable ballets *Swan Lake* (1877), *The Sleeping Beauty* (1890), and *The Nutcracker* (1892). Understanding that his medium was aural and that ballet, an art he loved passionately, was visual, Tchaikovsky, more than any composer before him, bridged the ear and the eye. He contoured sound into almost seeable shapes and themes, and then clothed these shapes and themes in vivid orchestral color and texture. In Tchaikovsky's ear, eye, hand, and heart, the unreal in ballet—the surreal—became psychologically sentient, searching, and *real*.[1]

Put simply, it is impossible to imagine the art of ballet without Tchaikovsky, impossible to know where it would

have gone, or if it could even have survived, without him. His *Swan Lake* brought a new musical seriousness to the art form. His *Sleeping Beauty* was life-changing for many of the artists who would shepherd ballet into the twentieth century. And his *Nutcracker*, today a hot-ticket holiday tradition, keeps the world's ballet companies financially solvent. There is no name in ballet quite as creational as that of Tchaikovsky. His desires, his fears, his life, his leaps—all went to the recalibration of this art form. If you can't bend the knee to Tchaikovsky, I'm not sure you can love ballet. But let's begin with the haunting theme that everyone knows from *Swan Lake*—the music associated with the swan queen Odette—and see where it takes us.

It calls from the woods at the end of act 1, this music belonging to Odette—a princess who has been transformed into a white swan by a sorcerer. The theme, as curvaceous as a swan's neck, is heard again at the beginning of act 2, when the young Prince Siegfried, out hunting for swans, approaches the lake with his crossbow. Listen to how repetition, a plaintive pulse of desperation, drives the theme. It curves and turns upward again and again as if trying to break above the note of F-sharp, just as Odette curves and turns within the sorcerer's spell, trying to break out of it. In this music, justifiably renowned, Tchaikovsky has captured both the swan and the spell. Furthermore, Odette's theme is initially brought to us by a

woodwind—the oboe—voice of the green woods and the wet reeds. Floating this lone oboe over a harp's liquid ripples, Tchaikovsky places us at the edge of a lake, where land meets water, where life gets eerie and slippery, and where human and nonhuman become one in the body of the ballerina who dances Odette.

So metaphorical is his music that one can feel Tchaikovsky not only composed his ballets but, to a stunning degree, choreographed them. *The Nutcracker*, the most tightly constructed of his three marvels, hardly needs a written synopsis: with eyes closed, one can hear the story and pretty much know what's happening. But even *Swan Lake*, the first of the three and the ballet that pleased Tchaikovsky the least, was richly pictorial—even cinematic—a departure that went wading into deeper waters. Where ballet music of the time tended to be either tunefully thin or utterly forgettable, *Swan Lake* was the work of a musical genius.

The score was controversial, explains the scholar Roland John Wiley in his peerless study *Tchaikovsky's Ballets*, because "the composer is applying symphonic principles to ballet music." This was no small thing. Seeking to compose with the kind of organic development and imaginative sweep of a symphony yet faced with the prosaic demands of plot and staging, Tchaikovsky crafted a principality of tonal relationships—characters allied or enmeshed by key—that creates a feeling of architectural containment and coherence: a space that is also a sensibility. *Swan Lake* was more structurally sophisticated than nineteenth-century ballet audiences were used to. And these structures were sensual.

That said, it still bears the mark of the romantic ballet and still, excepting the splashy national dances in the grand ball of act 3, wears a great deal of white. Back in 1844, Théophile Gautier had complained about the sudden lack of color onstage, bled away by the craze for *La Sylphide* and its gossamer offspring, the *ballet blanc* (white ballet)—glow-in-the-dark visions costumed in white tutus. "[The] scene-painters received orders only for romantic forests, valleys illumined by the pretty German moonlight reminiscent of Heinrich Heine's ballads," writes Gautier. "The new style led to a great abuse of white gauze, tulle, and tarlatan; the shades dissolved into mist by means of transparent dresses. White was the only color used."

Wiley maintains that "*Swan Lake* is the last (and perhaps finest) example of the romantic ballet." As an expression of existential isolation—a defining condition of romanticism—the score has no equal in classical dance. In the excellent compendium of 1970 *The Lives of the Great Composers*, Harold C. Schonberg writes of Tchaikovsky's attitude toward opera: "Unlike many composers of the time, Tchaikovsky was primarily interested in character rather than vocal effect. . . . What he wanted was a libretto featuring strong human emotions, around which he could supply illustrative music." This can also be said of his ballets, and it's another way in which Tchaikovsky was pushing forward. The probing melodic lines he introduced have the feeling of soliloquies, of autonomous thought atmospherically pressured, shaped, and shaded. These are songs for the body. By the time he composed *The Sleeping Beauty*, in 1890, and *The*

Nutcracker, in 1892, Tchaikovsky was unleashing rainbows of radiant characterization.

Swan Lake unleashed something else as well. The musical eddies and undertows that circle and surge beneath its moonlit and torchlit surfaces, an understructure that suggests repressed energies, make it seem less a fairy tale than a gothic romance rife with ambivalence. In all three of Tchaikovsky's ballets, the search for a soulmate is the text. The stirrings of eros—blocked in *Swan Lake*, awakening but interrupted in *The Sleeping Beauty*, unready yet present in *The Nutcracker*—are subtext. This man was the first composer to write ballet scores that possess a subconscious.

While some critics damned his ballets for being too rich, too symphonic, "too capricious," too not-what-they-expected-a-ballet-to-be, others understood that he was advancing the art form by the very act of composing for it. The critic Nikolay Kashkin, a friend and ally, wrote of *Swan Lake* that "there is almost no example of such a significant artist dedicating his talent to this genre of composition." In France, Léo Delibes—a contemporary of Tchaikovsky's and a significant artist of very different gifts—was composing ballets of crystalline delicacy and light, Second Empire confections something like the Blaschka glass flowers on display at Harvard University, forever in dewy bloom. Delibes's *Coppelia* premiered in 1870 and his *Sylvia* in 1876, the year before *Swan Lake*'s premiere. Tchaikovsky didn't hear *Sylvia* until after *Swan Lake* was finished, but he was so struck by it that he wrote to a friend, the composer Sergei

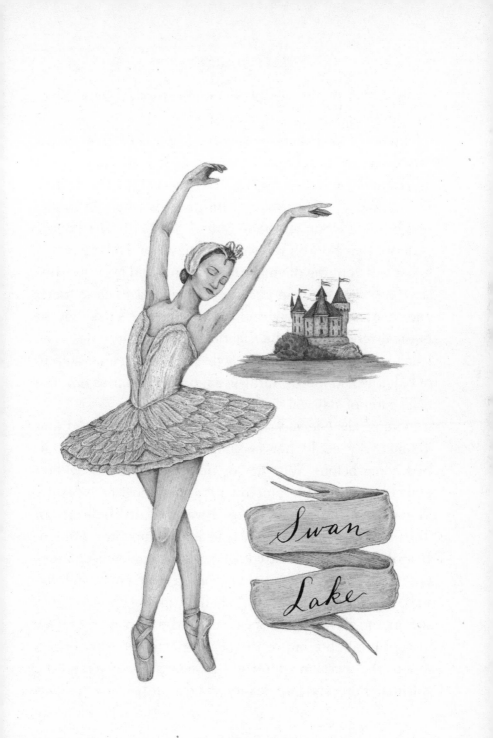

Swan Lake

Taneyev, "Had I known of this music I would have never written *Swan Lake*."[2]

Luckily for ballet, he hadn't known of this music. Impressed by the score's charm and wealth of melody, Tchaikovsky absorbed the lessons of *Sylvia* into *The Sleeping Beauty* and *The Nutcracker*, while his own heavier plumb line brings a luminous rue to *Swan Lake*. With *The Sleeping Beauty* a new horizon was suddenly in view: the kingdom of ballet was donning the imperial blue and gold of czarist Russia. The critic Herman Laroche, Tchaikovsky's close friend and smartest champion, said of the composer's magnificent musical rendering of the Charles Perrault fairy tale, "The local color is French, but the style is Russian." The art form of ballet would follow suit: Russia, not France, was now the flag bearer of classical dance.[3]

Come *The Nutcracker*, music critics finally realized that Tchaikovsky could not be judged against anything that had come before. Whether or not the score was deliberately experimental is something for musicologists to debate. What was clear enough in 1892 was that, in the words of Tchaikovsky's musical colleague and competitor Mikhail Ivanov, "ballet [had] started out along a completely different path from before." Tchaikovsky was breathing his own longings, anxieties, and ideals into ballet, waving his wand over the art and allowing it to speak not to the French aristocracy or a cultural elite but to the beating heart in every breast, and to the incessant skirmish between the sensual and the spiritual, hope and fate, reality and dream.[4]

SINCE TCHAIKOVSKY'S DEATH IN 1893, THE PORTRAIT handed down through the decades has been that of a melancholy man afraid of his own shadow. Even in 1970, Harold Schonberg called Tchaikovsky "a nervous, hypochondriacal, unhappy man—unhappy at home, unhappy away from home, nervous in the presence of other people, terrified lest his homosexuality become open knowledge." There is truth in this assessment, but not nearly the whole truth.

More recent scholarship reveals a cultivated artist seriously engaged in creation and dealing with all the furies attendant upon it: worries about inspiration, doubts about his latest output, frustration with reactionary critics ("I don't have any luck with critics," he wrote after the premiere of his then-maligned, now-beloved Violin Concerto in D Major, op. 35). He bemoaned anything that came between him and his music: the need to make money by teaching, social obligations, day-to-day responsibilities. But he adored his siblings and their children, found peace in the countryside, enjoyed close friends, took daily walks, played cards, kept diaries, and wrote thousands of letters.[5]

True, he was shy and ultrasensitive. Somatically sensitive, too: some of his physical complaints had to be the result of his own pitching emotions. As he became a name in Russia and the West—the famous Tchaikovsky!—he became increasingly cosseted. The literary giant Leo Tolstoy was a fan and, for a short time, a friend. The two men were similar in their philosophical searching, in their ability to deeply identify with female heroines. Both, in strokes broad and

fine, addressed Russian culture and nature. But Tchaikovsky had an anxiety that Tolstoy did not, his homosexuality.

It was an open secret in Tchaikovsky's circle. In nineteenth-century Russia, according to Alexander Poznansky's revisionist biography of 1991, *Tchaikovsky: The Quest for the Inner Man*, homosexuality, when practiced discreetly, was tolerated in the upper classes from which Tchaikovsky came (his family, considered lower gentry, was comparatively privileged). We know from his letters that Tchaikovsky felt there was nothing wrong with his sexual orientation, was comfortable with his sex life, and would have been happy to leave it at that. He was attracted, in the classical manner, to young men coming of age, that androgynous beauty still upon them, and knew all too well the painful discipline of the platonic relationship. Touchingly, he had a particular love of men's hands.

Still, Tchaikovsky bowed to bourgeois views. Aristocrats who were gay might flout the norms with flamboyance, and Tchaikovsky had many such friends. But for himself, the thought that society might judge him, that his name as an artist could be sullied and his family shamed, this mortified him. He felt that his loves and lifestyle were an Achilles heel that left him open to scandal. Wanting the question settled, he made a marriage that could only be called disastrous. In 1877, after almost no courtship at all and with the proviso that he would be more of a brother than a husband, Tchaikovsky wed the music student Antonina Milyukova. She appeared to understand that it was to be a *mariage blanc* but soon made clear that she expected physical love. Trying

to evade one trap, Tchaikovsky had stepped into another. The attempt at marriage lasted three months, after which the composer broke with his benighted wife and had a nervous breakdown. From then on, though they lived apart, Milyukova would be a financial and emotional millstone around Tchaikovsky's neck. Mere mention of her name sent him into a panic.

How fascinating, then, that at just about this time, in late 1876, Tchaikovsky began his long epistolary friendship with a rich widow, Nadezhda von Meck. Here was a true *mariage blanc*, a relationship based on shared ideals about art, music, and life, but bodiless, shared only through paper and pen. Meck was a generous benefactor who intuited Tchaikovsky's every financial (and often emotional) need and supplemented his income for fourteen years.

This Sturm und Drang around sex and love—Tchaikovsky's self-imposed order to marry, his fooling himself into thinking it could work, his continuing infatuations with men, his platonic affair with Meck—all this was swimming in his psyche during the composition and preparation of *Swan Lake*, feeding the eddies and undertows previously mentioned.

The ballet's plot is of unknown provenance but is thought to pull strands from folktales and from the swan symbolism in Richard Wagner's opera *Lohengrin*. It also comes from the imagination of Tchaikovsky himself: his niece and nephew remembered "house performances" of an impromptu ballet he called *The Lake of Swans*. So let us call *Swan Lake*—this hatchling of Tchaikovsky's living room—an act of mythopoeia.

It tells the story of Siegfried, a prince who has come of age and must marry. Full of longing for something, he knows not what, he goes hunting by a lake and meets the swan princess, Odette, spellbound by the sorcerer Baron von Rothbart. When she tells him that a wedding vow from a virgin youth will break the spell, he says that he will be that youth. At the birthday ball where all must be settled, Siegfried remains aloof until Rothbart arrives with a princess in black who looks like Odette. This is Odile, a facsimile created by Rothbart to trick the prince. She works her wiles, he makes his vow, all is lost. In a rising storm, Tchaikovsky's swan theme lashing upward toward release and resolution, Siegfried rushes to the lake. He leaps with Odette into the deadly maelstrom and the full orchestra drops away. Harp arpeggios ripple over a silvery spiccato in the strings, suggesting the last words of another moment in Wagner, the ecstatic *liebestod* (love death) that ends 1865's *Tristan und Isolde:* "To drown now / sinking— / unconscious— / utmost bliss!"

The conflicts in *Swan Lake* are strikingly personal, and one can easily play the game of Art Imitates Life. As theater, Odette is the match made in heaven and Odile the hellish mistake. But on a more analytical note, we might also see Meck in the pure Odette, Milyukova in the impure Odile, and Tchaikovsky in the solitary prince, foolishly seduced by a fake. Perhaps the spellbound swan is in some measure the composer himself, set apart by his sexuality, swinging between the world of convention and the demimonde. We know that as a teenager and young man, Tchaikovsky loved to impersonate female dancers and for fun, according to his

brother Modest, "would give full-scale performances that everyone applauded." Or perhaps Odette is love itself, forever shadowed by its lustful likeness, Odile.[6]

Art is more complicated than such equations and less declarative. Compared to the diaphanous Sylphide, carefree daughter of the air, the voluptuous swan is opaque, her feathered breast heavyhearted. Better to say that *Swan Lake* is a coalescence of fear and yearning given wings and flight.

TCHAIKOVSKY IDOLIZED WOLFGANG AMADEUS MOZART— "worship" is the word he used in a letter to Meck. He orchestrated or set for voice Mozart piano pieces that he felt should have a wider hearing. He cited Mozart as the inspiration for the first movement of his Serenade for Strings (the music Balanchine used for his *Serenade*). And he brings a Mozartian sparkle to the overture of *The Nutcracker*. Eleven months after *The Nutcracker's* premiere, when Tchaikovsky was fifty-three, he died of cholera. Did Tchaikovsky understand, one wonders, that his achievement in composing for the ballet was like that of Mozart's for opera?

"Each of Mozart's major operas is its own cosmos," writes Brigid Brophy in *Mozart the Dramatist*, and in each "love is the dominating force." Placing these operas in civilization's artistic pantheon, Brophy compares Mozart to geniuses of literature. Like William Shakespeare, he is "a supremely *intelligent* and a supremely *psychological* artist," and like Jane Austen, he allows his female heroines a new and liberating

moral agency. Such comparisons are persuasive because opera has a literary dimension, the libretto, that expands and enriches interpretation. Mozart's greatest operas—*The Marriage of Figaro* (1786), *Don Giovanni* (1787), and *Così Fan Tutte* (1790), all three with librettos written by the poet Lorenzo Da Ponte—stand at the end of the eighteenth century as monuments to lyric expression conceived as drama. One can enjoy the sound of these operas without understanding a single word. But ignorant of the text, how thoroughly can one know them?

One hundred years later, toward the end of the nineteenth century, Tchaikovsky too built monuments to lyric expression conceived as drama—*Swan Lake, The Sleeping Beauty*, and *The Nutcracker*. Each of these is its own cosmos. In each, love is the dominating force. Tchaikovsky's achievement is all the more inclusive because sense and sensibility are engaged without language. All is before us. We see what we see and, on various levels, we know what we see. Tchaikovsky's three ballets may be quite distinct—*Swan Lake*, a night-blooming breed of German romanticism; *The Sleeping Beauty*, a French fairy tale; *The Nutcracker*, a Frenchman's refashioning of a phantasmagoric story by a German writer (Dumas *père* rewriting E. T. A. Hoffmann)—but in each the destinies of soulmates are carried upon a flow of ceremonies and parties, birthdays and debuts, engagements and weddings, all the communal rites of passage we practice in our modern-day lives. Maybe this is why these three ballets have become rites of passage themselves.

Swan Lake is ballet's tragic romance nonpareil, a great "date" ballet. Every classical company performs it—*must* perform it—for in the mind of the public, Odette's swan-woman quality of indeterminate hybridity, an anthropomorphic enigma, says ballet with a capital B. *The Sleeping Beauty*, which commences with a royal christening and the preparatory fuss over the list of invited guests, is actually an engraved invitation to the enchanted kingdom of ballet. It is, for balletomanes, the quintessence of classical dance, a hierarchical structure in which a company shows off its own kingdom—from corps to soloists to principals. And *The Nutcracker*. For countless children around the world, this Christmas treat is the first ballet they will see, a work of art made especially for them while holding secret meanings for their parents.

Three doors to three worlds, and all three embodying one theme, the first and simplest in classical dance: the pursuit of balance. From the symmetry of first position—weight lifted and centered on a single vertical axis—to every movement and phrase that follows, the balletic body is aligned and its energy controlled. The classical training seeks to minimize those moments when balance is lost or momentum is uncontrolled, but as dancers grow stronger and bolder in their pursuit of swiftness, projected power, and the appearance of abandon, they may throw themselves off-balance and must recover—or fall. Elegant self-correction, rebalance extracted from the air, these forms of visible recovery are exciting displays of artistry under pressure. Today we prize these slips into the abyss followed by

self-rescue. The American ballerina Suzanne Farrell became famous for the way she spiraled through a phrase off-axis, riding the rim of a whirlpool or slipping into a musical riptide. Just as we all take risks in life, some worthy, some not, so ballet dancers take risks. "This is the theory of dancing," writes the transcendentalist Ralph Waldo Emerson in his essay "Beauty," published in 1860 in *The Conduct of Life*, "to recover continually in changes the lost equilibrium, not by abrupt and angular, but by gradual and curving movements."[7]

Overweighted with emotion and anxiety, brimming with beauty, and spiked with fear, Tchaikovsky's music expresses his own experience with light and darkness—the joyful embrace versus the vacuum pull of the void. As biographer Poznansky writes of Tchaikovsky's mercurial emotional dynamics, which were drawn resplendently into his art, "Righting the balance was for him a necessary way of living." We know this is true of *Swan Lake*, where Tchaikovsky is in wordless sympathy with a story he had a hand in creating—a story in which balance is hoped for but lost, just as it was in his frantic and futile attempt at marriage.[8]

In *The Sleeping Beauty*, two fairies—the giving Lilac and the taking Carabosse—struggle over the fate of Princess Aurora. Tchaikovsky links these two fairies through the key of E—E major for the goodness of Lilac, E minor for the wickedness of Carabosse—as if to say they are equal forces in one's fate, the fortune and misfortune we swing between. This theme of balance was brilliantly expressed by Marius Petipa, the choreographer with whom Tchaikovsky collaborated on *Beauty*. At Aurora's sixteenth birthday party, in the

Tchaikovsky

Rose Adagio, she dances with four princes and faces a series of balances on pointe, for she is on a precipice, the point(e) where she must choose a husband. The pricked finger will come before Aurora can make that choice, and one hundred years later the right prince will find her. As we all eventually learn, failure and misfortune can sometimes lead to a better fate, one beyond our imagining.

With *The Nutcracker* we are again off-balance, but in a more recognizably domestic setting. When Tchaikovsky, on the heels of his *Sleeping Beauty* success, was commissioned to compose music for this ballet, he was uncertain about the story. *The Nutcracker* was to be the second half of a program that opened with a one-act opera, *Iolanta*. Composing both works during the same time period, Tchaikovsky enjoyed work on *Iolanta*, whose subject he had chosen, and lamented the difficulties of *The Nutcracker*, which was suggested by the director of the Mariinsky Theatre, Ivan Vsevolozhsky. *Iolanta* is focused, an allegory set in a rose garden, and might be described as a troubadour poem opened into opera. *The Nutcracker* is a two-act flight of fantasy that begins realistically in a drawing room and then, at a moment difficult to determine, becomes an outlandish dream that peaks in a pleasure dome of sweets. The two works are like fraternal twins: *Iolanta* introverted and conservative, *The Nutcracker* social yet straying. After their premiere in 1892 they were soon separated.

Critics at the time puzzled over *The Nutcracker*, feeling that its two acts were not compellingly connected and that the ballet defied tradition. Act 1 is a Christmas party with

social dances, some solos for dancing dolls, and then the theatrical transformations of the dream. Act 2, set in Confi-turembourg (Land of the Sweets), sees the dream continu-ing with a series of *divertissements* and a grand pas de deux. Well into the 1950s, even after George Balanchine cho-reographed a definitive *Nutcracker* for the New York City Ballet—a production influenced by the Mariinsky version in which he'd danced in his youth—many critics were still judging this masterpiece as child's play. We don't see it that way anymore, and by the end of the twentieth century quite a few productions had brought brushstrokes of psychoanal-ysis to *The Nutcracker* (Sigmund Freud's *The Interpretation of Dreams* was published in 1899). Looking at the ballet through the lens of *Iolanta* unlocks even more meaning.

Iolanta is the story of a blind princess—age sixteen, like Aurora in *The Sleeping Beauty*—raised in a rose garden and secluded from the world. Her father, King René, has for-bidden anyone, on pain of death, from explaining the con-cept of sight to Iolanta. Cherished yet isolated, she feels the stirrings of something missing, a disequilibrium similar to sadness. "I long for something," she says, "but what?" When the young prince Vaudémont trespasses into the garden and sees Iolanta, he falls in love at first sight and unknow-ingly reveals to her that she is blind. The Moorish doctor Ibn-Hakia is glad of this. "Now her consciousness has been awakened and her mind is open to the truth."

But does Iolanta want to see? She answers, "Is it pos-sible to wish eagerly for something that I only understand with confusion?" Because Vaudémont's life hangs in the

balance, she commits herself to treatment. Love is paralleled with light.

This wishing eagerly for something one doesn't quite understand is a perfect description of adolescence, a time when sexual energy is changing the nature of one's longings. The heroine of *The Nutcracker*, Clara, is younger than Iolanta, too young for real romance. She finds sudden affinity not with a man but with a man-doll, the Nutcracker, which is a gift from her godfather, the inventor Herr Drosselmeyer. It is concern for this doll, left in the drawing room, that brings her downstairs in the dark, where suddenly everything comes alive and the Christmas tree begins to grow. With the tree's mighty rise, its theme a garland hung higher and higher in climbing curves—a musical sensation of tumescence mixed with transcendence—Tchaikovsky allows his bright orchestration to simultaneously lower into the dark and sonorous orchestral floor, as if giving the tree roots.

The Nutcracker, Balanchine always said, "*is* the tree." And though its enlargement in the dark offers easy sexual symbolism, there are better ways to understand it. The poet Rainer Maria Rilke, in his letter "To a Young Girl," wrote in 1921, "All the soarings of my mind begin in my blood." We feel this same soaring in Tchaikovsky's tree—mysterious yet lyrical, limbic yet lofty. "I long for something, but what?"[9]

Beneath the towering tree a battle ensues. Mice attack toy soldiers, who have come to life and take battle formation, led by the Nutcracker, their general. The Mouse King swaggers in and goes after the Nutcracker with a broadsword. Just as the Mouse King is about to win, Clara pulls off a slipper,

throws it at him, and faints; the distracted Mouse King is run through by the Nutcracker. Tchaikovsky's music floods the stage with peace, and the Nutcracker, transformed into a young prince, awakens Clara. The two, according to the original scenario, "walk over to the Christmas tree and are lost in its branches."

How productions handle the stage direction "lost in its branches" will differ, but it is the tree that releases Clara and the Prince into a primal place, a snow-covered forest of firs soon to be engulfed in a blizzard—the "Waltz of the Snowflakes." The act ends in a crepuscular whiteout, the elemental realm of folkloric ice maidens and snow queens, whose glacial palaces of crystal facets and refractions, windowless and resounding, are home to the imagination.

Where the Christmas party that begins act 1 is decidedly real, act 2's party is deliciously surreal. Clara and the Prince arrive in the Land of the Sweets, a matriarchal place of plenty that has an empathetic empress in the Sugar Plum Fairy. Here the pair are feted with a literal feast for the eyes, divertissements boasting Tchaikovsky's most exotic colorations—hot chocolate, coffee and tea, mints and marzipan—the bounty of an Old World patisserie. A child's garden of earthly delights, it is perhaps a proxy for the physical delights of adult sexuality.

Emerging from the sensual splendor of the sweets kingdom is the Sugar Plum pas de deux, and here we experience one of ballet's exalted adagios. Marked *andante maestoso* (slow, with majesty), it begins at a great height, floating, and in this dance for Sugar Plum and her cavalier we see

Clara's idealized vision of an adult coupling—an artful partnership moving as one. From its first notes, however, this music contains a shift in tone, a vein of sorrow. More of a motif than a melody, eight notes descending steeply with growing gravity, the adagio becomes an echoing and elegiac refrain. Something has been left behind—childhood? its bright blindness?—and in its place is something profound, a monumental sense of life's deepest challenge. We are fallen and mortal, and yet we aspire to goodness, to grace, to the creation of lasting relationships and immortal structures.

"Two worlds," intones the doctor in *Iolanta*, speaking for Drosselmeyer and also for Tchaikovsky, "that of the flesh and that of the spirit, have been united in all manifestations of life." United, yes, but not naturally or effortlessly balanced. This is the human condition, a never-ending pas de deux between flesh and spirit. This is the dance, the inner one we all experience, that Tchaikovsky willed to the stage. Into the art of ballet he planted his tree of knowledge, its boughs almost breaking with visions of love and loss, yet holding strong to this day.

ふve

ARABESQUE, ABOVE ALL

\mathscr{A}RABESQUE.
 In ballet, it is a position that stands alone.

In music, the term "arabesque" refers to a compositional form—a reverie or flight—or to the ornamentation on a melody. In art, the arabesque is an ancient curvilinear motif, first seen in the Hellenistic period and brought to bracing dynamism in the arts and architecture of Islam. An abstraction of plant tendrils circling and spiraling in space, curves interlacing to form fields of op-art reverberation, the arabesques of Islam are one of the glories of civilization. Conceived without beginning or end—an echo chamber, really, of swirling regeneration—the Islamic arabesque symbolizes the eternal flow of nature and the infinity that is God.

The arabesque of ballet is another glory of civilization. It too has a decorative energy that enamors the eye. And

it too taps into a current of eternal flow. You can find the arabesque in figure skating, where it is called a "spiral," and on a silver blade really does seem as though it could flow forever. The arabesque appears in gymnastics—on the floor and on the beam—and it used to pop up in circuses, performed on the rump of a horse that cantered in a circle in a ring. But it is only in ballet that the arabesque blossoms in a multitude of pitches and permutations.

In this chapter we will explore the arabesque literally and figuratively. What does it look like, how is it achieved, and what might it mean? Why are some arabesques more memorable than others, and who owned the great ones? We will then look at a masterpiece called *Monotones*, which consists of two short ballets that add up to an extended essay on the arabesque and its line in space. In *Monotones*, choreographer Sir Frederick Ashton honors the arabesque's origins on earth, sends it drifting into the heavens, and shows it holding the East, the West, and the Unknowable within its geometry.

WRITTEN DESCRIPTIONS OF BALLET'S ARABESQUE TEND TO be perfunctory. The great Russian teacher of the twentieth century Agrippina Vaganova, in her *Basic Principles of Classical Ballet*, writes of first arabesque, the most basic of all arabesques: "The body rests on one leg. The other, extended and straight, is lifted from the ground to an angle of no less than 90 degrees. The arm opposite to the lifted leg is extended forward, the other one is taken out to the side."

In *The Dance Encyclopedia*, Chujoy and Manchester add what Vaganova forgets to mention, that the lifted leg is "extended straight in back." Unlike other leg extensions, which are performed to the front, the side, and the back—the *développé*, for example, slowly unfolding upward from the knee, or the *battement*, a stiff broom-sweep upward—the lifted leg in arabesque knows only one direction: to the back. Like all extensions, the arabesque may be supported on a flat foot, or on demi-pointe, or on pointe.

Gail Grant goes a bit deeper, writing that ballet's arabesque "takes its name from a form of Moorish ornament." She adds that the dancer should create, from fingertips in front to airborne pointe in back, "the longest possible line."

Those familiar with yoga will find a rough approximation of an arabesque in yoga's Warrior III pose, but with key differences. In Warrior III the torso is dropped downward so that, like a battering ram, it is parallel to the ground and completes the horizontal line of the leg lifted in back, which in yoga is *not* turned out. The pose is a T shape.

The arabesque is a cross or + shape. The torso is held proudly upright with head high. The arm that reaches forward and the leg that is lifted in back are both parallel to the ground, thus creating the "longest possible line" of which Grant writes. Inherent in this longest line is a buoyant spirit of travel. The lifted leg is turned out in the hip, as it must always be in ballet, which means that the narrower, more stream-lined front of the leg is on view (the knee is not facing down to the ground but outward to the side). Ideally, the pointed toe should tip upward, sending the horizontal line skyward.

At first glance, the position appears to be an intersection of vertical and horizontal lines, an arrangement of right angles. And yet, when we hear the word "arabesque," we think of curves, a flourish in the air. After all, the first syllable of the word sounds like "air." There is, in fact, a curve within the cross, one that can be drawn, as with a calligrapher's pen, in the shape of a curling zephyr. With nib placed behind the dancer's shoulders, the line rounds up and over the head and breast and continues its sweep under the pelvis to follow the length of the lifted leg in a great swash. This macro curve is an echo of the micro curve in the small of the back, a pliant power that is the mainspring of every arabesque.

"The deciding factor in the arabesque is the back," writes Vaganova. "Only by holding it well can one produce a beautiful line."

The anatomical play of curvilinear flexion inside a rectilinear quadrant gives the arabesque its quality of inner life and aerial autonomy. If one position above all others is a logo for classical dance, a summation of its aspiration to ascend, it is the arabesque. Hops, jumps, and leaps go up, but they must come down. The arabesque goes up and stays. Balanced on a flat foot, it can be held for quite some time, each passing second like a bead on a rosary. As a balance on demi-pointe and pointe, it is a suspension that can lengthen, heighten, or aerate the moment or meaning at hand. And when the leg is lifted higher than ninety degrees—intensifying the curve within the cross—the impact is enormous.

arabesque

Still, one does want to ask of this decidedly unnatural yet oddly compelling *thing,* What are you? Structure or symbol? Animal, vegetable, or mineral?

Carlo Blasis, the eminent Italian ballet master and theoretician, was happy to accept the position as lovely in itself. In his treatise of 1828, *The Code of Terpsichore*, he writes, "Nothing can be more agreeable to the eye than those charming positions which we call *arabesques*."

For Akim Volynsky, who revered the purity of the position's extended leg, its "geometrically straight line," but understood that it must also feel for that cosmic curve—the vigor of the vine—the arabesque was something almost holy. "In its psychological ardor the arabesque strives toward the distant charm of the circle," he writes. "And in this circle is the dancer's entire essence." This puts one in mind of King Arthur's inner sanctum—the round table—and the lances of crusading knights. For dancers, achieving the best arabesque their anatomy will allow is tantamount to pulling a sword from a stone. And the pursuit of a brilliant arabesque is like a search for the grail. Dancers with extreme flexibility in the lower back may lift their leg so high that the curve cups toward a U and the arabesque begins to look like a chalice. Such imagery informs the very stories to which ballet is drawn: *Raymonda*, which premiered at the Mariinsky Theatre in 1898, is about a knight of the Crusades and the lady who pines for his return.[1]

How interesting that Blasis and Volynsky, with a hundred years separating their observations, both invoke "charm" in their descriptions, though each with his own meaning. Bla-

sis is using the definition "to delight greatly," and this the arabesque does. Each dancer has his or her own arabesque, its silhouette a convergence of their bodily proportions, flexibility, commitment to correctness, and sheer will. When the corps perform arabesque in unison, each arabesque varies in ways that seem subtle at first. With more experience in your seeing, the variations become distinct. This one has more ease through the shoulder line. That one a more tipped-up toe. Here is a severe cross that reads like rectitude. There, a line tipsy on curves. The arabesque, remembering its Islamic origins in the kingdom Plantae, lifts and opens like a flower, and each dancer wears hers or his with a difference.

Volynsky aims toward the definition "to control as if by magic." So often arabesques do seem charmed, the levitational result of love's intoxication or of sorcery and spells. The position can suggest a flying carpet, or cape-trailing gods and goddesses, or the winged hybrids that have attended empires—genies, griffins—or creatures of myth and lore: the stallion Pegasus; Tolkien's Ringwraiths; Tchaikovsky's white swan, Odette.

It's a bird. It's a plane. It's Arabesque!

Majesty and monarchy are resonant in the pose, which can be stately, statuesque, queenly (the extended leg like a long train), seeming to survey its land, its country from on high. A stageful of arabesques is a royal garden or, as in the opium dream in *La Bayadère*, Tibetan snow lilies multiplying in the mind.

As to the definition "an ornament worn on a bracelet or chain," some dancers have a way of filling their arabesque

with so much air that the supporting leg hardly exists and they appear to dangle from the sky. Certainly the arabesque ornaments any chain of steps—that is, enchaînement—that includes it.

But these are all fancies—my own arabesques—and they barely scratch the surface.

THUS FAR WE HAVE CONSIDERED ONLY FIRST ARABESQUE, but as Grant writes, "The forms of arabesque are varied to infinity. The Cecchetti method uses five principal arabesques; the Russian School (Vaganova), four; and the French School, two." A trip to any technical manual will illuminate the different arm positions and body alignments. Add to this the fact that if a choreographer so wishes, all these arabesques can be held low, at angles under ninety degrees, and that the supporting leg can be in plié, which puts the arabesque under pressure. The arabesque may be tipped over into *penchée*, a skydive wherein the extended leg lifts toward twelve o'clock, thus carrying the upper body over and down. Today the penchée often ends in a split, legs creating a vertical line, six to twelve. Arabesque penchée is generally performed on pointe, with support from a male partner, but it can also be a balance on the flat foot—a very precarious balance—as in act 2 of *Giselle*, where it suggests empathy with the earth from which the newborn Wili has just emerged.

A dancer can have a spectacular arabesque and yet not achieve stardom or high rank. But can you be a great

dancer without an expressive arabesque? Unquestionably, an arabesque that is memorable for all the right reasons is the crowning glory of a ballerina, the profile on her coin. Is it a gold-standard arabesque, like Margot Fonteyn's, a cross of surpassing correctness that is something of a beatitude? Or is it silver, softer and more tempestuous, like the thrown arabesque of Suzanne Farrell, lightning in a sky of changing color?

The Russian critic Gennady Smakov, in his book *The Great Russian Dancers*, describes Anna Pavlova's fabled arabesque as "ethereal and sculpturesque," an oxymoron. Agnes de Mille, who as a girl saw Pavlova perform, never forgot how her arabesque "balanced on the poised arc of the foot, the other leg stretched to the horizon like the wing of a bird."

Depending on the role, dancers may temper their arabesques. In *Swan Lake*, Odette's arabesque is long, lambent, and sometimes, in the Russian manner, ever so slightly bent or broken at the knee—brokenhearted! The arabesque of the black swan, Odile, will be sharper, straighter, hard-hearted. But whatever the tempering, Volynsky is right when he speaks of the essence inherent in a dancer's arabesque.

Galina Ulanova, for instance, was a moonbeam eminence at the Bolshoi Ballet and had an arabesque to match—a shaft of light through a mist of tulle. Ekaterina Maximova was mythic, her arabesque, from the top of her head to the tip of her toe, like a drawn longbow. The arabesque of Alla Osipenko, its line beginning at the breastbone like the curved blade of a snow sled, was a Flexible Flyer gliding on the invisible drifts of Leningrad. Her Kirov colleague Natalia

Makarova, who defected from the Soviet Union in 1970, brought to America an arabesque that rose like warm bread, never forced, always softly, freshly sculpted. The arabesque of Balanchine ballerina Diana Adams suggested the boom on a sail—an odyssey. Gelsey Kirkland's was a blow dart: fast to its target, ripping out of nowhere and hitting the heart. The uncommonly pliant backs of the Italian and American ballerinas Alessandra Ferri and Maria Calegari gave us arabesque in excelsis—sips from the chalice—while Sara Mearns, a New York City Ballet star of recent vintage, uncorks a colossal arabesque that dwarfs everything in its path.

Men, too, can brand history with an arabesque. Rudolf Nureyev, whose 1961 defection to the West stirred the world like a Molotov cocktail—his arabesque was a crossbow aimed at destiny.

A BEAUTIFUL ARABESQUE IS THE HIGHEST EMBODIMENT of what we call a dancer's *ligne* or "line." We judge line by mentally juxtaposing a dancer's outline upon the textbook standard. How correctly placed is the upper body and head? How academically positioned and stretched are the limbs? How pointed the toe and how high the foot's instep and arch? Then there is that something extra that comes from the dancer's proportions, their personal fortune of lengths and curves, their own creaturely qualities.

In truth, our response to beautiful line is instinctual. We know it when we see it and don't need a textbook at hand.

The search for the right word to describe it is part of the fun. A clean line. A rococo line. A proud, porcelain, impish, hawkish, stern, kittenish, chaste, coltish, Superman-ish, Miss Jean Brodie–ish, whatever-ish line. The possibilities are endless. But never, no matter how still or held the position— especially the large and visible arabesque—should line look lifeless.

One of the midcentury masterpieces of classical dance is a ballet called *Monotones*. It was choreographed by Sir Frederick Ashton for the Royal Ballet, and it is actually two ballets, a pair of trios set to the music of Erik Satie, orchestrated versions of his piano pieces *Trois Gymnopédies* (1888) and *Trois Gnossiennes* (1890). Can we classify Satie's compositions as musical arabesques? They may be too pensive for that, though musicologist Rollo Myers, in *Erik Satie*, writes that the *Gymnopédies* suggest "the tracing of some graceful arabesque by naked boys dancing under an early-morning sky." These inscrutable melodies, each a single strand, sinuously curve and climb, float and flare, surge and search. The ballet Ashton made to them suggests a pair of calligraphy miniatures, and the first one choreographed—in 1965, to the *Trois Gymnopédies*, now called "Monotones II"—explores the balletic arabesque in its myriad articulations, teasing out the otherworldly beauty of balletic line in space.[2]

In an interview filmed on the occasion of the Joffrey Ballet's televised performance of "Monotones II" in 1989, Ashton explains that he had wanted to use this music for many years, "but somehow I couldn't get the right idea for it. And then suddenly there was a gala performance and they

wanted something not too long for it. And also it happened to be the time when you Americans were all landing on the moon, and this sort of took my fancy. So I thought that I'd do something—what the French call *lunaire*—something about the moon, about how people might be on the moon and how people might move on the moon."[3]

The space race was in full swing in the 1960s, and by March of 1965 America had successfully landed three unmanned spacecraft on the moon. A mere six days before the gala premiere of the first *Monotones* (the title could be an anagram—"Moontones"), the Soviet cosmonaut Alexey Leonov was the first man to walk in space. As often happens with genius, Ashton's artistry was on the same wavelength as technology. But let's be clear, this ballet takes its cue from Satie's luminous melodic tendrils and probes with luminous concentration the vocabulary of classical dance, which is its own form of exploration in space.

The cyclorama is black. The dancers, two men and one woman, are costumed in belted white unitards and white skull caps, the belts and caps studded with diamond crystals. The dancers look like trapeze artists, and the synchronized trance in which they perform (both halves of *Monotones* are choreographed legato, "smooth and connected") casts a strong spell. The words Smakov used to describe Pavlova's arabesque—"ethereal and sculpturesque"—perfectly describe the vision of weightless weight that Ashton creates and sustains. These celestial bodies bring a slow-motion gravity to the most basic academic steps—plié in fourth position, glissade, sous-sus—moves here imbued with great moment. At

the same time, the arabesque has never looked so unmoored, a ghost ship named *Infinity*.

It is everywhere in this ballet, which seems to breathe not with lungs but with arabesques that sweep open then closed, unwinding upward, shooting outward, disappearing inward. The three dancers move in unison, or the two men bookend the woman, or they echo on flat foot a step she is performing on pointe. Their patterns feel self-generating, as if the ballet could go on forever. Sometimes the three take hands, the woman in the middle, and then they look like paper dolls unfolded. Lifting into three matched arabesques, they're a three-masted barque guided by the stars. Still holding the mens' hands, the woman frequently opens into a lone arabesque that changes direction as the men circle her like wind blowing an astral weather vane. Her supporting leg is the axis upon which this universe turns.

The *Trois Gymnopédies* was an overnight classic, but at ten minutes it was too short to work well in repertory. "So then there was another one," Ashton says of the ballet that would become the first half of *Monotones*, "which was the Earth. And so I did two halves, I did the moon and the Earth. And that's really how it came about." In 1966, "Monotones I" premiered, followed by "Monotones II," and the two-part *Monotones*, starting on Earth and ending in space, was complete.[4]

"Monotones I" is set to Satie's *Trois Gnossiennes*. These melodies, more orientalist than the limpid *Gymnopédies*, are redolent of the seductive unknown that drew nineteenth-century explorers to the tombs of Egypt and Iraq, and drew

Monotones II

artists like Satie to mysticism and the occult, subjects of fin de siècle sects that sought a spirit authentic and pure. The trio this time is made of one man and two women. They wear the belted unitards and caps of "Monotones II," but with a decorative addition: banding that snakes around the sleeves. And these costumes are not the white of the galaxies but a muted shade of chartreuse, the color of stipules on a stem. The caps, belts, and bands are embellished with crystals of emerald, citrine, and diamond. Like incense, Satie's spare music rouses visions of Persian gardens, Moroccan alleyways, mosques, and mihrabs. Yet it is mostly through inflection that Ashton expresses the Arabic in arabesque.[5]

The two halves of *Monotones* embody a tension at the heart of nineteenth-century classical dance, the same tension that finds kinetic consummation in the arabesque. I'm speaking of the pull between Western classicism and Eastern exoticism, between line that is austere and line that is ornate, between the cross and the curve that is planted within it. Pashas and pirates, slave markets and seraglios, Brahmins and temple dancers—all brought an atmosphere of perfumed eros to the stage and allowed choreographers to filigree classical steps with ethnic ornamentation. At the Mariinsky and elsewhere, the art form embraced this polarity, giving us the ballets *Le Corsaire* (1856, set in Turkey, based on Lord Byron's best-selling poem of the same name), *The Pharaoh's Daughter* (1862, set in Egypt), *La Bayadère* (1877, set in India), and *Raymonda* (1898, set in Hungary but featuring a sexy Eastern "other," the Saracen knight Abderakhman).

Such plots kept with the tenor of the times. The romantic poets of the first half of the nineteenth century offered escapist transport to exotic climes (Lord Byron: "The Assyrian came down like the wolf on the fold . . . "), and trips to the East worked well in such operas as Bizet's *The Pearl Fishers*, Verdi's *Aida*, and Delibes's *Lakmé*. The artists Jean-Auguste-Dominique Ingres (*Grande Odalisque*) and Jean-Léon Gérôme (*Pool in a Harem*) were painting naked women in languorous curves, as if they were arabesques of flesh. And even in *The Nutcracker*, Tchaikovsky's steamy music for "Arabian Coffee" hints at veiled bowers. When the century turned, orientalism blazed once more as Sergei Diaghilev's Ballets Russes made its name with works of bejeweled color and stylized lust. *Cléopâtre* in 1909, *Schéhérazade* and *The Firebird* in 1910, *Thamar* in 1912— this concentrated revival of a lustrously hedonistic East heated up ateliers across Europe, titillating the decorative arts and fashion.

"Monotones I" begins with its three dancers standing apart on a diagonal, their arms raised against a golden glare. They walk in a stately manner, then pause with one leg pointed behind them in *tendu derrière* (basically, an arabesque that has yet not lifted its toe from the ground). They sink into plié while the upper body yearns forward, a position called *arabesque allongée à terre* (arabesque extended on the ground), which here suggests longing. They soon come together and take first arabesque, but in response to spasms of dissonance in the music—the accidentals and the quavering appoggiaturas that give Satie's phrases their East-

ern flavor—the arabesques crimp into the position called *attitude*, in which the lifted leg is bent ninety degrees at the knee. This is the classical pose of Mercury, the mythological god of messages, as sculpted by Giambologna.

Everywhere there is curving, carving movement. Throughout the ballet, the dancers twirl and circle like cylinder seals. Often their hands delicately finish the line with a whorling motion, the corkscrew tip of a newborn vine. In a line perpendicular to the audience the three perform arabesque, the women facing one way, the man between them the other: they plié into attitude and the likeness of a lotus flower appears before us. A series of hops in arabesque plié, a traveling V formation, evokes low flight over desert sands. "Monotones I" ends where it begins, sinking into arabesque allongée à terre, hands raised against a green-gold glare.

"Satie reduced his musical materials to a minimum," the musicologist Jann Pasler writes. "This allowed him to forge an original perspective on simplicity. . . . There is intensification, deepening awareness of one idea or state of mind rather than a constant movement from one to the next."[6]

The same can be said of Ashton's response to Satie. Seemingly simple, its range of steps kept to a minimum, *Monotones* goes deeper and deeper the more one knows of music history, art history, dance history, world history, and its choreographer's history. Let's dig into that history.

Ashton was English, born in 1904, when King Edward VII was on the throne. The temperament in England was still Victorian and its kingdom was still an empire, possessing colonies all over the world and soon to include territories in the

Near and Middle East. Implicit in the imperial character was a tradition of exploration and excavation. In 1962, three years before Ashton took on Satie, David Lean's film *Lawrence of Arabia* was released. So it wasn't just the space race that was in the air; Arabia was there too. Maurice Jarre's Oscar-winning score—sensual, dissonant, enigma on steroids—was a ravishment of white robes, the timeless East romancing the world. And Lawrence was T. E. Lawrence, the idealistic and ascetic English archaeologist, warrior, and writer. His life could be a ballet. In a photo from 1919 that shows him dressed in Arab robes, he wears a belt that bears a knife, its curve an arabesque.

In 1922, in response to drawings sent to him by the illustrator of his forthcoming book, *Seven Pillars of Wisdom*, Lawrence wrote of one drawing, "The sword was odd." Musing on the sword's possible meanings, he invoked the Arab Movement, King Faisal of Iraq (whose name meant "flashing sword"), the Garden of Eden, and Sir Thomas Malory's *Le Morte d'Arthur*. He concluded, "I don't know which was in your mind, but they all came to me—and the sword also means clean-ness, and death."[7]

The arabesque is odd.

Just as Lawrence saw multiple meanings in a sword, the balletgoer will see multiple meanings in the arabesque, depending on the way a dancer performs it and the air of the ballet it breathes. Many meanings, of course, can be the same as no meaning. After forty years of ballet-going, I find that the arabesque is still, for me, a mystery. Like the *Gnossiennes*, which Satie composed without time signatures or bar

lines and which take their title from the word "gnosis"—a term that is shared by many religions and means "knowledge" or "spiritual insight" or "enlightenment"—the arabesque is always on the move, outside of time, seeking that which is hidden, and as silent as the Sphinx. In *Monotones* it is the arabesque that carries us from ancient sands up into the stars, that cuts across time and space with the speed of light. This, Ashton seems to say, is what arabesques do.

six

THOUGHTS ON PERFECTION

"*I*T WAS PERFECT," NINA SAYS OF HER DEBUT AS Odette/Odile. It's the last scene of a movie, the 2010 psychodrama *Black Swan*, and these are the last words this ballerina, played by Natalie Portman, will ever speak. Her relationship with perfection—physical, technical, artistic—has haunted her throughout the movie, and pointedly, as she changes from Odile's black tutu to Odette's white one, she pulls a shard of broken mirror from a wound beneath her ribs. Could there be a better symbol for the dark side of a dancer's—or anyone's—pursuit of perfection? The studio mirror has become a maddening dagger of constant criticism.

The soprano Maria Callas, revered by generations of opera lovers, was famously imperfect in her technique and was treasured all the more for it. The pianist Vladimir Horowitz

played with such elegance and fire that no one cared about the flubs. Most great painters, even those with superb drafts-manship, move beyond or beneath correct technique to brushwork of extravagance and strangeness. But at the bal-let, the expectation of perfection is more pronounced, and not just because the bodies onstage have been tempered into paragons of human form. The idea of human perfectibility was built into ballet's beginnings. As the historian Jennifer Homans tells us, during the art's formative years in the late 1500s, it was believed that through ballet, man could "raise himself up, closer to the angels." In *Black Swan*, Nina's de-sire for perfection becomes a punishing tunnel vision. We as viewers need not fall into the same trap.[1]

Early on, the challenges of ballet are athletic and the training of one's body to move in arcadian traceries and ce-lestial spheres is a beguiling sort of sport. Work from the waist down is fairly straightforward. Rickety pliés become fluid, arabesques inch higher, placement grows more lifted and aligned, turnout opens wider. Above the waist, *port de bras* (carriage of the arms)—the upper body's own constella-tion of arcing lines and volumes—is rudimentary at first and then increasingly lyric. Learning this esoteric language of the body is fun. But as the athleticism of ballet matures into the art of ballet, a change may occur. The technical refine-ment that is a professional necessity can become a spiritual quest as well, and sometimes a compulsion.

All artists feel this quest to some extent, but none feel it in every joint and muscle the way dancers do, or face it daily, as dancers must, in the unforgiving mirror, a looking-glass

dimension that reflects all flubs and flaws, not to mention extra ounces and pounds. One of the weird tensions of classical dance is that this intensely physical art form so often expresses fleshless states, both existential and supernatural. The truer a dancer's line and the more pure her technique, the more convincing the weightless, soulful illusion. This is a reality of ballet that the tenets of political correctness cannot change. We are all welcome to take ballet class and to study as fervently as we please. But every year only a couple hundred students will make it into the world's top dance academies, and of these, only a small percentage will one day make the cut into a professional ballet company. Eventually a few will spring from the corps de ballets into soloist status. Even fewer will be promoted to principal status. Stardom? It's Mount Olympus, a pantheon reserved for those with rare qualities and godlike powers.

Dancers on a career track develop an eye highly sensitive to flaws that the nondance world tends not to perceive. Rudolf Nureyev wished his legs were an inch longer and worked devilishly to get the appearance of more length. The young Gelsey Kirkland, so uniquely gifted, wanted to look and dance like anyone but herself. As she has written, it took her years to accept her own body and its brilliance. Every dancer has some beef about his or her instrument, an unchangeable issue of proportion or silhouette that keeps perfection just beyond reach. And yet, there is no final standard. "Whereas high C is high C," notes the critic Matthew Gurewitsch, "an arabesque is the arabesque of a particular body. So a 'perfect,' Platonic arabesque may not even exist."[2]

One could argue that this pursuit of an abstraction—the Platonic arabesque, let's say—is not only necessary in an art form as physically demanding as ballet, it is bound up in ballet's philosophy of transcendence, its belief that the body itself can speak to classical ideals of harmony, aspiration, and liberation. Veronika Part, a ballerina trained at the famous Vaganova Academy in St. Petersburg, her vast arabesque like the coming of snow in the north and her classical line as close to perfection as it gets, says, "Every single day until the last day of your dance career you have to work, you have to strive to achieve perfection. But better than perfection is the ability to let it go. When you're onstage you have to know that it's impossible to be perfect and you just rely on your experience and talent. The great performance is when you feel, *Oh my god, I'm just completely free*. This is amazing."[3]

The Balanchine ballerina Heather Watts, who joined the New York City Ballet in 1970, arrives at the same conclusion but from a different path. "Perfection," she says, "is a moving target. Each day you begin anew, trying for a higher bar every time you go out onstage." Watts suggests that dancers confuse perfection with security,

> which is doing the same pirouette you did in rehearsal. As dancers we like to be ready and rehearsed and precise and assured and confident. But Mr. Balanchine was really into calculated risk-taking, trying to reach an ideal that was an imaginary hope. It's hard and scary to risk everything in a live performance, but we were raised to that. In class

we risked, in rehearsal we risked, we did it all day long so that we'd be ready to risk at night. You could say the "perfection" was that the performance was alive.[4]

The critic Joel Lobenthal contends that "there is no perfect performance. The endless amount of things that can technically go wrong are formidable enough, but even if every mechanical hurdle is cleared, there's the expressive aspect of the performance, the details of style and interpretation. Ballet is an impossible ideal. [The Balanchine ballerina] Tanaquil Le Clercq once said, 'Why do you do it? *Because* it's impossible.' Which is why any complacency that creeps in is fatal."[5]

For the balletgoer who wants dancing that looks like a polished object you can put in your pocket and who feels the performance is ruined by a wobble or bobble, there is an antidote. Look instead for immediacy, for freshness, for energy.

THERE IS ANOTHER WAY TO LOOK AT THE QUESTION OF perfection, and it comes to us from one of the greatest plays in the English language. At the end of Shakespeare's *Hamlet*, as the young prince prepares for a duel with Laertes, his friend Horatio begs him not to fight. He feels Hamlet cannot win. But Hamlet views things differently. "I have been in continual practice," he says. "If it be now, 'tis not to come; if it be not to come, it will be now." With this gnomic bit

of wordplay he seems to be saying that one's state of mind, one's acceptance that one cannot control the unknown that lies ahead, is more important than winning—or, as pertains to ballet, than perfection.

Wise balletomanes will tell you that some of the most extraordinary performances are those in which a dancer does not completely succeed. He or she is stretching into a big new role, or has been cast against type, or is reconstructing a role, feeling his or her way to something larger or deeper or curiouser. Concentration that reads like stillness, even as the dancer is moving. Precision that looks undressed. A tightrope sensation of being between the idea and its attainment, between the shape and its meaning. These tremulous delicacies are measures of integrity, of in-the-now artistry. A dancer may not be there yet, but having been "in continual practice," he or she is ready for risk. "The readiness is all," Hamlet says in summation. "Let be." Which sounds very much like Veronika Part's words, "Let it go."

There are also those performances of which dancers will say, "I was all over the place," meaning something was just off, the tempos were too fast or slow, or they got thrown by a mistake. "I probably use that phrase at least once a day when talking about my dancing," says the New York City Ballet ballerina Sara Mearns.

> It can mean I wasn't really on my leg, or I messed up the steps, or my body didn't feel great. But it can bring about some very interesting, unexpected, unplanned, and miraculous moments onstage. Your body is not a machine

and sometimes it will not do what you have in mind—your body or mind will go rogue—and half the time something crazy, something unseen before, will happen. And those will be the moments you will remember forever. So good can come from being "all over the place." You just never know what or when it will be.[6]

"In art," says the critic Don Daniels, "the fault can mean the source is real—it authenticates on some level below the delivered single stroke. In ballet, a mistake can cause the audience to watch even more carefully. It intensifies reception."[7]

Imagination makes its own rules. In his famous essay of 1952, "Some Lines from Whitman," the critic Randall Jarrell quotes a section from Walt Whitman's titanic poem "Song of Myself" and then writes, "There are faults in this passage, and they *do not matter.*" In other words, artistry that dares, reaches, risks, and gives may contain moments that are not correct or didn't work. This goes double for performance, which only happens once and cannot be edited. By all means, applaud the performance that appears to be flawless. But pay close attention to the performance that's vulnerable to the moment, more open than closed, letting go or going rogue. In the end it isn't perfection we remember, it's life. The self that is singing.[8]

SHE'S ALIVE!

*I*N 1841 THE BALLET *GISELLE* CAME INTO THE ART form like a microburst. Théophile Gautier, the French poet, critic, and balletomane, explained its genesis in an open letter to *La Presse* shortly after *Giselle*'s premiere at the Paris Opera. He writes that while leafing through a book by Heinrich Heine called *De l'Allemagne* (On Germany), he came across a passage that told of "elves in white dresses, whose hems are always damp, of nixies who display their little feet on the ceiling of the nuptial chamber, of snow-colored *Wilis* who waltz pitilessly." He said to himself, "What a pretty ballet one might make of that!" and set to writing a scenario. Getting no further than the title—*Les Wilis*—Gautier laughed off his attempt to translate into theater "that voluptuously sinister phantom world." But that very night at the Opera, he ran into the librettist Jules-Henri

Vernoy de Saint-Georges and told him the legend of the Wilis. "Three days later," writes Gautier, "the ballet of Giselle was finished and accepted. At the end of the week, Adolphe Adam had composed the music, the scenery was nearly completed, and rehearsals went into full swing." An immortal ballet was whipped up in a matter of days—minutes, it almost seems.

In his classic study *The Ballet Called Giselle*, the English dance historian Cyril W. Beaumont looks into the reality behind Gautier's blithe essay and finds that *Giselle* did come quickly into being, though not as fast as Gautier would have it. Adam, the composer, wrote in his unpublished *Mémoires* that the score took eight days to finish and then elsewhere wrote that it took three weeks. Whichever number is correct, Adam was motivated. *Giselle*'s synopsis, read to him by the choreographer, Jules Perrot, was genuinely balletic, and Adam knew that the dancer who could make it a success, Carlotta Grisi (Perrot's lover at the time), was ready and waiting. "I was in a hurry, and that always stimulates my imagination," Adam writes. "I was on very good terms with Perrot, with Carlotta, the work took shape as it were in my drawing-room."[1]

One thinks of James Whale's movie *The Bride of Frankenstein* (1935), which begins cozily in a drawing room inhabited by the English romantics Lord Byron, Percy Bysshe Shelley, and Mary Shelley, Percy's wife. A thunderstorm rages outside, and inside Mary observes that "it's a perfect night for mystery and horror. The air itself is filled with monsters." She entertains the two poets by spinning a sequel to

her gothic novel *Frankenstein; or, The Modern Prometheus*, published in 1818. The story, we are reminded, is about "a monster created from cadavers out of rifled graves." Mary's new story—and hence the movie—reaches its climax during yet another thunderstorm. Dr. Frankenstein is making a female mate for the monster, and she can only be brought to life by lightning strikes. In the writing of *Frankenstein*, the real Mary Shelley was much influenced by a hot topic at the turn of the eighteenth century: galvanism, which refers to the stimulation of muscles by electric currents, zaps that jolt unmoving matter (the legs of a dead frog, the limbs of a dead man) seemingly into life.

In a way, the creation of a ballet is a form of galvanism, only the stimulation comes from cultural currents, from poetic, aesthetic, and romantic affinities subconsciously swirling about and suddenly reaching a critical mass. A ballet is made up of many components—scenario, music, choreography, sets, costumes, lighting, dancers—and each component carries its own meanings and allusions. If one of these is out of whack, it confuses the whole. When a ballet is successful, these components come together as if inevitably, and we in the audience have the pleasure of teasing out the interplay of cultural and classical dynamics. When a ballet has a feeling of epochal importance—like Vaslav Nijinsky's *Le Sacre du Printemps* (1913) or George Balanchine's *The Four Temperaments* (1946)—its momentum can feel like a meteorological or scientific phenomenon. Think of spontaneous combustion or centrifugal force, a magnetic field or a perfect storm or an atom bomb.

Giselle, a lightning strike in a drawing room, is a case in point. No other ballet takes up the subject of energy as literally as *Giselle*. We see this in its story, a grid that includes the power pull of Giselle's love, the sexual charge of her lover, the blown fuse of betrayal, the white-hot voltage of the Wilis (lightning bugs crossed with Lucifer), and the crossover from one state of being to another. And we see it in the choreography, in the way it deploys classical dance's opposing modes of musicality: allegro and adagio. *Giselle* is a gift that keeps on giving, a sustainable source, solar and lunar, that purrs like an engine beneath the art form.

THE STORY IS SIMPLE. GISELLE IS A PEASANT GIRL OF SPIRIT and sensitivity who loves two things: dancing, in spite of her physical delicacy, and the handsome peasant Loys. She does not know that Loys is really a nobleman in disguise, Duke Albrecht, who is already betrothed to Princess Bathilde. The courtship of Loys and Giselle fills much of act 1. When the gamekeeper Hilarion, a rival for Giselle's affections, reveals Loys to be Albrecht (he produces the aristocrat's sword and also the horn that calls forth his retinue), the shock is too great and Giselle breaks down in the famous mad scene. It is a slow dissolve, a trance of dance fragments retrieved from happier moments—the courtship reflected as if in a cracked mirror. Giselle's mother had warned her that impetuous emotions would lead to a bad end, possibly the dank

Giselle

Act One

unrest of the Wili, and here it is. Her heart broken by betrayal, Giselle falls dead at the end of act 1.

Act 2 begins at dusk in the wood where Giselle is buried. The nocturnal Wilis, called from their graves by their icy queen, Myrtha, perform corps dances of communal discipline and might. Myrtha then calls forth the newborn Wili, Giselle, who steps tentatively from her burial mound. Should any man enter this glade before dawn, the Wilis will dance him to death. Hilarion and Albrecht each come to mourn at Giselle's grave, and each, in turn, is caught in the white web of the Wilis. Albrecht survives, saved by Giselle's love.

"The two acts into which *Giselle* is divided," Beaumont writes, "might well be entitled: I. The Sword; II. The Cross."[2]

Elemental spirits like the Wilis had been flitting through European myth and folktale for centuries in forms as various as rusalki, undines, and will-o'-the-wisps. There were also vampires—the Slavonic *vile*—from which the word "Wili" may derive (the Norse word *vilja* means "to want, to desire, to will"). But there was a much closer precedent from which Gautier and Vernoy de Saint-Georges were pulling. One could even say that *Giselle*, like the monster in Shelley's *Frankenstein*, began its life in a graveyard—specifically the graveyard in "The Ballet of the Nuns," the influential interlude that appeared in Giacomo Meyerbeer's opera of 1831, *Robert le Diable* (Robert the Devil).

Robert is the Devil's son by a mortal woman. Wishing to lure Robert to the dark side, the Devil leads him to a ruined abbey where the ghosts of lapsed nuns, devout women who gave way to pleasures of the flesh, rise from their tombs

(through traps under the stage) and attempt to seduce Robert with their dancing. Choreographed by Filippo Taglioni, "The Ballet of the Nuns" starred his daughter Marie Taglioni as the corrupt head nun Helena, and it was illuminated by a new invention—gaslight. The ballet's glimmering prurience was such that the artist Edgar Degas couldn't resist painting it twice. One year later, in 1832, Filippo Taglioni choreographed *La Sylphide*, again starring his daughter Marie, who rose to pointe as the pure-hearted Sylphide and changed ballet forever.

In dreaming up *Giselle*, it's as if Gautier and Vernoy de Saint-Georges took the licentious ghost-nuns of *Robert le Diable* and the airy sylphs of *La Sylphide* and alchemized them into Wilis—betrothed maidens who were jilted before their weddings and died of it. "In their dead feet," Heine writes, "there lingers yet the *Tanzlust* that they could never satisfy in life." What a perfect premise for a ballet—"dance lust"—and what a sly euphemism for sensuality and sex. The pent-up fury of the Wilis in their wedding-white tulle proposes that they are virgins unfulfilled. But might not some have been seduced and abandoned? Think of Donna Elvira in Mozart's *Don Giovanni*, gunning for the don. There are those who have wondered if Giselle's delicate condition is pregnancy.[3]

The Wilis have "an unstilled, unappeasable hunger to complete the uncompleted," writes the ballerina Violette Verdy in her book *Giselle: A Role for a Lifetime.* But what is uncompleted? Love and marriage? Intercourse and orgasm? Babies never conceived or unborn? Driven by

desire unforgotten and vengeance unrelenting, the Wilis are a closed circuit of negative energy—hysteria dressed in mist. "*Hysterics suffer mainly from reminiscences*," write Josef Breuer and Sigmund Freud (italics theirs) in a groundbreaking paper on trauma published in 1893. In the dances of the Wilis we see reminiscence ritualized.[4]

Robert le Diable and *La Sylphide* are but two among many free-floating precedents pulled into the energy event that is *Giselle*. Gautier had planned to base his act 1 on Victor Hugo's poem "Fantômes," which contains the line, "She was over fond of dancing and paid with her life," but the poem did not offer enough narrative strangeness and suspense. As a new plot took form, the flower scene in act 1—he loves me, he loves me not—drifted in from Goethe's *Faust*, while the mad scene at the end of the act, bringing about the "pretty death" that opens the way to act 2, taps the mad scene in Donizetti's opera of 1835, *Lucia di Lammermoor*.[5]

And we mustn't forget the evergreen theme of privilege, the blasé abuses committed by those of class and landed wealth, personified here by Albrecht and his act of deception. Is he a cad or careless or carried away? When *Giselle* premiered, the Paris Opera was itself famous for the way men in high places kept and shared female dancers, who, out of financial necessity or social climbing, accepted après-theater roles that ran from the amusing and affordable *cocotte* to the costly *grande horizontale*. Gautier, we know, was madly in love with Carlotta Grisi, the ballerina for whom the role of Giselle was created. In *Giselle*, death turns the tables on power and privileges the peasant girl.

"I am not talking to you now through the medium of custom, conventionalities, nor even of mortal flesh;—it is my spirit that addresses your spirit; just as if both had passed through the grave, and we stood at God's feet, equal,—as we are!" These are not the words of Giselle the Wili, though they could be. These sentences come from Charlotte Brontë's novel *Jane Eyre*, published in 1847, six years after the premiere of *Giselle*. They are spoken by the heroine Jane, principled but poor, as she asserts her right to love her employer, Edward Fairfax Rochester, a man of station and wealth. Jane will be betrayed by Rochester, who hides a truth from her, but she will find her way back to him in the end. It is Giselle, having actually "passed through the grave," who addresses Albrecht in a pas de deux that really is a ghostly medium.[6]

BY NOW, YOU MAY HAVE NOTICED THAT BALLETS, ESPEcially those that tell a story, often deal in dualities, their plots braced between mated oppositions. Reality/fantasy. Society/soul. Life/afterlife. True Odette/false Odile. West/East. Awake/dreaming. These paired states need no explanation, no words. We all know them from having lived them, and we recognize them onstage. Opposition is built into classical dance, almost as if it were a fifth law of thermodynamics. We see opposition in the technique: power contained = power projected. We see enduring theater built on slender narratives stretched taut between existential

extremes. And we see two opposing modes of expressive energy: allegro and adagio, musical terms that can be understood simply as fast and slow.

"Allegro" is generally defined as "quick, brisk, and lively." All dancers perform allegro, though it can sometimes seem to have a slightly masculine cast. When Marie Camargo took the heels off her shoes back in the 1700s, allowing her more speed, plié, and elevation, it was said that she danced like a man. And in the 1920s, when Lidia Ivanova, the innovative soloist of the Mariinsky Theatre, became the first female to perform a split jeté, it was said that she leapt like a man. Virtuosity en l'air is where men wow the audience with *grande batterie*—feats like the double *cabriole devant*, in which the legs sweep forward and up, one calf beating twice against the other, while the upper body lies back in the air—and jaw-droppers like the *rivoltade*, a human helicopter that sees one leg whipping over the other at the top of a leap. Also classified as allegro is petite batterie, steps that bounce and "beat" closer to the earth but with the trilling continuity of coloratura, an operatic term for vocal ornamentation that is here applied to the feet (women excel in petite batterie). Allegro is bright and extroverted. It requires unflagging ballon and a light touch, like any hostess with the mostess. It can also be fierce, volatile, demonic. Allegro is spring warblers singing in the canopy, or bats pinging and winging at dusk. There is something of the soufflé about allegro—it should always be rising.

"Adagio," or as the French say, *adage*, is a word derived from the Italian *ad agio*, meaning "at ease or at leisure." For

the dancer, there is nothing leisurely about it. Normally performed to music with tempi between andante (a moderate walking speed) and largo (very slow, with feeling), adagio is composed of radiant extensions, long balances, and imperturbable promenades (a slow turning in place on one foot). A seamlessly sustained display of balletic line—like a silent aria or an orchid's interior—adagio sees stillness and movement together building a monument to emotion. Although men can be eloquent in adagio, its beauties, enlarged by pointe work and more becoming to the flexible female body, make it "she," a woman's realm. Because adagio is slowly sculpted, its imagery lingering in long breaths, it allows more time and meaning to come and go through its curving corridors of movement, as if the ballerina is taking us through the hallways of her heart. Adagio can be introverted, casting shadows of longing or regret, and so ageless it seems on intimate terms with eternity, like a vaulted cathedral, a gothic ruin, an old-growth forest. Its subject is often, if not always, love. The first section of a grand pas de deux is an adagio in which the woman is displayed, supported, and seconded by a man.

Allegro and adagio are not, however, mutually exclusive. A dance characterized as allegro can contain measures of adagio, and an adagio can flash with brisk accents. Answering the dictates of music, or offsetting them for effect, classical dancing ranges along a continuum between allegro and adagio. Of particular interest and difficulty are allegro steps performed at adagio tempi. George Balanchine loved to explore this otherworldly zone, and his last masterpiece, *Mozartiana*

(1981), is sown with slowed-down allegro, which makes the ballerina look larger, more autonomously untouchable. The greatest male dancers, when performing the big aerial moves of grande batterie—especially cabriole devant—can seem to find quietude at their highest point, wresting adagio out of thin air.

In *Giselle* the energies of allegro and adagio are divided—matchlessly—between its two acts, giving dramatic amplitude to the ballet's other divisions: day/night, life/death, mortal/immortal. Act 1 is sunlit, dominated by life and allegro, the upbeat and bouncing *ballonnés* and *ballottés* that convey elated young love and its seemingly boundless horizon. By the end of the act, in the mad scene, these same steps have slowed and frayed. Act 2 is darkness in a wood, a humid environment of ensnaring arabesques and silvered limbs, the atmosphere drenched with adagio as with the full moon's phosphorescence.

The brilliant solos for the Wilis' matriarch, Myrtha—the most bitterly wounded of them all—are sumptuous, sweeping, and furiously airborne. They are also scaled too large and full for the musical phrase, resulting in a vague yet pervasive frisson of adagio. A Wili is both feather-light and fixated, her energy wrought in the troubled bed that brought her to her grave. Giselle, too, is feather-light. But she is not fixated. The adagio weight she carries is that of forgiveness.

Just as the book for *Giselle* was written by two men, the ballet's choreography was the work of both the Paris Opera ballet master, Jean Coralli, and the great male dancer Jules Perrot, though only Coralli was credited in the program. The

Giselle Act Two

dance historian Cyril Beaumont speculates that the mime of act 1 is the work of Coralli, as are act 2's solos for Myrtha and its group dances for the Wilis. Perrot, who was Carlotta Grisi's mentor as well as her lover, is believed to have choreographed all of Giselle's dances and scenes. It is Perrot who was responsible for Albrecht and Giselle's ardently prolonged pas de deux in act 2, an Orpheus-and-Eurydice reprieve of incandescent closeness and complicity. This is adagio ecstatically pierced with white arrows of allegro.

DANCERS, ESPECIALLY THOSE CAST AS GISELLE, ARE KEENLY aware of the ballet's dichotomous energies, the huge shift between its two acts. They too talk of opposition and the role it plays in performance. "The movement is always opposite to what the heart is playing," the ballerina Alessandra Ferri once told me. "Giselle in act 1 is very light, but she's a real woman, so the movement is more down to earth. In the second act we have a very deep and powerful woman with a very light body—with no body, really."[7]

To achieve an illusion of ethereality requires enormous upper-body control and, counterintuitively, a strong push into the ground. We can see that push in the famous set piece of act 2, a massed drill in which the Wilis—one half on the left side of the stage, the other half on the right—advance toward each other in arabesque hops pressed low in demi-plié (temps levé en arabesque), their lines crossing, combing, and merging in feral oneness.

Entrancing is Giselle's induction into the Wilis, which takes place after they have performed their incantatory dances. Summoned from the earth, Giselle steps forward, her head bowed. At Myrtha's command she performs the same temps levé en arabesque as the Wilis had earlier, but her hops in plié don't travel, they turn tornado-like in place—a sci-fi passage into a new circle of existence. Because it is dark onstage, and because Giselle's head is still bowed, this spin can be dizzying because the ballerina cannot spot the turn. (Spotting is when a dancer holds her gaze on a single location for as long as possible during a turn and then snaps her head and eyes back to it with every revolution). So the passage is disorienting for the dancer and can be scary to do. (Gelsey Kirkland performed it with her head thrown back—extra scary.) The Russian critic Akim Volynsky described the passage as "a chaos of movement . . . an emotional storm. . . . But at the same time, how magnificently this chaotic movement emphasizes the reawakening from decay and death!"[8]

Like Mary Shelley's lightning strike, this allegro spin galvanizes Giselle. But even before act 2 begins, ballerinas are making their transition into the void. In her book *Giselle and I*, Dame Alicia Markova, the greatest Giselle of her generation, writes about Olga Spessivtseva, arguably the greatest Giselle of all time. The young Markova was mentored by Spessivtseva and in 1932 watched her in the role from the wings, taking in every detail of every performance. Spessivtseva's portrayal of Giselle's mad scene and death at the end of act 1 left Markova in tears: "Here was a 'fourth dimension'

in the world of ballet. I had not been schooled in this." Back in the dressing room, preparing for act 2, Spessivtseva would "dip her silken black hair straight into a bucket of water, to make it sleek after the disorders of the Mad Scene." In those days dancers didn't have the hairnets and hair sprays that came later. Yet how chilling this preparation, a baptism in a bucket. For even if the water was warm, imagine how cold Spessivtseva's hair soon became. And recall Heine's words in *De l'Allemagne*, his reference to "white dresses, whose hems are always damp."

When it comes to that white dress, the uniform of the Wili, Markova relates another detail, one that took her breath away. Spessivtseva's act 2 costume, hanging on the wall, was a bodice *with no skirt attached.* "Yards and yards of white tulle were somehow whipped around her waist in an instant, and sewn on by her dresser with lightning movements; and there she stood, miraculously ready for the stage. This was something created for an hour, but with skill and forethought as unsparing as though life depended on it."

Life did depend on it. Albrecht has only this hour with Giselle, only this hour to find forgiveness, and she has only this hour to save him. Spessivtseva's skirt is symbolic of classical dance at its ephemeral best. Spontaneous. Singular. Unstable matter playing gods and monsters, moment sewn to movement and coming to life before our eyes.

Spessivtseva debuted as Giselle in 1919 and owned the role for as long as she danced it. The critics outdid them-

selves describing her unusual exultation, spectral and unsettling. Tragically, her identification with Giselle turned out to be prophetic, for she had a fragile psyche and in 1937 was institutionalized for schizophrenia (today, she would probably be diagnosed as bipolar). "It was as if this role pulled loose some hidden personal spring in the artist's psychological mechanism," writes the dance historian Gennady Smakov. "The energy of latent insanity held the audience spellbound."[9]

Virginia Woolf, a contemporary of Spessivtseva's and herself no stranger to mental illness, envisioned the end of corporeal existence—which is not the end of energy—in her novel of 1925, *Mrs. Dalloway*. It is a beautiful grey-blue morning, and Clarissa Dalloway, Woolf's fictional heroine, is shopping for flowers, for the party she is giving that night. She is full of reminiscences, thinking of the girl she was, the people she loved, the marriage she made, and the marriage she didn't make. "Did it matter then, she asked herself, walking towards Bond Street, did it matter that she must inevitably cease completely; all this must go on without her . . . ?" She then answers her own question. "On the ebb and flow of things here, there, she survived, Peter survived, lived in each other, she being part, she was positive, of the trees at home . . . being laid out like a mist between the people she knew best, who lifted her on their branches as she had seen the trees lift the mist."

This is how *Giselle* ends. Dawn has come and the Wilis must recede. Giselle bourrées backward to the cross that

marks her grave and Albrecht catches her one last time, lift-ing her out of an arabesque so that she rests like mist upon his branching arms. "Death but the Drift of Eastern Gray," wrote Emily Dickinson in 1863, "Dissolving into Dawn away." Giselle leaves him, and the sun rises.

eight

ROUND AND ROUND

I STARTED STUDYING BALLET IN MY TEENS. IT WAS A late beginning for a professional career, but I thought that with determination and desire it might still be possible. I was long-limbed and had natural turnout. I'd always been athletically adept and I couldn't get enough of class, that beckoning world of arcs and angles, proportions encoded as if by Leonardo da Vinci. Each plié at the barre sank down into history. Each relevé lifted up into a crown. The forging of one's arabesque was like apprenticeship in a guild: is it good enough for membership? Not yet. Vexing were the combinations, convoluted step sequences rattled off by teachers who expected us to briskly dance them back. You can't be in a ballet company if you can't pick up combinations quickly, as if by instinct, and in a few years' time it *is*

instinct. Alas, all hope went dizzily out the door when it came to pirouettes, my Waterloo.

"Turning and turning in the widening gyre," writes William Butler Yeats in his poem "The Second Coming." "Things fall apart; the centre cannot hold." In ballet, the center has to hold, and when it comes to turning, the gyre cannot widen, at least not too much. If it does, you're in trouble.

Remember childhood? Spinning in place on the lawn, arms outstretched and eyes fixed on the blue above, then the drunken drop into the grass below? Or maybe you were seated on a swing that was slowly turned, the swing chains twisting, tightening, then released into a mini tornado. It's irresistible, the desire to spin. Toddlers do it, dolphins do it, male woodcocks in their high-dive mating dance do it. There's even a gorilla named Lope, in England's Twycross Zoo, who became a YouTube sensation doing it. For all creatures, it seems—and for weather systems, too— exhilaration and exhibitionism marry in the spin. In ballet, that spin must also be pretty and precise. And just as gymnasts are bedeviled by the need to stick their landings, so dancers must finish a spin in balance, with a smile or a sigh, a theatrical flourish or a dynamic sweep into the next step. We in the audience do not want to worry about the dancers we're watching, but we soon realize that turns are an endless worry for them.

The word "pirouette" is derived from European sources— the Burgundian *pirouelle* (spinning top), the French *pied-roue* (foot wheel)—and it implies a whirl or spin. More specifically, Gail Grant writes, it is "a complete turn of the body

on one foot" that can be launched from any of the five positions, though the most common preparation is from fourth. Pirouettes can be done in place or as a traveling series that circles or crosses the stage (these are called *piqué*—"pricked"—pirouettes). Traveling pirouettes are easier as the momentum is linear and allows the dancer to make adjustments if necessary. A pirouette that takes place in the air, both feet off the ground, is called a *tour en l'air* or just *tour*. These are performed mostly by men, the norm being two revolutions. A series of double tours is as daunting for a dancer as it is debonair, for as with pirouettes in place, there's no cover for incomplete revolutions or an insecure finish. These moves spotlight themselves.

There is no question that pirouettes, tours, and turns come under the category of "the more the merrier." They excite the audience, and with good reason. When a ballerina confidently makes a double pirouette into a triple, it can feel like a force of nature has stepped in. And when a man spins like a top without slowing or tipping and then ends the spin in a dashing drop to one knee or a hushed amen into fifth position, he's heroism in tights. In the 1985 movie *White Nights*, Mikhail Baryshnikov makes a bet that he can perform a pirouette of eleven revolutions and then—I'm amazed every time I watch this scene—completes eleven spins in six seconds as if it were nothing. When did dancers start doing more than one revolution per pirouette? Lincoln Kirstein tell us that multiple pirouettes began sometime around 1670, while in *Balanchine's Complete Stories of the Great Ballets* Francis Mason writes, "Pirouettes have dazzled

audiences since the history of ballet began, but multiple pir-ouettes were not introduced until 1766."[1]

Whenever multiples began, it was another way in which the art of classical dance expanded, fitting greater kinetic activity into the same musical measure, thereby enlarging ballet's range of expression. A role in which the character is at an emotional extreme has more intensity if the dancer throws doubles on turns that are normally singles—or makes a triple of a double. But it can't be messy or unmusical. The same standard of clarity applies to all turns, no matter how many revolutions. Because it is rare to see a triple on pointe that is as creamy and easeful as a double, fans can and do debate which is better: two beautifully executed revolutions or three wind-whipped and potentially wild ones? For every balletgoer who values quality over quantity, there is another who cheers the go-for-broke approach. When a ballerina performs pirouettes that are supported, meaning that a man is lightly bracing her from behind, keeping her centered and giving impetus to her spin, the number of revolutions is ex-pected to climb.

Some dancers are natural turners, and how lucky they are. The ballerina Gillian Murphy makes a lark of triple pirouettes and often throws in a fourth revolution because there's time, and why not? But even natural turners are aware that something of a mind game is involved. In an in-terview in *Ballet Review*, when asked what it takes to turn as she does, Murphy said, "I don't know. . . . I try not to think about it too much." (If it ain't broke, don't fix it.) Pushed for an answer, she said that fear is the main obstacle for many

149

dancers. "Once you're fearful you stop breathing, you stop using your *plié*, and you tense up." Murphy also reiterated that byword of ballet: opposition. "There is a feeling of stability that comes from my core, but also a downward sensation into the ground that's working against the pull of the upper body. Opposition throughout the whole body."[2]

By simultaneously pushing down into the earth and pulling up into the sky, the vertical axis of the turn is not only held taut, it creates heat. Akim Volynsky wondered if the word "pirouette" wasn't a distortion of the Greek root for "fire": *pyr*. "A fiery circle," he writes, "that's what a pirouette is." But these circles are not always fiery. They can be crystal diadems, wells of longing, inner turmoil, monster whirlpools, calla lilies, a ring around the rosie, a pocketful of posies. Turns are the natural flower of turnout.[3]

Dancers who have an uneasy relationship with turning, whose pirouettes are fraught, "like the circles that you find in the windmills of your mind," are in constant search for the rabbit's-foot rub that will make turning foolproof. Strengthen the core! Keep the weight forward! Relax into the momentum! And yet some of the loveliest pirouettes come from those who are not great turners, who produce instead a slower revolution, a more palpable emotion, a rising, less-rooted warble. When pirouettes are too invincible, too enameled in their finish, they begin to look synthetic or as if they belong in a circus.

In the debate between art and tricks, no set of turns is more contentious than the thirty-two *fouettés en tournant* (whipped turns) in *Swan Lake*'s act 3. Added to the 1895

Mariinsky production of the ballet, they come at the climax of the Black Swan Pas de Deux and were first performed by the Italian ballerina Pierina Legnani. A fouetté turn sees the body carried 'round by a leg that lashes out to the side at hip level and then pulls in. It combines this out-and-in motion of the whipping leg with an up-and-down (relevé-plié) motion in the supporting leg, and is not unlike a whisk frothing up egg whites. The music that accompanies the Black Swan fouettés is fast—Tchaikovsky marked it "allegro"—and the number thirty-two is considered sacrosanct by many ballet-omanes. The ballerina performing Odile is expected to do all thirty-two and to do them in control, without wandering about the stage like a skittle.

Just as sopranos dread the high C in Aida's aria "O Patria Mia," most ballerinas approach Odile's fouettés with trepidation. And most do not do all thirty-two but twenty-eight or twenty-nine or thirty, which is just fine. Many drift to the right, to the left, or downstage. Some get halfway through and then abandon ship, finishing with a stage-circling ring of piqué pirouettes. The list of those who've opted out is illustrious: Olga Preobrazhenskaya, Anna Pavlova, Alexandra Danilova, Natalia Dudinskaya (famed for her turns), Alicia Markova, Maya Plisetskaya, Antoinette Sibley. They all pooh-poohed the fouettés.

So why do the fouettés? For starters, there is tradition and the expectations that come with it. Then there's the undeniable excitement of the event, the way the fouettés fit the music and their ripple effect in the ballet. This whirlwind motion lifts Prince Siegfried to a fever pitch of admiration

and blind desire. Odile, a dominatrix if there ever was one, is "whipping" him up to the vow of love that will betray Odette. So the thirty-two fouettés are a trick in both senses of the word. That is their meaning.

We can accept that each artist has different strengths and weaknesses. But is it fair that one ballerina should be held accountable for all thirty-two fouettés while another replaces them with something easier? If a female dancer can't perform the thirty-two fouettés, should she even dance Odette/Odile? (In the past, Odette and Odile were sometimes cast as separate roles, requiring two ballerinas.) Or should we bow to an artist's wisdom when it comes to aesthetic choices based on technical realities and judge instead whether we are persuaded by her choices? There are no right answers to these questions. I, personally, am happy with beautiful fouettés that hear the music, even if the number is less than thirty-two, and I don't mind if they float downstage as long as they stay center stage. With growing experience, you will develop and defend your own view on where the bar should be set.

Thus far we have looked at turns that are self-contained—pirouettes, tours, and fouettés. But you will quickly notice that turns are occurring all the time in classical dance. A person who can "turn on a dime" is always collected, always ready to change course at a moment's notice, and this is business as usual in ballet, a world in which the words *en tournant* (turning) can be applied like an amendment to almost any step. Arabesque, jeté, sous-sus—all can be performed en tournant. Turns give the dancer dominion in

space, the directional freedom of a voice or a musical instrument but in three dimensions. In "The Love Song of J. Alfred Prufrock," T. S. Eliot writes, "In a minute there is time / For decisions and revisions which a minute will reverse." Ballet brings physicality to these decisions and revisions.

Finally, in the realm of pirouettes and turns there is yet another distinction to be made, and it has to do with the direction in which they turn: not north, south, east, or west, but outward or inward—*en dehors* or *en dedans*. The term "en dehors" (outward) means that a pirouette will turn toward the lifted working leg and away from the straight supporting leg. Ever since my student days I have remembered en dehors as "through the door," because a turn toward the working leg has the feeling of a door opening into unbounded space. So there's a sense of entrance—*I'm here!* Turns en dehors are outgoing. They are essentially turnout excited into movement.

The term "en dedans" means "inward." Here the pirouette turns toward the straight supporting leg—into the dancer, you might say. It's an involution, en dedans, with a shadow about it, something hidden or ambivalent or hugged close, and therefore used more often in adagio sequences where the slow inward curve leads us into an inner landscape.

In en dehors and en dedans we have an approximation of, respectively, music's major and minor tonalities. Knowing this can help one understand why a passage has the effect it does, the conviction and bravado of en dehors, the reluctance or introspection of en dedans.

Some turns beg for analysis, especially those strikingly outside the norm. Let's look again, for example, at Giselle's graveyard induction into the Wilis, that dark swift spin in arabesque, the stir of dead matter into stunned existence. It is a turn en dehors, so it should radiate ease and balance. Yet because the working leg, the right in this case, is lifted behind in arabesque, and because Giselle's right arm is reaching forward and up, she is turning into a cliff drop, a vertiginous shear of emptiness to her right.

In what dimension is Giselle now dancing? On a plane between being and nothingness? Or somewhere between the grave and gravity, the worm and the wormhole? Or is she held between moonlight and the mist—a bioluminescence? How amazing that a spin can ask such questions.

SEX AND THE SINGLE GIRL

*O*N MAY 29, 1913, IN PARIS, SERGEI DIAGHILEV AND
his fire opal of a ballet company, the Ballets Russes,
premiered a work that was disturbing and clairvoyant,
impossible to categorize yet vastly symbolic, violent but
touched with lyricism. The work had its first performance
at an open dress rehearsal, where it passed without prob-
lems. Its premiere the following night inspired a riot, the
most famous—or *infamous*—audience uproar in history. In
its original form the work saw the stage between eight and
eleven times; reports vary. Of these performances, the last
four were given in London. After that, due to company pol-
itics, the work went unperformed, and by 1920 it was lost.
The score, composed by the brash young Igor Stravinsky,
was as controversial as the dance, and it is not only *not* lost,
it is a classic that remains mesmerizingly brutal to this day.

You've probably guessed that I'm writing about *Le Sacre du Printemps*—*The Rite of Spring*. Here was an epic rejection of everything its audience held dear.

Diaghilev began his career in Russia, editing a new-style arts journal that was gorgeously printed and self-consciously controversial, *World of Art*. The ballet company he created in the West, established in 1909, was also a "world of art." The modus operandi of the Ballets Russes was collaboration, the fluorescent moment when the right composer, choreographer, designers, and dancers are brought together with one goal: a ballet that will astonish. "*Étonne-moi*," Diaghilev told his colleague-collaborators. "Astound me." The critic Stark Young writes of the company's early years, "There was a completeness, a unity, a varied singleness of perfection in the case of each production . . . that I had never seen before and have never seen since." At the Ballets Russes, classical dance was not just the equal of the honored art forms, it was *primus inter pares*, first among equals.[1]

"Ballet is perhaps the most eloquent of all spectacles," wrote one of Diaghilev's collaborators, the artist and critic Alexandre Benois, in 1908. "Ballet possesses that sense of liturgical ritual of which we have lately dreamt so intensely."[2]

The company's early years saw choreographer Mikhail Fokine, in 1910 and 1911, producing a host of iconic works—*Schéhérazade*, *The Firebird*, *Le Spectre de la Rose*, and *Petrushka*. The company's last two years, 1928 and 1929, saw the emergence of young George Balanchine and his first masterpieces—*Apollon Musagète* (its title was shortened to *Apollo* in 1957) and *The Prodigal Son*. Between Fokine and

Balanchine there were three other choreographers, each of them groundbreaking: Vaslav Nijinsky; his sister, Bronislava Nijinska; and Léonid Massine. Of these three, Nijinsky's ballets are the ones that changed dance, and his third work, *Le Sacre du Printemps*, stands as a doorway between the nineteenth and twentieth centuries. Well, no. The Ballets Russes—its illustrious artists, its outsized influence—is the doorway. *Le Sacre* is a shudder of prescience.

For now, we will stay focused on the shuddering, shattering *Le Sacre*—its break with conventional classicism, its repudiation of Belle Époque niceties and hypocrisies. Technique was undercut, transcendence was off the table, and in place of a dignified ballerina front and center, a girl—variously called "the Chosen One" or "the Chosen Maiden"—was singled out for death in the ballet's last minutes. In the body of the Chosen Maiden the paths of classical ballet and modern dance crossed. How would the ballerina go forward into the twentieth century? How would classical choreographers use her singular status to engage both cultural changes in the coming decades and their own artistic concerns? Would she be honored, mocked, diminished, or enlarged? The answer to this last question: all of the above. So let's return to 1913 and *Le Sacre du Printemps*.

THE BALLET IS ABOUT A PRELITERATE TRIBE THAT SWINGS between fear and awe, ignorance and imagination. Every spring, to appease the unruly seasons, the tribe offers a child

bride to the sun god, Yarilo. This is the ritual, the sacrifice of a Chosen Maiden. According to S. L. Grigoriev, the company's régisseur (rehearsal director / stage manager), *Le Sacre* "was in two scenes, but had no real plot, the action representing merely a series of primitive rites. With one exception there were no individual dances, but only big ensembles." In the words of the dance historian Cyril Beaumont, who saw and admired *Le Sacre* in London, the convulsive movements of these ensembles were "a tremendous shock to one's conception of ballet." The lone individual dance of which Grigoriev writes—the "Danse Sacrale" (Sacrificial Dance)—sees the Chosen Maiden quaking, lunging, and buckling, then rocketing into the night sky as if to escape. She dances until she drops dead.[3]

Thanks to sixteen years of scholarly research and detective work by the dance and design team Millicent Hodson and Kenneth Archer, the lost *Le Sacre du Printemps* was restored to three dimensions in 1987, in performances by the Joffrey Ballet. Hodson and Archer pieced the dance together from still photographs, artists' drawings, set designs, existing bits of costume, Stravinsky's notes, the memories of Nijinsky's assistant Marie Rambert, and Rambert's annotated rehearsal score. Gaps were bridged intuitively. We will never know how close this restoration is to the original, but we have a semblance of the ballet—a guide, a map, a legend—and that semblance is thrilling.

When Nijinsky choreographed *Le Sacre* he was one of the greatest ballet dancers of all time, his name synonymous with aerial genius and animal energy—air and earth. His

The Chosen Maiden

leaps, described as long pauses in the air, transfixed the West. But it was earth that transfixed him. Nijinsky's first choreographic effort reflected that. Premiering in 1912, *L'Après-midi d'un Faune* (Afternoon of a Faun) took its title from its score, Claude Debussy's 1894 setting of a hallucinatory poem by Stéphane Mallarmé. The poem's mythological subject was well within the realm of the classical, but Nijinsky's choreography pressed strangely away from ballet's fullness in space. Telling the story of an inebriated faun and his lascivious pursuit of some nymphs, Nijinsky, who also danced the role, created movement that was flattened into a kind of bas relief, as if Greek friezes had been peeled off an ancient urn. Taut, feral, grounded, this strangely stylized ballet was not what audiences expected of Nijinsky, god of the grand jeté.

The following year, with *Le Sacre du Printemps*, Nijinsky went even further back in time and farther away from classicism. Legs were turned in, fists and feet (no pointe shoes) were curled and sickled. Gone was ballon. There was something cloven and driven, ignorant and ecstatic in the postures and velocities of this spring revel and its unspeakable final rite (which is revisited in Shirley Jackson's 1948 short story *The Lottery* and more recently in Suzanne Collins's Hunger Games trilogy). In surviving photographs the dancers look like human rag dolls, playthings of cruel gods. There was nothing here of ballet's lift and illumination, its refined reach into space. Nijinsky's tribe was rooted in a ruthless cycle of survival. And yet it was also open to wonder, to a selfless mysticism that civilized Europeans of the twentieth century had lost or had buried under centuries of elaborate

etiquette and decorative (read: decadent) excess—an eti-
quette and excess of which ballet was now a part.

Le Sacre's three collaborators—the composer, Stravinsky;
the set and costume designer, Nicholas Roerich, who was
also an anthropologist; and the choreographer, Nijinsky—
were "going native" in complete consciousness. "Who else
knows the secret of our ancestors' close feeling to the earth?"
Stravinsky had asked himself before he teamed up, in 1910,
with Roerich, who was asking the same question. With Ni-
jinsky, one feels his cunning faun had pointed out the hidden
path to this pagan world. The three men were circling back
to something immediate and unadulterated—a baseline—
and if it was base in other ways, so be it. They were under the
spell of an ancestral secret, in love with it, almost.[4]

Just as five Frenchmen in thrall to a ghost story had spun
out the complicated erotic energy that is *Giselle*, three Rus-
sians gave themselves to voracious nature primeval. Like
mediums, they received the secret and birthed *Le Sacre*,
which they called "our child." As Stravinsky said of his pro-
cess composing the score, "I had only my ear to help me.
I heard and I wrote what I heard. I am the vessel through
which *Le Sacre* passed."[5]

Le Sacre du Printemps was rupture that was meant to re-
new, which is what all aesthetic breaks are about. But was
it even a ballet? Had Nijinsky actually made one of the first
truly modern dances? Or was he sacrificing classical dance on
the altar of something inchoate, undefined? We know that
he had expressed disapproval of ballet's softness and round-
ness and was instead seeking angularity and virility. Let's just

say that *Le Sacre*, its shock waves rocking artists of every discipline, could have been called "The Rite of Modernism." "A thoroughly new vision," the aesthete Count Harry Kessler writes of *Le Sacre*'s premiere, "something never before seen, enthralling, persuasive, is suddenly there, a new kind of wildness, both un-art and art at the same time."[6]

This convergence of un-art and art, "our child," anticipated the mindless slaughter of the trench war—World War I—that commenced fourteen months later, in July 1914, and took men into the mud. And the orchestral locomotion of Stravinsky's score, monstrously hurtling on a horizontal track—"the tyranny of this rhythm," writes the critic Émile Vuillermoz, "its iron will"—portends the far-off railroad deportations of World War II: "The composer has written a score," proposed a commentator at the time, "that we shall not be ready for until 1940." The critic Jacques Rivière calls *Le Sacre* "a biological ballet . . . spring seen from the inside, with its violence, its spasms and its fissions." He invokes the genetic imperative: the double helix, the selfish gene, the sweat-soaked contraction. *Le Sacre*, after all, is about fertility and the future.[7]

It is also about the window dressing that *Homo sapiens* bring to the subjects of sex and violence, self-obliteration and regeneration. "Our whole life," Nijinsky would write, "is regeneration." The death of this girl, decreed by the patriarchs, is really a rape recast as a rite.[8]

And then there is the Chosen Maiden, the body in which art and un-art most ferociously interlock. She is the "ballerina" in this ballet, but with none of the ballerina's

heightened liberty in space. How is she chosen? In a night-time trance called "Mystic Circles of the Young Girls." In this dance a group of tribal daughters form a circle and then move along its path in tiptoeing glides, skips, and stops. One maiden falls, recovers, and the gliding continues. When the same maiden falls a second time, the die is cast. If you've ever seen the way flocking birds close rank against one of their own who is disabled or differently marked, you know the truth of this moment.

But it wasn't just nature, it was culture. The Chosen Maiden has fallen out of line, very un-ballerina-like, just as young women during World War I and on through the 1920s were going to fall. The teens and twenties were the decades of the suffragette, a time of cultural uncorseting that also saw flappers loosed on society, young single women suddenly unchaperoned, hungry for raw life, and tauntingly modern in their silk sheaths, a shape like the rough wool shifts of Nijinsky's maidens.

Incredible to think that only twenty-three years had passed since the Mariinsky premiere of Petipa and Tchaikovsky's *The Sleeping Beauty* in 1890. Aurora, the springtime teen in *Beauty*, carries her culture out of a century's sleep into a civilized new dawn, whereas the springtime teen of *Le Sacre*, with no Lilac Fairy to amend her fate, must die for the good of her tribe. Both works pay homage to the sun: *Beauty* to Apollo and the Sun King, *Le Sacre* to the sun god Yarilo. How close these two works are in content—mythology to anthropology. And how far apart in form—aristocratic artifice displaced by animal instinct. In *Le Sacre* civilization

is absorbed back into primitive patterns, just as the dead maiden will be absorbed by the earth. Where *The Sleeping Beauty* is up-up-up, *Le Sacre du Printemps* is down-down-down. Mere months before the premiere of *Le Sacre*, Marcel Duchamp's *Nude Descending a Staircase, No. 2*, a cubist painting rendered in earth tones, its visual stutter-steps not unlike Stravinsky's percussive rhythms, caused a stir at the 1913 Armory Show in New York.

In 1920, Martha Graham, the greatest modern dancer of the twentieth century, danced the Chosen Maiden in Léonid Massine's new version of *Le Sacre du Printemps*, and in 1931 she premiered her early masterpiece *Primitive Mysteries*. All pattern, pure ritual, entirely female, it could be described as *Le Sacre* distilled into origami, the Chosen Maiden holding court while keeping secrets. Out of her own body, Graham pulled a dance vocabulary that was womb-weighted and spring-fertile—a new tradition. The great women of modern dance, Self-Chosen Maidens all, did the same. They preferred earth over ethereality, a bare foot to a satin slipper. Ballet and the ballerina would find their own way to be modern.

I have dwelled on *Le Sacre du Printemps* not only because of its historical import as a dark hinge between classicism and modernism, and not just because the Chosen Maiden—a symbol of irreducible isolation, of differentness laced with doom—was in actuality a descendant of ballet's earlier chosen maidens (Giselle, Odette, Aurora). I have dwelled on *Le Sacre* because it so well illustrates the way a ballet can startle our seeing, can make us question where we've been—

our movement norms, our norms of thought—and where we might be going, instantly throwing us in-between, into a transitional void that bristles with uncertainty and excitement.

Up until 1913 the evolution of classical dance had come in techni-poetic increments that were decorously developmental, but with *Le Sacre* the art form received a rupture that was decidedly undecorous, proving that ballet could sustain such ruptures—violent ones. Assault and aggression, expressionistic extremes and quotidian bringdowns—the way in which a choreographer challenged tradition was itself a viable and vibrant form of articulation. What had already happened in classical music and fine art was now happening in classical dance.

"The winds must come from somewhere when they blow, / There must be reasons why the leaves decay," wrote W. H. Auden in 1940, in the poem "If I Could Tell You." Auden is, in essence, saying something similar to Njinsky's "our whole life is regeneration." No one can predict when and where a fresh force will twirl up out of the dust, bringing a sudden change and leaving mature forms brittle on the branch. When we watch a new ballet, when we wonder "What the hell is going on?"—and believe me, all of us have felt this way when faced with out-there, avant-garde work—we must bow to the void and its vicious gales and look for the way classical assumptions and conventions are teased or tweaked, bent or broken, deconstructed or treated ironically. We must think about the ways in which art and un-art are mixed, because so much of twentieth-century ballet is about this mix. And we must be mindful of the

being at the center of this mix, the ballerina. For she is the vessel through which classical dance passes.

IN 1923, TEN YEARS AFTER THE PREMIERE OF LE SACRE, Nijinsky's sister Bronislava Nijinska choreographed a work for the Ballets Russes that teleported her brother's superstitious natives into a stark Siberia. The ballet was called *Les Noces* (The Wedding). Again the score was by Stravinsky, only this time the Chosen Maiden was a peasant girl betrothed to a peasant boy, an arranged marriage between two reluctant teens whom we might call the Chosen Couple. Nijinska was sympatico with her brother's modern sense of weight and posture, but she worked her dancers differently, more like woodcut puzzle pieces. She locked them into abstract shapes of community, then unlocked them in kinetic explosions coldly mathematical. The Chosen Couple is held outside the pattern, though we know that they will be drawn back into the pattern. What are social ceremonies but momentary flare-ups of individuality set against life's faceless flow?

It's always fruitful, when responding to a new ballet, to look at what it lifts from a previous template and what it leaves behind. *Les Noces* was reiterating the message of *Le Sacre du Printemps*, sans murder. Its subject, the marriage of Russian peasants, was similarly superstitious and rural. But it was marriage of a different sort that engaged Nijinska. In

Les Noces she married ballet's roundness to her brother's angularities, yoked ballet's lightness to *Le Sacre*'s weight. She assembled architectonic structures that had a faux-naïf feel and brought to the village girls' pointe work—snappingly staccato—a sensation of wolves' teeth and icicles, a cold culture. In the way Nijinska keeps the upper body static, arms curved high above the head while only the legs are animated and active, we see classicism at a remove, stylized so that it suggests the straitjacket of communal mores. Likewise, the ballet's chosen maiden—the young bride—is remote and almost removed, slowly disappearing as the deflowering approaches. It is the community that dances. At the ballet's end the silent couple is led to a bedchamber, as if to say that this is where they will do their dancing. The ballerina is still missing.

Let's leap to the thirties, to Antony Tudor, a dreamy English genius who was born William Cook in 1908, the son of a butcher. He was an unlikely candidate for choreography, but then choreographers are the unlikeliest of all artists. Tudor came of age in London, at the school of Marie Rambert (yes, Nijinsky's former assistant), and there he became familiar with the post-Nijinsky choreographers of his time, including Nijinska. Tudor's breakthrough masterpiece, *Jardin aux Lilas* (Lilac Garden), premiered in 1936. It had the same subject as *Les Noces*—an arranged marriage—but Tudor's marriage is set in the straitlaced Edwardian era. The music is Ernest Chausson's fevered Poème for Violin and Orchestra, op. 28.

A portrait of desire contained and controlled, the ballet's sensibility is equal parts Edith Wharton's *The Age of Innocence* (1921) and T. S. Eliot's *The Waste Land* (1922)—"April is the cruellest month, breeding / Lilacs out of the dead land, mixing / Memory and desire." In *Jardin aux Lilas* we see young Caroline at a garden party on the eve of her wedding. The man she loves is there, as is the older man she must marry, whom she doesn't love. And he may not love her; his former mistress has come to the party—*inflamed*. The young lovers steal any moment to be alone, small talk and whispers revolving around them, a social clockwork, time running out. Caroline is dressed in sacrificial white.

Tudor's movement strategy is so very Nijinska, especially his use of a stilled upper body. Only here, it reflects the tight corseting of upwardly mobile Edwardians, the fine chill in England's ideal of restraint, a physical pianissimo that invests small inflections with huge meaning. And now sex is present. Expressive power comes from the pelvis, a lower-body agency that is like a cry from the deep, legs lashing and reaching in longing and rage, while the body above beams composure, correctness—"Keep calm and carry on." Tudor was emphasizing a new opposition in classical dance—ego versus id, angel versus animal. In his pursuit of psychodynamic truth, movement that reveals the subconscious in action, Tudor brought a readable body language into his ballets, powerful and distinctly modern. "The audience was called upon," Agnes de Mille explains, "to accept the balletic gesture as a form of simple dramatic communication. It was also asked to watch women who looked like

their mothers and aunts kicking over their heads, or wrapping their legs around men's bodies."

Not surprisingly, the abdominal strength and spinal flexibility needed to dance Tudor, what he called "center-of-the-body consciousness," was a hallmark of Martha Graham's modern-dance technique. Both were mining those caverns measureless to man—the psyche in all its complicated storytelling.

To this end, *Jardin aux Lilas* is quietly brilliant in the way it plays with temporality, again suggesting epochal lines by T. S. Eliot, published in 1936, the year of *Jardin*'s premiere. "Time present and time past," begins "Burnt Norton," "are both perhaps present in time future." Charged moments—fleeting glances and furtive gestures, passionate lunges and hasty retreats—seem to slip into memory right before our eyes. We see characters in states of disassociation, watching themselves losing everything. When Caroline faints on the arm of her fiancé, Tudor freezes the moment—the whole party—for almost forty seconds, during which Caroline's soul lifts out of her faint and walks blindly toward her lover, then reverses (rewinds!) back into that faint, and the party resumes. This compositional layering was completely new to ballet. *Jardin aux Lilas* ends with the entire party posed for posterity, as if holding still for a picture made with the era's dry-plate camera. A moment is caught forever, its sorrow undetectable. I dare you to watch this ballet and not die a little.

"I didn't have to open any boundaries with these ballets," Tudor said in 1973. "I had to come back to the streets, and

the people I lived with. . . . I want every single person in the audience, from a three-year-old child to a seventy-year-old whatever, to know exactly what the drama is."[9]

It was in America that Tudor pulled out all the stops. Where desire is the silent vibration that sets *Jardin* atremble, it is a force unleashed and explicit in *Pillar of Fire*. Choreographing for the American Ballet Theatre in 1942, Tudor took on the most important early work of the Austrian composer Arnold Schoenberg, the hot-ember *Verklärte Nacht* (Transfigured Night), which was based on Richard Dehmel's poem of the same name, published in 1896 and considered obscene in its time. It is a conversation between a young couple as they walk in a wood on a cold night. The woman, who believed she would never find love, confesses that, having given herself to a stranger, she is pregnant, and "Now you, oh you, have I met." The man comforts her. Their love, he says, will transfigure the child, making it his.

Tudor named his heroine Hagar, and though Dehmel's poem and Schoenberg's music share a fin de siècle sensibility, Hagar is a twentieth-century ballerina, a chosen maiden created this side of Freud. Her drive for love and sex is as natural and adamant, overwhelming and unbalancing, as it is for most of us when young. She wears a plain dress, close-collared, and is soon pulling at that collar. And look at the way she performs arabesque, arms swept desperately back. We see an entrapment like the white swan Odette's, but the timbre is tense, the pose unflowing. Tudor was doing something different in *Pillar of Fire*. Where Odette's arabesques are numinous flowerings—an expression of the sublime in

Pillar of Fire

sublimation—Hagar's rigid arabesque fights sublimation. Where Odette is held beautifully spellbound in classical forms, Hagar fits uncomfortably in classicism, a too-tight collar. She torques and twists, caught not in a metaphor but in the morals of her time. Repelled and attracted by the young libertine from the shady House Opposite, her dance with him is a labyrinth of spins and turns—it's hard to tell who is seducing whom. When he turns away, she throws herself at his shoulder and is carried into the shadows. Afterward, stumbling forth, she stands before her own house in shame, head and back bowed like the curve of a question mark. Stark punctuation, this long pause awaiting an answer. And it comes in a coda of heart-bared fulfillment. For the ballerina, *Pillar of Fire* was a trial by fire. As of 1942, she proved that she could dance sexuality that was blunt and unpretty, that her classicism could carry messy emotions, that she could even be graphically sullied, and yet her relationship with transfiguration remained intact.

· She also proved, in the 1940s, that she could be something lighter and brighter, leaner and keener. For it was in the war-torn forties that American style across the board was codified. It took its kinetic MO from General George S. Patton: we do not hold positions; we move, advance, always ("In case of doubt, attack"). It was young Leonard Bernstein, who, with a morning's notice in November 1943, unrehearsed but so ready, leapt to the podium of the New York Philharmonic to conduct a matinee for the ailing maestro Bruno Walter; in one afternoon "Lenny" loosened Europe's grip on the conductor's baton. It was Jackson Pol-

lock and action painting, his canvases down on the ground so that he could, he said, "literally be in the painting" as he flung, poured, and dripped paint into brainstorms. It was graphic designer Alexey Brodovitch opening white space in the pages of *Harper's Bazaar*, and photographers Irving Penn zooming in (at *Vogue*) and Richard Avedon getting real. It was a new genre of dressing from Seventh Avenue called "sportswear," separates that assumed nerve, muscle, speed, and space were implicit in everyday life. And it was George Balanchine, inching toward the 1948 founding of his New York City Ballet, its aesthetic combining Patton's attack, Bernstein's readiness, Pollock's immersion, Brodovitch's white space, Penn's scale, Avedon's realness, and Seventh Avenue's chic freedom. Nerve, muscle, speed, and space were changing the texture and tempo of classical dancing, which was suddenly breathing a whole new superoxygenated air.[10]

October 1942, six months after *Pillar of Fire*'s spring premiere, saw another ballet with a difference, this one presented by the Ballet Russe de Monte Carlo, a reboot of Diaghilev's Ballets Russes (which disbanded with his death in 1929). It was choreographed by the aforementioned Agnes de Mille, daughter of the playwright William C. de Mille and niece of Cecil B. DeMille, the larger-than-life film director who was one of Hollywood's pioneering talents. Born in New York City and raised in Los Angeles, she too had studied with Rambert in London. She knew Tudor well and Martha Graham even better. It took de Mille years of struggle as a soloist, making art dances in many

vernaculars, before her minor presence jumped into a major key. The ballet was *Rodeo*. And although her greatest fame would come from her work in Broadway musicals (*Oklahoma!*, *Carousel*, *Brigadoon*), her allegiance to classical dance was first and foremost.

Rodeo (pronounced "ro-*day*-oh") is about cowboys, their sweethearts, and an awkward cowgirl who rides with the men to be near the wrangler she loves. Aaron Copland's commissioned score, one of three immortal works he composed for dance in those years (the other two were Eugene Loring's *Billy the Kid*, in 1938, and Martha Graham's *Appalachian Spring*, in 1944), was raw and wistful, a music of plains and thunder. And de Mille, it's as if she rode across time to the West of her youth, not just that mythic land of space and sky but to Hollywood, home of the infant art form—comic two-reelers, Cecil B. DeMille westerns—that she grew up with. In *Rodeo* she tethered classical lift and loft to an earthy simplicity and wit. This new ratio of high to low both weighted and enlarged de Mille's use of gesture, which made for emotional moments that felt like camera close-ups, only without the camera. This, too, was ballet. As for the ballerina, a cowgirl dressed in boots and dungarees, she covers the stage bucking, wheeling, and galloping, falls splat off her horse and lies prostrate on the ground. The template is Nijinsky's Chosen Maiden, except that this girl is in control of her own fate. When she falls she gets up, bowlegged, to ride again.

Another leap—to ballet postwar. At the New York City Ballet during its formative decade, the 1950s, the Chosen

Maiden was enthroned, for she had fused with the muse. Very early in his career, Balanchine began to draw insight and inspiration from one dancer at a time, a sort of serial monogamy. Whether they were wives, lovers, or infatuations (sometimes unrequited), these chosen ones of his heart spurred choreographic invention and innovation, each muse constituting an artistic phase—short, long, shallow, deep. Tamara Geva. Alexandra Danilova. Vera Zorina. Marie-Jeanne. Maria Tallchief. Tanaquil Le Clercq. Diana Adams. Allegra Kent. Suzanne Farrell. "When Balanchine was in love," the New York City Ballet dancer Edward Villella writes in his autobiography *Prodigal Son*, "when he was creating for his muse, the studio—the theater itself—seemed bathed in a glow." This doesn't mean that Balanchine only focused on women he desired. He made rich roles for Patricia Wilde, Melissa Hayden, Violette Verdy, Patricia McBride, Kay Mazzo, Karin von Aroldingen, and Merrill Ashley. He also carried the imprints of two women—his coolly aloof mother, Maria, and his impulsive classmate Lidia Ivanova, the lost ballerina of his youth. But as Balanchine said to his friend Lucia Davidova, "I know the stimulus. In order to continue working I have to follow my love." Each new interest—whether she bewitched, bothered, or bewildered—excited new possibilities of movement.[11]

Balanchine, who was born in 1904 and died in 1983, was a giant of the twentieth century, as exploratory as Stravinsky, as prolific as Pablo Picasso, as experimental (when he chose to be) as the latest theatrical wunderkind coming down the pike. But his nineteenth-century paradigm—the

artistic arousal kindled by the artist-muse relationship—persisted. And even as this paradigm was disappearing from music, literature, and painting, it continued to work in classical dance because a ballerina is an artist as well as an instrument and therefore a partner in the making of a ballet. Sir Kenneth MacMillan and the headstrong Lynn Seymour in the 1960s. Peter Martins and the audacious Heather Watts in the 1980s. Christopher Wheeldon and the cryptic Wendy Whelan in the new millennium. Each of these choreographers drafted off the energy and edge of the ballerina before him, finding in her, as George Bernard Shaw's Henry Higgins finds in the transformed flower girl Eliza, "a tower of strength: a consort battleship."[12]

Postparadigm choreographers did come. William Forsythe's brainy deconstructions of classical dance idioms implicitly deconstruct the ballerina. Stripping away or subverting context, dislocating dancers in syntax that looks computer generated, Forsythe's ballets are hypnotic endgames that leave the audience with a lot to think about but not always a whole lot to love. The modern dancer Mark Morris, who is sometimes called on to make ballets, has been quite vocal about his dislike for classical hierarchy and for worlds in which chosen ones are the norm. A "ballet" by Morris likes to wear quotation marks and skews to the ensemble, hugging a communal ethic of equality that brings ballerinas into parity with the corps. And Alexei Ratmansky, one of the busiest classical dance–makers of the twenty-first century, never seems deeply fixed on one dancer or moonstruck in her presence but bounces about

the company roster, which makes for a choreographic experience that's more ready-to-wear than couture.

Perhaps predictably, the most successful mainstream female choreographer of the last few decades, Twyla Tharp, has been inspired by the single girl hardly at all. Irreverence is the byword with Tharp, who moves from avant-garde to rock to pop to jazz with a soft-shoe élan, a love of shtick, and a ferocity that can go adoring or aggressive in the blink of an eye. In her work with classical companies she has preferred to focus on a Chosen Man—a cocksure Cagney, a brooding Brando—playing to his vanity and sending him into giddy cadenzas of virtuosity. Tharp and her men leave ballerinas in a destabilizing wake, stars glimmering but dimmed amid the fireworks, a bit of a comeuppance but also a bit of a breather. As we will see in the next chapter, male ballet dancers deserve their every second in the spotlight.

BALLET IS WOMAN—
BUT LOOK AT ITS MEN!

"*W*E MUST FIRST OF ALL COMPLIMENT MLLE. THERESA Elssler," wrote Théophile Gautier in 1838, "on the good taste she has displayed in not giving *pas* in her choreographic work to male dancers; in fact, nothing is more distasteful than a man who shows his red neck, his big muscular arms, his legs with the calves of a parish beadle, and all his strong massive frame shaken by leaps and *pirouettes*."

Three years later, in 1841, Gautier and his like-minded friends cooked up the Wilis of *Giselle*, specters adept at ridding the stage of "distasteful" male dancers. If the gentle sylphs of *La Sylphide*, nine years earlier, had lured ballet into the romantic era, the unpitying Wilis roared like enforcers setting an example. The female dancer would take

classical dance for her own the way the Wilis took their male prey—for keeps.

As we learned in Chapter One, the art of ballet began as a cathedral for kings, its steps and symmetries evoking architectures of inspiration and invincibility. The crown was "contextualized" (as academics would say) within rose-window geometries, turret-like pirouettes, and arabesques acting as flying buttresses. But with the female's rise during the romantic era, a rise both literal—the pointe!—and figurative, and with her consequent passage into realms more "liminal" (academics again), the king's crown of gold gave way to the ballerina's tiara of dewdrops. Ballet's universe, once patriarchal, was now matriarchal, and men had become intruders in a terrain of white tulle.

Put plainly, when the classical technique was bifurcated by the introduction of pointe work, the female ballet dancer was privileged in her art in a way female artists had never been privileged before. Her wider pelvis had already made way for more liberated turnout. And being less musclebound than a man, she was lighter and quicker, with more motor refinement. Add in pointe and she was protean—metaphorically intrepid. "Balanchine was fascinated by the way a woman looked on pointe," says Suki Schorer, who danced for Balanchine and teaches at his School of American Ballet. "I think he said that if it wasn't for the pointe shoe, he might not be a choreographer." It was female technique that engrossed the greatest choreographer of the twentieth century, and fathomless female range that roused his artistry. It was Balanchine who said, "Ballet is woman."[1]

He also said, "Put sixteen girls on a stage and it's everybody—the world. But put sixteen boys and it's always nobody."[2]

This is not as negative a comment as it seems. It doesn't mean male dancers can't be sensational, because sensational male dancers have jolted the art form throughout history. And it doesn't mean that Balanchine didn't make remarkable roles for his leading men, because he did. Balanchine is simply saying that in ballet, men don't accrue meaning through multiplication the way women do. When the English choreographer Matthew Bourne produced a revisionist *Swan Lake* in 1995, his swan corps was made up of men, to great theatrical effect. These swans were weighty and aggressive, as swans are in real life. But they were more of a squadron of swans than the drift, whiteness, bank, bevy, or lamentation that a corps of women calls up. As spectacle, groups of men are statements of strength, power structures like armies and teams, whereas groups of women suggest sensibility, a commune or carnival of souls. Even when a female corps evinces power, as do the malevolent Wilis, the "she" of the corps continues to invite poetic empathy.

This is the way the art developed. The male classical dancer reads most potently in the singular, dancing solo or as the partner in a pas de deux, where we can revel in the strength *and* sensibility that isolates and transports him. In this chapter we will consider what is required of the male dancer as an artist and as a star, and then zero in on some of the most important male dancers in history, looking at how they raised the bar on technical standards, stimulated

interest in the art form, and fueled new audience expectations. So let's go back to Gautier. Having decried male dancers in 1838, he found one to celebrate two years later, an about-face that seems a good place to start.

"WHAT LEGS!" GAUTIER EXCLAIMS OF JULES PERROT'S performance in the opera ballet *Le Zingaro* in 1840. "His success was assured before he had made a single step." At last, Gautier is thrilled by a man in tights, whose legs remind him of the youth in a painting by Raphael. He goes on to describe Perrot's "quiet agility," his "perfect rhythm," and his "easy grace," and then defends his own judgment, writing, "These praises are the less to be doubted coming from us, since there is nothing we like so little as to see male dancers. . . . Perrot has vanquished our prejudices."

Gautier's drumbeat of criticism against male dancers suggests that in his day there were a lot of substandard technicians among the male ranks. At the same time, his excitement about Perrot spotlights a verity: phenomenal male dancers thrill everyone, including female-centric balletomanes. The impact of masculine might in classical harness is electrifying, even to those who know nothing about ballet. When the Pittsburgh Steeler Lynn Swann, a wide receiver of uncommon aerial elegance, began wowing the sports world in the 1980s, the press was soon calling him "Baryshnikov in cleats." This reference to the ballet superstar Mikhail Baryshnikov, who defected from the Soviet Union in 1974,

was a thrilling moment of mainstream acceptance for classical dance. In equating football and ballet, the press enlarged both athlete and artist. The Euclidean beauty of Swann's upward trajectory to the flying ball, the jock prowess of Baryshnikov in the air—both musculatures belonged on the ceiling of the Sistine Chapel. If we can appreciate one, why not the other?

"Ballet as we know it was born when the acrobatics of the professional and the aristocratic grace of the courtier were united," writes the English critic Arnold Haskell in his book *Ballet: A Complete Guide to Appreciation.* One might say that whenever jesters or harlequins appear in a ballet, we are seeing a flashback to the bumptious early days of classical dance, to the vigor and physical wit rooted in gymnastics, the trapeze, and the commedia dell'arte. Perrot was himself an embodiment of Haskell's comment, for he started his career as an acrobat in the Italian circus and then began, in the 1820s, to train with one of the greatest of French classicists, Auguste Vestris, a phenom of the previous generation. Because Perrot wasn't very attractive from the waist up, Vestris advised him to "jump from place to place, but never give the public time to study your person." Perrot's ballon made him the male equivalent of Marie Taglioni, the new queen of ballet, and he became known as "Perrot l'aérien."[3]

The acrobat and the aristocrat. The male dancer is trained to bring both together in one body. No matter how high a man may jump, how long he hangs in the air, how many spins he fits into a musical measure, if his line is amiss, his toes unpointed, and his landings sloppy, he has fallen

short. Conversely, while the danseur noble—a male lead of classical proportion and sterling polish—may win admiration and even love for his technical mastery, if his leaps are middling and his pirouettes lack dash, he will leave many in the audience unsatisfied. Purring animal magnetism is part of the male dancer's arsenal. Ballet's men may descend from a French king in Louis heels, but they are also lions and tigers and bears. (Maybe not so much bears.)

Where Auguste Vestris and Jules Perrot were touchstones of the nineteenth century—just as Louis Dupré and Gaétan Vestris (Auguste's father) were of the eighteenth—Vaslav Nijinsky was the first touchstone of the twentieth. Or perhaps the better word is "flashpoint." His impact as a dancer and his vision as a choreographer were incendiary, and he is often cited as the greatest male dancer in history. "For those who did witness his dancing," wrote the dance historian Cyril Beaumont in 1932, "he will always remain the ultimate standard by which male dancing must be judged."[4]

Yet seeing that his descent into madness (more on this later) cut short his performing years—a mere 1907 to 1917—and that no film record of his dancing exists, Nijinsky is now something of a chimera, equal parts prodigy and tragedy, genius and peasant, fact and myth, silent totem and sacrificial lamb. His most famous roles were the male leads in *Le Spectre de la Rose*, *Petrushka*, and *L'Après-midi d'un Faune*. And while this Rose Ghost, soul puppet, and faunman would eventually give himself over to the tenets of Tolstoyan simplicity, he was actually Dostoyevskian in his psychological complexity. The world called him "god of the

dance"—as Louis Dupré, Gaétan Vestris, and Auguste Vestris had been called before him—but Nijinsky called himself "a clown of god."

His parents were Polish, dance comedians descended from generations of acrobats, and Nijinsky's first performance, at age seven, took place in a circus. He went on to study in St. Petersburg at the Imperial Theater School and in 1907 joined the Mariinsky Theatre, where he was immediately lauded for his classical style and his breathtaking elevation and ballon. "He did not come down completely on the balls of his feet, but barely touched the floor with the tips of his toes," writes his sister, Bronislava Nijinska, of his gift for flight. His toes were so strong, she says, and his rebound so quick, that his push up from the ground was "imperceptible, creating the impression that he remained at all times suspended in the air."[5]

The Mariinsky Theatre was strict about *emploi*, an approach to casting that "employs" dancers based on type. Whereas women are pegged along a continuum—romantic versus classical, an adagio technician versus an allegro temperament—men fall into categories: danseur noble (princes), heroic (roles like the rebel Spartacus), demi-caractère (character and mime roles), character (national dances in boots), and grotesque (jesters and witches). So which was Nijinsky? His face was more sensual than princely, with an Asian cast. Like Perrot, he did not have the physique of a danseur noble. "He has no chest muscles, enormous thighs, a wasp waist," said the sculptor Aristide Maillol.[6]

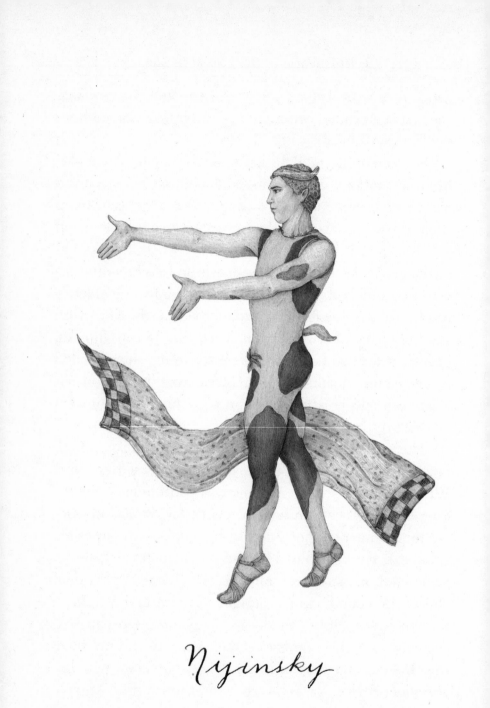

Nijinsky

Nijinsky's artistry rendered questions of category moot. "He can look tall or short, magnificent or ugly, fascinating or repulsive," wrote Carl Van Vechten, the American essayist and photographer, in 1916. "His dancing has the unbroken quality of music, the balance of great painting, the meaning of fine literature, and the emotion inherent in all these arts. There is something of transmutation in his performances."[7]

Nijinsky was under contract at the Mariinsky, but in 1909 and 1910 he also performed in Paris with Diaghilev's Ballets Russes, where he was rapturously received in the new ballets of Mikhail Fokine. "His super potent projection," said the actress Elizaveta Timeh, "stirred the audience of both sexes equally." This acclaim in the West annoyed Mariinsky management, who tamped Nijinsky down and held him back with boring roles. ('Twas ever thus. There's a love-hate relationship between company directors and their stars because dependence on the artist infuriates management. This leads to power games that become self-inflicted wounds.) Diaghilev, buoyed by success, wanted Nijinsky full-time—the two were already lovers, sharing hotel rooms on tour, and Diaghilev's new company needed Nijinsky's heat and light as a headliner. The scandal that would break the Russian contract and free Nijinsky for Diaghilev was, in a way, symbolic.[8]

In January 1911, for his first Mariinsky performance of Duke Albrecht in *Giselle*, Nijinsky decided to wear his Paris costume: tights and a short tunic. Not only was the tunic shorter than usual, but Nijinsky omitted a Russian staple of

male modesty—the regulation trunks that were worn over tights. Members of the imperial family were up in their box, and the prudish dowager empress Maria Feodorovna was affronted. During the intermission she demanded a more covered-up costume for act 2. Nijinsky refused and was dismissed the next day.

Was Diaghilev behind the costume change? Some historians think he was, though Sjeng Scheijen, in *Diaghilev: A Life*, writes that it was probably "Nijinsky himself who escalated matters through his stubborn pride and social ineptitude." The larger point is this: the "super potent projection" of which Timeh spoke, a somewhat priapic presence, was intrinsic to Nijinsky's capture of the West. Indeed, it was showcased in 1912, when the last action in Nijinsky's performance of the ballet *L'Après-midi d'un Faune*, which he had choreographed, saw his faun prone upon a stolen veil, delivering unto it a single stylized but unmistakably orgasmic thrust. This act of realism was too much for some in the audience, who denounced it as "bestial." But it was also a truth unveiled: ballet consists of desirable bodies and ecstatic energy. Nijinsky's visceral impact on his audiences, his frank physicality and complete release into a role, seem to have had the aspect of a consummation.

"Nijinsky does not dance from his feet," writes the critic Edwin Denby, having analyzed the artist in both posed and stop-action photographs, "he dances from his pelvis."[9]

Touchstone and flashpoint, Nijinsky was also a fulcrum. Never has a single dancer, like the surge through a synapse, provided such push to the turn of a century, though admittedly

it was two works choreographed by Nijinsky—*L'Après-midi d'un Faune* and *Le Sacre du Printemps*—that forever fused this man with modernity.

Fate was cruel. An impetuous marriage led to a break with Diaghilev, and Nijinsky, who could not thrive without a company structure and financial support, became increasingly disorganized and delusional. His final performance, a solo full of stillness, took place in 1919 in a hotel in St. Moritz. Soon diagnosed as schizophrenic, Nijinsky lived his long last years, thirty of them, in and out of European hospitals. He died in England in 1950.

But the standard he set lived on, and the public continued to want dominion from male dancers—prophetic imagery and supercharged symbolism. Every era possesses superb men, and the seasoned balletgoer will find much to love in the quiet classicist, the explosive virtuoso, the Byronic young danseur noble. The public at large demands more. And the public at large got it in 1961 in the person of Rudolf Nureyev—pronounced "noo-*ray*-ef," as if something solar shoots through the name. He joined the Kirov Ballet (formerly the Mariinsky) in 1958, but he broke the proverbial sound barrier on June 16, 1961, when he made the split-second decision to defect from the Soviet Union. Within hours Nureyev was a worldwide figure of freedom.

In retrospect, it's hard to imagine it not happening. The company was on tour in Paris and Nureyev, a young dancer tasting Western liberties for the first time, was testing the patience of the Soviet watchdogs, who were guarding against defections. The West, for its part, flipped over the raw young

Russian and called him the new Nijinsky. "He has the same presence," said the retired ballerina Lubov Egorova, who had danced with Nijinsky many decades before. It was history repeating itself, for back in 1910 all Paris had called Nijinsky the reincarnated Vestris.[10]

Comparison to the reigning model, or to the alpha of the previous generation, is one of the ways we assess a new talent and also hone our eye to the differences—physical and artistic—in dancers. How does he take the stage? Respond to music? Handle the height of his grand jeté? Is he more artist or athlete? Instinctual or theatrical? "Here is the greatest actor in the world," Sarah Bernhardt said of Vaslav Nijinsky. For Ninette de Valois, director of the Royal Ballet, it was the decorum of Nureyev's curtain call that convinced her of his greatness. And isn't it tantalizing that many of the people who compared Nureyev to Nijinsky had never seen the latter dance? Fantasy is so much a part of ballet that when we've studied enough studio stills, read enough eyewitness reports and rave reviews, we feel we've glimpsed, if only in our mind's eye, those long-ago beings.[11]

Fully aware of Nijinsky before him, Nureyev had flouted the Kirov's self-same costume rules by dancing his Leningrad debut in Don Quixote without the crotch-covering bloomers. Because it was 1960, half a century after Nijinsky's dismissal, Nureyev not only won the day, the rule was changed. That he too excited desire in both women and men goes without saying. And while not androgynous in the way Nijinsky is said to have been, Nureyev did customize his technique with ideas stolen from the ballerina's playbook: a stretched

and spearlike leg, a high demi-pointe, an unabashedly big arabesque. Did Nureyev lose himself in a role the way Nijinsky had? He never lost himself in any role. And the "transmutation" of which Van Vechten wrote, which begins with humility, what of that?

Nureyev's parents, Farida and Hamet, were Muslims—she a Tatar, he a Bashkir—who met in the old Muslim city of Kazan when Hamet was a student. Both believed in education and in the ideals of Communism, and although they had urban dreams for their children, Hamet's job as a *politruk*, a sort of political policeman, meant frequent relocation to grim outposts. Rudolf was born in 1938 on a train heading east into the frigid vault of the Soviet Union, so locomotion, travel, was sewn into his life story from the start. So was want. His early years coincided with World War II, his father away in the army and poverty all around. When "Rudi" saw his first ballet, at age seven, that was it—"I wanted to be *everything* onstage." But his father, having returned from war, was dead set against dance for his son. Rudolf secretly took ballet lessons from a local teacher and with staggering resolve worked his way to St. Petersburg, at age seventeen, for intensive study at the Vaganova Academy (formerly the Imperial Theater School). "I will be the number one dancer in the world," Nureyev told his classmates. A latecomer to the art, he did not have time to be humble.[12]

A fiery young man when he debuted first in St. Petersburg and then in Paris—flaring nostrils, narrow waist, sculpted loins, buttocks by Leonardo—Nureyev's technique was still

unfinished. His grand jetés were high but somewhat hilly. His double tours were clean in the air but took off from a ragged fifth. His arms could flail, his effort obvious. This was all due to the late start of his formal training. But he turned like a cyclone and took the stage with an insolent swagger, as if he owned it, and that swagger was riveting. (Audiences like a little whipping now and then.)

An incarnation of Nijinsky? Nureyev was speaking to the sixties cult of the self, its mash-up of fashion, rock, photography, celebrity, and brazen sexuality. Where Nijinsky had become increasingly ascetic, Nureyev was hedonistic, with the devouring look of a carnivore (that untamed gaze, those big-cat cheekbones) and a dash of the carnal—"Rudi in the nudie," fans would chant. The defection in Paris, six steps to the custody of French officials, was reported as a "leap to freedom," and this inflation set the tone of Nureyev's persona in the West. Everything was hyperbole or allegory or both, as if he was living his life onstage.

And he was. His first two roles post-defection, both in *The Sleeping Beauty,* were defining. Nureyev's Prince Désiré named the force that drove him: desire for the stage, for stardom, for singularity, for sex (he was as prowling offstage as on). And his Bluebird expressed his need for freedom and flight and foresaw his uncaged migration from company to company: the Royal Ballet, the National Ballet of Canada, the Joffrey Ballet (in a triple bill of Nijinsky roles), the Boston Ballet, the Paris Opera Ballet, and many more. Nureyev spoke of his "vagabond soul," but he was really more like traveling royalty. The doublets he wore in his prince roles,

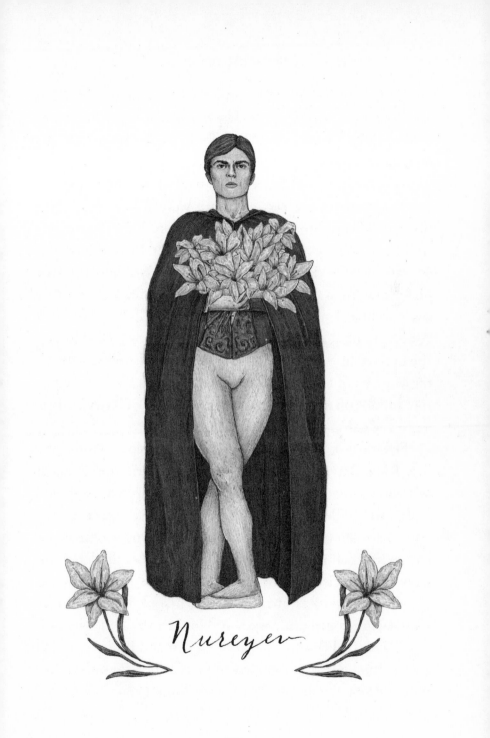

made of brocades embellished with gold and silver bullion and cut to accentuate his V-shaped torso, were like custom-made castles that traveled with him, dream homes for his wandering heart.

Was he the best dancer out there? Even in Nureyev's greatest decade, the sixties, there were others who were not as hot to the touch but evinced more light. The beautiful Yuri Soloviev, who was also on that 1961 Kirov tour to Paris, was a dancer of angelic classicism and opulent plié. New York City Ballet's Edward Villella—grinningly swift and brash with a lashing finish—was crown prince of American dance. The Royal Ballet's Anthony Dowell had the cursive line and flow of a romantic poet, and young Peter Martins of the Royal Danish Ballet was like an Arthurian knight on a white charger, his academic clarity casting a spell of calm.

Erik Bruhn, a Royal Danish danseur noble of wintry dignity and a Barrymore profile, forged an international career as a guest artist with many companies. Bruhn was a paragon of Bournonville technique, the scrupulously quick-footed and ever-temperate Danish school of classical dancing—ballon in a bell jar. Not only was he Nureyev's model of unclouded classicism, Bruhn would also be the love of his life, proof that opposites attract. Bruhn, a cool drink of water; Nureyev, nitroglycerin, ready to blow. In the end, Nureyev never matched Bruhn's elegance en l'air and Bruhn couldn't match Nureyev's stardom; but then, is a classical pianist like Alfred Brendel going to win against Mick Jagger?

Nureyev demanded for male dancers a prouder place in the spotlight, and he demanded *from* male dancers testosterone—a Dionysus at the reins of Apollo's chariot. Look at photos of Nureyev in fifth position. It's the deepest, longest love affair he ever had. And that is perhaps his greatest legacy, a love of classical dancing that made legions love it too.

WITH NUREYEV'S DEFECTION, A CLASSICAL DANCER WAS suddenly the focus of political news, a high-profile subject for the nondance audience. His was the first of a slew of defections from the Soviet Union—Natalia Makarova in 1970, Mikhail Baryshnikov in 1974, and Alexander Godunov in 1979—each one a high five for freedom, a vote for velvet curtains versus the Iron Curtain. What does it say about a country, after all, if its most acclaimed dancers don't feel they can find creative fulfillment on their native soil? The West cared about these Soviet defections because of Cold War one-upmanship. It also cared because the world was still chauvinistic and the defectors were mostly men and somehow that meant more. Ballet insiders revere the ballerina, and Makarova's arrival in the West was a gift and a goad to aspiring female dancers. But her defection did not have the same news value as those male names ending in *v*: Nureyev, Baryshnikov, Godunov. The nondance public is brought to ballet by out-of-this-world men. It is easier to read and appreciate awesome leaps and

turns—the acrobatics of classicism—than the intricacies and aesthetics of pointe work.

If Nureyev was a wake-up call, Baryshnikov swept ballet up and away. Here was a quantum leap for male technique. Though at five-feet-six he was not as tall as the traditional danseur noble, Baryshnikov's faultless proportion of leg length to torso, his elegantly articulated musculature and long, well-pointed feet, gave him gravitas. And his classical alignment—an Elysian Field of symmetry and lift, as if he were always in the center of a sphere—made "Misha" seem a heartthrob dropped from heaven, his big blue eyes full of cerulean sky. He was just so boyish, so plush, his momentums unbroken, his phrasing unforced, secure in the air, so much so that he seemed to rest up there, pillowing back at the top of a double cabriole devant, not pausing, as Nijinsky was said to do, but slowing time down.

Here was the compleat male classical dancer, an Icarus who kept his head clear and his wings cool, aiming at the sun but never coming too close. For choreographers Baryshnikov was a wondrous toy with which to play, high-tech yet huggable and so coordinated he could do whatever they asked of him. He played most memorably with Twyla Tharp, who in 1976 choreographed a mischievous portrait of Misha called *Push Comes to Shove*. The princeling was suddenly a human gyroscope—twirling and tipping; swinging between dance idioms; mocking tradition, himself, and the audience; his serene inner balance all the while undisturbed. When Baryshnikov had met every dance challenge the West had to offer, he went on to act in plays, movies, and on televi-

sion, developed solo shows of performance art, and worked to realize the Baryshnikov Arts Center in New York City, a space for experiment.

Defections are mostly a thing of the past. Russian companies now tour frequently, Russian dancers can join companies outside their country, and Russian stars enjoy jet-set careers. Even Cuba, which didn't lift restrictions on travel abroad until 2013, allowed stars Carlos Acosta and José Manuel Carreño to take their talents out into the world in the 1990s. And while political drama and the interest it generated helped float the boat for all ballet, it also stole attention from homegrown talent. When Baryshnikov joined the American Ballet Theatre in 1974, the young Fernando Bujones was already there. The first American to win the gold medal at the International Ballet Competition in Varna, Bulgaria, he was a comet in his own right. "Baryshnikov has the publicity," Bujones claimed. "I have the talent." In a ballet company, the competitive pecking order is not for the faint of heart.[13]

Today, male dancers all through the roster are expected to have power turnout, stretched limbs, and bona fide pointed toes—not kinda pointed. The practice of emploi is pretty much over, with men of all shapes and sizes cast against type, especially in the wake of Baryshnikov, who may have been short but was a giant onstage. No one would want to see dancers like Julio Bocca, Angel Corella, or Herman Cornejo, whirlwinds in the Misha mode, stuck in demi-caractère roles for life. Moreover, it has come to pass that the dancing of a company's male corps is sometimes

more memorable than that of its female. Men dancing beautifully leave a big impression.

I'll never forget, in the early 1990s, the enchantment of a young American named Ethan Stiefel. New to the New York City Ballet, this strawberry blond with an aw-shucks ease had a line as fine as a nineteenth-century engraving and the thrust and flourish of a rapier tip in a winning duel. Stiefel heralded a new era of refinement in male dancing, and for many years he shared the top of the roster at the American Ballet Theatre with another avatar of gleaming classical style, the Brazilian-born Marcelo Gomes. Given ballet's millennial bumper crop of regal masculinity, it was a no-brainer when, in 2006, a show called *Kings of the Dance* began touring with a changing roster of four or five leading male principals from around the world—international stars like Stiefel, Gomes, and Corella, David Hallberg, Johan Kobborg, Nikolay Tsiskaridze, Roberto Bolle, and Leonid Sarafanov. This male-centric evening of classical dance, a success along the lines of opera's the Three Tenors performances, proved that heading toward its fourth century, the art of ballet is still a cathedral for kings.

TO HAVE AND TO HOLD . . .
AND NOT TO HOLD

I HAVE TALKED ABOUT BALANCE THROUGHOUT THIS book, the state of equilibrium that dancers must maintain whether they are moving or still. Balance is an ongoing tête-à-tête between a dancer and the nothingness into which he or she dives daily, an endless romance, if you will, except that dancers, swept literally up and off their feet, cannot end up on the floor. The ballerina Suzanne Farrell, famous for her ability to keep eye contact with equilibrium even when dancing at full tilt, off-axis, called her 1990 autobiography *Holding On to the Air*. She was honoring the impalpable element that dancers embrace every day in the studio, in the spotlight, and with a whole heart: air.

Balance itself is impalpable. It makes no difference whether the balance we're talking about is physical, emotional, or mental (but aren't they all related?). You can't grasp balance with a fistful of fingers. It is always a process. Better today, worse tomorrow, recovered a bit, then suddenly as certain as the sunrise, a golden float that lets us believe we will be balanced forever, framed in magic casements. And then, on a bad day, the spell is broken, fled like the nightingale and its song in the ode by John Keats. And we must accept the bird's right to fly. It is often said that dance is a metaphor for life, and this is true. Each of us is a dancer when it comes to balance.

Here, in this very short chapter, we will train our lens on something more specific: a balance. By this I mean those moments when a dancer takes a pose or position and holds it for seconds at a time.

A balance can be taken on both legs, as in the thirty-two sous-sus held by the corps in *La Bayadère*'s white act, "The Kingdom of the Shades." Do not discount or downgrade the two-legged balance. For thirty-two dancers to hold sous-sus on pointe for seven seconds is *something* (and so chancy that some productions let the Shades bourrée for seven seconds). And regard fourth position on pointe, a two-legged balance big and beveled. It's a bridge that is also a steeple.

A balance can be held on a single flat foot. Most often this takes the form of an arabesque or an adagio extension, such as Giselle's act 2 *développé à la seconde*, the leg slowly unfolding to the side and up, high as an elephant's eye, a move so exposed that ballerinas feel free once they've gotten through it.

A balance can be held on a demi-pointe—more difficult than you'd think—and more perilously and climactically on full pointe. A long-held balance on a single pointe has great poetic and theatrical impact, but not if it is gripped or grueling.

Balances often come at the end of an enchaînement, and when these are held, especially on pointe, it is something like an impetuous kiss that surprises one with its duration: full of moment, beyond words. Think of the dragonfly that pauses iridescently, its four wings more audible than visible, a vibration like that of a church organ. Weightless sonority, a hovering iridescence, the epiphany of a kiss—these are all forms of transport between the earthly and the unknown.

"A balance comes out of calm," a dancer told me recently. "You can't balance if you're nervous."

So satisfying balances emerge out of a dancer's well-being in the moment. They're like the "sweet spot" in tennis, a buoyancy that swells in from "the zone," and for the dancer they're bliss. For us, too. We want and admire these organic balances, emblematic of a flow so heightened, so resolved, it holds itself in mesmerizing suspension. That a measure of resolution can exist in the middle of ongoing motion is one more of those startling contradictions unique to ballet. I am reminded of an organ concert I attended at one of the old stone cathedrals of Paris—Saint-Eustache, where young Louis XIV received Communion. Sound seemed to hang in the air, subject to gravity, like fruit one might pick.

The most famous balances in the classical dance repertory belong to Aurora in *The Sleeping Beauty*. They come in

the Rose Adagio of act 1, when we meet the young princess at her sixteenth birthday party and she meets four suitors, each of whom dances with her a number of times, presenting her with rose after rose after rose after rose. The adagio is roughly five and a half minutes long, and high points are its four different displays of balance. In each of these displays Aurora balances four times. In all but the third display, the suitors, in sequence, help her set up each balance. (The Rose Adagio is one of the most consistent numbers in ballet, but from company to company there may be staging differences.)

The first balances, which open the adagio, are performed in a high développé à la seconde on pointe. The second set are performed in attitude—the pose of Mercury—on pointe. In the third set Aurora is on her own, stepping four times into an arabesque on pointe and then easing down off pointe into an arabesque penchée. The fourth set, the adagio's grand finale, again takes attitude on pointe, only this time each suitor, holding Aurora's hand, circles her slowly so that her attitude revolves a complete 360 degrees. Four circles in all. And each time, between letting go of one suitor's hand and taking the hand of the next, she strikes that balance in attitude. The stamina required is immense.

If you add up the balances (four sets of four), the final number is sixteen—Aurora's age, the number of candles on her cake. These fours give the Rose Adagio a structure of symmetry that frames sixteen instances of risk: Aurora's tests in the void.

Remember, Aurora has little momentum into these balances, almost no flow to the sweet spot. Sixteen times she

must find her balance for a nanosecond, a split second, a full second, an endless second. No matter how experienced the ballerina, in the Rose Adagio it is always the first time. And this is as it should be. It is the tenderness of the moment that matters most, not a steely resolve leading to a frozen balance of immodest length. The petals of an opening rose are fragile, untouched, and it is the delicate untouched-ness of the balance that is paramount—the flicker of the candles on this cake. Do not bemoan a performance because your Aurora flickered.

Between the transported balance and its effortful, I-did-it opposite, there is a more fragile and short-lived result, one we often see in the Rose Adagio, a balance that is not "on" at the start but is found, flashed, and released. These quick glimpses of vulnerability, naked and then, if only for half a second, clothed in that sheerest of all fabrics—balance!—bring us closer to a dancer. And for having caught the moment, and cared for it, we are brought closer to our own experience of seeing.

BALLERINA: CIVILIZATION IN A TUTU

*T*HE WORD "BALLERINA," ACCORDING TO THE *OXFORD English Dictionary*, originated in the late 1700s and was the feminine of *ballerino*, Italian for "dancing master," which descended from the Latin *ballare*, "to dance." More recent definitions include "a female ballet dancer" or "a principal female dancer in a ballet company." The word, one might say, dances about, never landing in a precise fifth position.

It is not incorrect, if we go by *Merriam-Webster*, to call a corps girl a ballerina, and we often hear the term blithely applied to anyone who wears pointe shoes. Yet the more one knows about the art of ballet the more reverence one brings to the word "ballerina," perhaps because it is the last vestige of those vaunted titles of yore—"prima ballerina" and

"prima ballerina assoluta"—mantles of esteem that were earned like a knighthood and bestowed by queen, country, or company director. Such titles are now defunct, having been replaced by the neutral "principal dancer." The Paris Opera Ballet is the exception to this rule, calling its principals *étoiles*, or "stars," but then, as the birthplace of ballet, France is a law unto itself. Today, no queen or committee is handing out diplomas in ballerina-dom. It is an invisible crown that comes to a dancer on invisible hands.

There always have been and always will be different views about which women are wearing that crown. In 2013, an article in the *New York Times* created a tempest among balletomanes when it attempted to define the American ballerina—"ornery, direct, unaffected"—as opposed to the idealized Old World model, and went on to state that at that particular moment there were "11 prodigious American young women dancing in six different American companies, who deserve to be called ballerinas." A correction was issued four days later when it turned out that one of the women had been born in England. Which goes to show how tricky it is simply to categorize ballerinas, let alone try to define one.[1]

Nevertheless, every little girl who has ever owned that classic jewelry box, the one that opens on a tiny ballerina in a pink tutu, spinning to music, has felt the meaning of the word, that this dancer is something more than the rest: a precious gem, a jewel of the culture. Certainly the first ballerinas, emerging in the early 1700s, were glittering prizes, often supported and protected by royalty, aristocrats, and men of high culture. Celebrities at home and abroad, these

women had a personal and financial freedom unique for their time and were the focus of aesthetic debate, romantic fantasy, and adoring fans. And so it continues today—the debates, the fantasies, the fans. In this final chapter we will come at our subject from various angles, moving between past and present, between the material and the immaterial, and weighing the weightless refractions that go to the making of a ballerina.

The Byerley Turk, the Darley Arabian, the Godolphin Arabian. Just as thoroughbred racing has its foundation stallions, we could say that the art of ballet has its foundation ballerinas: Françoise Prévost of the noble emotions; Marie Camargo and her spirited virtuosity; the dramatic naturalness of Marie Sallé. This is not a fanciful parallel—horses and dancers—but one that has cantered along for quite some centuries. Think of the half passes and flying changes of classical dressage. Look at the lordly white Lipizzaners of Vienna, with their catapulting "airs above the ground"—ballotades, caprioles, and courbettes. The equestrian *haute école* (high school) shares a syllabus with ballet and a past in the courts and courtyards of kings. The step *pas de cheval* (step of the horse), a pawing motion with a leggy reach and sweep, frisky and exact, is a fundamental exercise in ballet class.

Think, too, of Edgar Degas. Both the hot-blooded horse and the classical dancer were recurring subjects for this

nineteenth-century painter, an artist continuously drawn to configurations of sensuality, stress, and status, the anatomies of desire that hugged both the paddock and the ballet studio. During the years that Degas painted there was a group of rich men—"demi-gods of the Jockey Club," Marcel Proust called them in *The Guermantes Way*—who were a nexus between horses and dancers. They had boxes at the Paris Opera and a penchant for the fillies.

"A dancer is both the racehorse," Brigitte Lefèvre, former director of the Paris Opera Ballet, once said, "and its jockey."[2]

In the late 1960s, a rather whimsical photograph was taken on the track at the Saratoga Race Course. It was a publicity still for George Balanchine's ballet *Jewels*, which consisted of three movements—"Emeralds," "Rubies," and "Diamonds"—and premiered in 1967 at the New York City Ballet. Wearing white jeans and down on bended knee, George Balanchine is holding the hand of Suzanne Farrell, who is in arabesque on pointe, costumed in her white tutu from "Diamonds." Inches behind them a handsome white horse, possibly a Lipizzaner, stands at attention. The horse's rider, because he is dressed in black, disappears into the backdrop of dark trees, and this foregrounds the trinity in white: a small man, a large steed, and, sur la pointe, a creature who is also a creation.

Jewels is a ballet of medieval imagery woven into a neoclassical nervous system, a fantastical full-length tapestry filled with forests and castles, knights and chargers, enchanted states and morphing maidens. In "Diamonds,"

Diamonds

a declaration of courtly love in the tradition of Dante and Petrarch, Farrell was variously a unicorn, a swan, an isolated princess dancing in history's hall of mirrors, and a ballerina isolated by Balanchine's obsession with her. She was also a young woman with her own physical history: in the photo, the left pointe upon which she balances is not very arched because a horse had kicked that foot when Farrell was thirteen. This somewhat silly press shot is actually a portrait of something serious. Its architectural arrangement of limbs catches an array of meanings—symbolic, subliminal, spontaneously structured—that speak of indwelling associations, what might be called the ballerina's immanence.

The notion of immanence exists in many faiths and refers to a divine or spiritual presence that is manifested in the material world. As an honorific, divinity has always been granted to the greatest female stage artists: the divas of opera, actresses like "the divine Sarah" (Bernhardt) and La Duse (Eleonora Duse), and the ballerinas of classical dance. If, in our media-saturated world, there is little mystery left standing between the audience and the star, the ballerina still has her silence onstage. The devotional physicality of her art, the containment and the grace, the spontaneous associations—these are spiritual raiments. And while fans no longer unhitch horses so that they themselves may pull a ballerina's carriage through the streets, as was done in centuries past, they still understand that each new ballerina is an event, that each has taken the art into her body and made it her own. This is what ballerinas have been doing

since those eighteenth-century originals—Prévost, Camargo, and Sallé.

Examples? Here are three. In 1832, the moonflower Marie Taglioni danced *La Sylphide,* ushering the pointe into ballet and gauzy romanticism with it. In 1836, a rosy rival to Taglioni—a retort—arrived on the scene in the form of Fanny Elssler, a ballerina from Austria. "What fire! What voluptuousness!" swooned Théophile Gautier, who referenced antiquity when he called Elssler "the muse Terpsichore . . . exposing her thigh." The total antithesis of white-tulle Taglioni, Elssler brought a luscious vitality to the romantic realm. And in the late 1800s, as Mary Clarke and Clement Crisp tell us in their book *Ballerina: The Art of Women in Classical Ballet,* the momentous drama of the Italian ballerina Virginia Zucchi, a tragedienne who took St. Petersburg by storm in 1885, was such a revelation and so reignited ballet at the Mariinsky Theatre that "it is possible to trace a very clear link between Diaghilev's work and Zucchi's influence in Russia." Without Zucchi, the Ballets Russes, that crucible of twentieth-century ballet, might never have come into being.

Taglioni: the defining moment, woman and role forever fused. Elssler: the enlarging antithesis, the art stimulated and dilating. Zucchi: the unexpected catalyst, a shock to the norm. Events such as these lead like stepping stones through the centuries and see classical dance continually recalibrated by each new ballerina and those properties specific to her.

But what properties spell the difference between a beautiful dancer and a ballerina? For there are many beautiful dancers who don't wear the crown, and technical mastery in itself does not a ballerina make (ballet is not gymnastics in toe shoes). On countless occasions the ballyhoo for a new ballerina has been prelude to a specimen so meticulously correct, so statically textbook, that we seem to be seeing a technical demonstration devoid of song, a performance analogous to those long-stemmed roses that throw no fragrance. Why did the free spirit Isadora Duncan, who rejected ballet and couldn't do a proper tendu if her life depended on it, have such impact at the turn of the century? Because whatever else she was doing, it was *dancing*. Duncan was echoing the poet Shelley—"Make me thy lyre, even as the forest is." She was invested in the West Wind, not in a triple pirouette. She reminded classical dancers what their technique was for.

Natalia Makarova once asked the choreographer Antony Tudor, "What is the difference between a good dancer and a ballerina?" and he said, "Same thing, except the ballerina is much better. The ballerina is perfect." Makarova did *not* agree. "There's nobody perfect," she replied under her breath, this from the woman who was technically peerless during her prime in the 1970s. Watch Makarova on film— her 1976 *Swan Lake* or 1977 *Giselle*, both broadcast live from Lincoln Center—and you see how understated and unforced her dancing, sculptural yet not marble-hard, no, her line was molded like butter and as basic as breathing. And her phrasing wasn't beat-bound but a weather of en-

jambments, end lines that don't end but slow and drift and lift. Makarova does not push to raise a leg higher than everyone else's; her leg is often lower. It is Makarova's supporting leg that is visibly energized, a concentration that moves up through her core like heat and makes her poise more radiant, her enunciation more eloquent. She's not interested in sky-high extensions or in dancing that is a slick carapace of perfection. It is artful communication she seeks.[3]

Remember that. It isn't a contest up there onstage, though it can sometimes seem that dancers are trying to outdo one another in terms of higher and faster. I suggest you keep an eye out for who is giving *more*. More-charming virtuosity. More delicacy. More musically responsive phrasing. Feet with more feel. Arms and backs that are animated by something more than the textbook. Moves rond de jambe with more volume. More face placed before you, lit as if by gaslight even though gaslight is gone. (It's surprising how few dancers know how to show you their face.) More there-ness. Or more not-there-ness—more being lost in the moment. Do you see what I'm getting at? Let it hit you, whatever it is, the difference that catches your eye. Enjoy it. And then later ask yourself, *Why did I enjoy it? What made this dancing special?*

The ballerina has to be more because she must engage the spotlight and shoulder the responsibility that comes with it: carrying the ballet. She must project a presence so compelling that she banishes expectations to be other than she is. Or put another way, she has to be strong enough or seductive enough or strange enough to lead us astray from the ballerina(s) we already love. As Marie Taglioni wrote

to her protégé, the young Emma Livry, "Make people forget me; but do not forget me."[4]

In fact, a ballerina is often defined as much by what she is not as by what she is. With Suzanne Farrell, for instance, it took audiences and critics time to accept the ways in which she let loose. Her uniquely porous classicism—so open to atmospheric pressures in the music, so mutable— was not always correct in its proportions or its alignment, and yet her dancing could have the force of an annunciation, of solitude stirred and unfurled in a godly updraft. Complaints about the liberties Farrell took with technique were spot-on but also beside the point. When she was onstage, the elements were earth, water, air, and Farrell. Here was classical dancing of unprecedented transparency. And it was Made in America.

IN THE BBC ADAPTATION OF JOHN LE CARRÉ'S MASTER-piece of Cold War intrigue, *Tinker, Tailor, Soldier, Spy*, the double agent says, "I still believe the secret services are the only real expression of a nation's character." The Danish choreographer August Bournonville was in the same vein when he spoke of ballet as "an important factor in the spiritual development of the nation." We can reword le Carré's line from a performing arts perspective: ballerinas are the only real expression of a nation's character.[5]

This was powerfully true in the nineteenth century and through most of the twentieth, when ballet training was

a cloister in each country and characteristics of national style were exceedingly clear. Style is more permeable today, given glasnost and globalization, yet we still see differences in placement, in the arabesque and its primary positions, in theatrical scale, and in *épaulement* (shouldering, a nuanced angling of the bust that brings shading to a phrase). These differences are grown from the ground up, beginning with first position, and carefully cultured in a country's "school" of dancing.

How to categorize (and with apologies for generalizing)? The French: refinement touched with chic, a love of academic line glamorously drawn and not overly attentive to the music. The Danes: modesty and delight, an animate world wreathed in warmth and wit. The Russians: musicality pulled from the deep and projected upward from the bottom of the spine, with grandeur. The Italians: virtuosity, emotion, and more recently the smoky shadings known in painting as *sfumato*. The English: duty and decorum, delivered with a correct accent and respect for the golden mean. (In their classical style, Denmark and England share an ethic of containment that reads like a moral standard.) And latest to the game, the Americans: more athletic than aristocratic, a linear attack freer from history and its airlocks.

Around age sixteen or seventeen the girls emerge from the cloister, and as always in a group of like females—a convent, a sorority, a hive, a coven, a cult—there will be the mother superior, the head girl, the queen bee, the radical, the romantic: the ballerinas. Each finds her own path to that high perch, and once there she is not only a measure

of her company—the state of its art—she is also a signature of the state.

Take the twentieth-century Soviet ballerina Galina Ulanova. Awkward and underpowered when she debuted in 1928, she made a virtue of her lack of virtuosity, performing with diffidence, at a technical remove. She seemed, according to one critic, "to be dancing for herself . . . listening to herself." From this remove, however, she achieved almost sainted status in a career that began at the Mariinsky Theatre and continued postwar at the Bolshoi Ballet in Moscow, where she reigned until her retirement in 1962.[6]

Citing Ulanova's pale eyes and round peasant face, long arms and long feet, the English writer and photographer Cecil Beaton called her "the little sugar-mouse." With her instinct for the silent-movie moment and a girlish simplicity that projected to the steppes, she was a heroic little sugar-mouse, and she struck a universal chord. Ulanova's stark lyricism spoke to the old Russian soul while her trademark selflessness flattered the new Soviet state, which named her a Hero of Socialist Labour—twice.[7]

Over in England, during these midcentury decades, Margot Fonteyn was the magnetic center of the Royal Ballet. She had been since the company's fledgling days, when it was called the Vic-Wells Ballet (renamed Sadler's Wells Ballet in 1939 and the Royal Ballet in 1956). One-quarter Brazilian, hence her dark eyes and hair, she possessed a sensitivity and directness that read like truth. In a country famous for holding back its tears, the young Fonteyn, in the words of the English dancer and actor Sir Robert Helpmann, "had the cu-

rious quality of making you want to cry." Fonteyn's physical instrument, much commented on, was so pleasing in its ratio of foot to leg to torso that its sum of parts seemed classicism incarnate. Proportion matters to the English, and Fonteyn's proportions—in stillness, while moving—were right as rain. Holding fast between extremes, she was harmonious and stoic at once.[8]

"I always remember that supporting leg on *pointe*," fellow Royal Ballet dancer Annette Page said, "the wonderful pulled-up knees." The French ballerina Violette Verdy thought this pull-up was "one of the most beautiful things Margot had" and told Fonteyn biographer Meredith Daneman, "That 'pull' was the center of her discipline, her reserve; and whatever came out of it—be it a glance, or a turn of the cheek, or an inclination of the head—could be read as something of great importance and value."[9]

By the time Fonteyn danced Princess Aurora in the 1946 Sadler's Wells production of *The Sleeping Beauty*, at Covent Garden, she was figuratively twinned with England's heir presumptive, Princess Elizabeth, with whom there was a resemblance. That postwar *Beauty*, performed in a city that had been relentlessly bombed in 1940–1941, in a country that had been the first to hold fast against Hitler, and with Fonteyn as the embodiment of dawn after darkness, was a magisterial moment of tremendous cultural pull. The English were reminding the world that civilization itself is an art.

At the same time in America, a young dancer, the daughter of an Osage Indian and his Scotch-Irish wife, was refeathering the prevailing profile of the ballerina. Maria

Tallchief, born in Fairfax, Oklahoma, could have been a concert pianist. But she also studied ballet from an early age, and it was ballet she chose to pursue. Tallchief worked with Bronislava Nijinska in Los Angeles, danced in the ensemble of Agnes de Mille's breakthrough ballet, *Rodeo,* and then landed in the hands of George Balanchine, who was busy creating an indigenous form—American ballet—and whom she married in 1946. Taken with Tallchief's Native American heritage as well as her musicality, he retooled her technique to his own standard of full-out yet crisp classical dancing. In 1949, for the company he'd cofounded the previous year with Lincoln Kirstein—the New York City Ballet—and for Tallchief, he rechoreographed a Ballets Russes classic, *The Firebird.* It was the first great success of the New York City Ballet.

Not a melancholy swan but a magical bird plumed in crimson feathers—the only creature of its kind—Tallchief emerged, Kirstein writes, "as the nearest approximation to a prima ballerina we had yet enjoyed." Americans embraced their homegrown ballerina. Her proud bearing and Osage-Irish exoticism was a New World answer to the old paradigm of the Russian ballerina. Just as the Petipa-Tchaikovsky *Sleeping Beauty* of 1890 planted the czar's flag on a French art form, so this 1949 *Firebird* seemed to say that America had now captured the flame of classical dance. The role itself spoke to Tallchief's ancestry, the nature myths of Native Americans, the simmering inner fire. Her glinting virtuosity and immaculate pointe work brought down the house. And to see her performing the ballet's berceuse (lullaby)—it

exists on film, Tallchief in practice clothes—is to see the feathered being sinking into its own spell. In this soliloquy of traveling bourrées, pointes pulsing almost imperceptibly, Tallchief's Firebird draws all into its deep-woods trance. She seems to float upon large languorous ripples born between her shoulder blades, softly surging through her arms and fingertips, quieting, lulling, making the air heavy with sleep. This is virtuosity turned inward, a slowed-down heart in a glade of solitude.[10]

WHEN YOU FIRST START GOING TO THE BALLET, YOU WILL accept that the women in leading roles must be ballerinas. But as time goes by you will begin to notice that some women don't carry the ballet, to *your* mind, as well as others. You will develop your own answer to the subjective question of what makes a ballerina.

Some look for command. When I asked Arnold Goldberg, the longtime timpanist of the New York City Ballet Orchestra, what the audience loved about Tallchief, he said, "As soon as the curtain went up and you saw Maria—*wow.* That was the feeling. I think the most important thing was her stature. The way she stood." That's what's known as authority.[11]

Others in the audience want Helen of Troy, a face that launches ships. "It must not be forgotten," writes Gautier, "that the first quality a dancer should possess is that of beauty." And here we dovetail into the matter of taste. On

Terpsichore, Muse of Dance

more than one occasion I've heard it said, by balletomanes of long experience, that yes, this or that ballerina is a wonderful technician, but she just isn't attractive enough. Some ballerinas won't send you, and that's okay. But remember, at the ballet, beauty is an open question in continuous play, and it is most eloquently achieved through artistry. We need only return to Ulanova, her big head and short neck. She used that neck like a trunnion, flinging her large plain face to the light, trusting her unglamorous but oh so Slavic and suddenly pearlescent face to the audience, putting her heartbeat in its hands.[12]

Fans may also point to the aura or atmosphere that attends the ballerina, the perfume or poetry of her inflections—usually the result of a port de bras that envelops her in a stole of whispers and projects a larger capacity for feeling. Whether or not these women also have technical strength is not always important. The afterimage of the atmospheric can have permanent staying power.

The ballerina Gillian Murphy, in an essay she wrote for *Pointe* magazine, thought offstage qualities were relevant. Her ideal ballerina was "someone whose depth of character and generosity of spirit makes her a leader not only in her performances but in class and in the rehearsal process." Does character offstage make itself felt onstage? This is a riddle as thorny as the brambles in *The Sleeping Beauty*. A Carabosse offstage can be a Lilac in the limelight.[13]

There are still others who look for something they've never seen before: new adventures within classical structures, a prodigal music of tides and undertows, a relationship

with energy that is the dancer's alone. This is where a ballerina breathes and blossoms. She goes beyond the others to make a language of ballet, not a language of words but of visions. When she is onstage you see more because she shows more—concentration, transformation, illumination, connection. Anna Pavlova, probably the most influential ballerina in history, toured the world in a short solo of shimmering pathos called *The Dying Swan*. Choreographed for her in 1905 by Mikhail Fokine, it was a transubstantiation of arabesques and bourrées that put the swan on an invisible cross and made of ballet, for three trembling, tremulous minutes, a sacrament—body and blood—and a passion.

More than half a century before Pavlova took the stage, the transcendentalist Ralph Waldo Emerson and the feminist Margaret Fuller went to see a performance by Fanny Elssler, who toured America and Cuba from 1840 to 1842. Fuller turned to Emerson and said, "Waldo, this is poetry!" He replied, "Margaret, this is religion!" The story, much circulated in periodicals of the day, is sometimes said to be apocryphal. But in his journal entry of October 1841, when Emerson describes his impressions of Elssler, whom he calls "this graceful, silvery swimmer," he again touches the religious and conjures the congregation. "Her charm for the house is that she dances for them or they dance in her," he writes. "We must be expressed."[14]

Back in the 1970s, discussing a big star at a rival company, a ballerina in everyone's book, George Balanchine said that he'd had the chance to hire her but didn't. Asked to

explain why, he said that this woman was wonderful dancing with others, in a pas de deux or an ensemble, but that he wasn't interested in seeing her dance alone. Simple as that. Something—the beyond, perhaps—was beyond her.

Seeing her dance alone.

King Louis XIV, ruler of France, exalted and emboldened the art of classical dance so that it proclaimed he ruled the universe too. But the vaults and waters of ballet belong to its ballerinas. From breast to pelvis to pointe, she alone contains the world entire. She is the artist and artwork as one. The light-winged nightingale and the emperor's golden bird as one. Horse and rider. Abbess and empress. Nature and culture. As one. She is music, sculpture, poetry, power, theater, and silence. Her own body and the body of every ballerina before her—one.

fini

ACKNOWLEDGMENTS

I WOULD FIRST LIKE TO EXPRESS MY GRATITUDE TO two revered colleagues, the critic Don Daniels and the historian Elizabeth Kendall, each of whom has inspired me for many years. Don and Elizabeth both read the first finished draft of this book and offered suggestions that improved it, a generosity I will always remember.

My thanks to musicians Arnold Goldberg and David La-Marche for their insights into both score and stage, and to my close friends, the deeply knowledgeable critics Matthew Gurewitsch and Joel Lobenthal.

I am delighted that the voices of Alessandra Ferri, Sara Mearns, Veronika Part, Heather Watts, and Deborah Wingert are part of this book. Each speaks eloquently of the art form.

Acknowledgments

Late friends and mentors were very much with me while I wrote: David Daniel, Anita Finkel, and Francis Mason. Of the adored Vadim Strukov, who died just before I began work on this book, I can only say how often I wanted his wisdom.

Early readers in the non-dance world, to whom I am indebted, include my brilliant best friend Lucinda Ballantyne, whose excitement from chapter to chapter helped carry me forward, and my godson Paul LaFreniere. My sister Caryn Jacobs offered invaluable editing at many stages and thrilling votes of confidence.

Working with Jessica Roux, whose illustrations for this book are charm incarnate, was wonderful from beginning to end. There is nothing like collaboration when it is easygoing and like-minded, and that describes my experience with the talented Jessica.

To the team at Basic Books—Katy O'Donnell, who chose me to write this book; Leah Stecher, who guided the manuscript into final form; Nicole Caputo, for her beautiful book jacket design; Roger Labrie, Erin Granville, and Stephanie Summerhays, who fine-tuned my prose; and Lara Heimert, leading the way—thank you all for helping me to realize this challenging assignment.

A big brava to Alice Martell, my "agent assoluta," who always performs with such aplomb. And to my husband, James Wolcott, who was there to answer any question, any worry, and to give the green light to every chapter, my love.

NOTES

Chapter One: First Position First: The Foundations of Ballet

1. Akim Volynsky, "The Book of Exaltations: The ABCs of Classical Dance" (1925) in *Ballet's Magic Kingdom: Selected Writings on Dance in Russia, 1911–1925*, trans. and ed. Stanley J. Rabinowitz (New Haven, CT: Yale University Press, 2008), 161.

2. Agnes de Mille, *Dance to the Piper* (Boston: Little, Brown and Company, 1951), 47.

3. Pierre Rameau, *The Dancing Master*, trans. Cyril W. Beaumont (1931; repr. Hampshire, UK: Dance Books, Ltd., 2003), xii.

4. Jennifer Homans, *Apollo's Angels* (New York: Random House, 2010), 3–4. The first chapter in this history of ballet beautifully sets out the origins and ideals of classical dance.

5. In a talk given at the Bard Graduate Center Gallery in April 2015, before the opening of his exhibition *Fashioning the Body: An Intimate History of the Silhouette*, Denis Bruna, the curator in fashion and textiles at the Musée des Arts Décoratifs in Paris and professor in fashion history at the École du Louvre, discussed the nobility of the upper body versus the ignoble lower body, a high-low dichotomy in seventeenth- and eighteenth-century thought and dress. In the book that

Notes

accompanied the exhibition—Denis Bruna, ed., *Fashioning the Body: An Intimate History of the Silhouette* (New Haven, CT: Yale University Press, 2015)—facts about posture and extreme corseting come from Anne-Cécile Moheng's chapter, "Whalebone Stays and Panniers: The Mechanics of Good Carriage in the Eighteenth Century," page 120.

6. Aurore Pierre, "From the Doublet to the Justaucorps: A Man's Silhouette in the Seventeenth and Eighteenth Centuries," in *Fashioning the Body*, 95. Writing of seventeenth- and eighteenth-century men at court, Pierre notes that "intelligence was often valued less by the aristocracy than other qualities such as deportment, a good figure, or good manners. The game of posturing, studied gestures, and perfect carriage trumped all others. Many men devoted themselves to their looks, developing a true 'art of appearance.'"

7. Lincoln Kirstein, "Ballet Alphabet" (1939) in *Ballet: Bias and Belief* (New York: Dance Horizons, 1983), 359.

8. Volynsky, "The Book of Exaltations," 146.

9. In 1913, when George Balanchine was accepted into the Imperial Theater School, the czar ruled Russia. But after the Russian Revolution (1917), which saw the monarchy routed, the school's name changed many times. In 1921, the year that Balanchine graduated, it was called the Petrograd State Theater (Ballet) School. In 1957 it was renamed the Vaganova Ballet Academy.

10. Interview with the author, New York City, June 11, 2015.

11. "All leg movements": Lincoln Kirstein and Muriel Stuart, *The Classic Ballet: Basic Technique and Terminology* (1952; repr. New York: Alfred A. Knopf, 1973), 32; "a kind of net or comb": Kirstein, "Ballet Alphabet," 357.

12. Lincoln Kirstein, *Thirty Years: Lincoln Kirstein's the New York City Ballet* (New York: Alfred A. Knopf, 1978), 40.

13. George Balanchine and Francis Mason, *Balanchine's Complete Stories of the Great Ballets* (1954; repr. New York: Doubleday & Company, Inc., 1977), 532. Dancers through the generations have spoken of *Serenade*'s enigma and its atmosphere of threat. In Francis Mason's *I Remember Balanchine* (New York: Doubleday, 1991), page 7, Alexandra Danilova says, "I, the girl on the floor, was pitied by the man, but

228

I was a frivolous girl who had one affair after another. Then I was left alone." And in the same book, page 160, Ruthanna Boris says, "I felt more and more strongly that it showed a pattern in Balanchine's life: a figure comes in and all the configurations change. That figure initiates the change but does not participate in it. . . . In the end she's the one that goes to heaven." Suzanne Farrell, in her autobiography *Holding On to the Air* (New York: Summit Books, 1990), page 59, writes that the ballet's "movements represent forces, energies, and these energies are disturbed, whirling." And Jenifer Ringer, in the galley of her memoir *Dancing Through It* (New York: Viking, 2014), began the prologue with a line describing *Serenade:* "There is a ballet that is like an ocean: it seems to stretch beyond the horizons of the stage and hides invisible mysteries beneath the currents that sweep dancers from calm pools to rushing vortexes." This line was edited out of the book's final version.

14. Author's phone interview with Robert Weiss, the artistic director of the Carolina Ballet and a former principal dancer with the New York City Ballet, July 21, 2014.

Chapter Two: The Point of the Pointe

1. Quoted in Laura Jacobs, "*The Red Shoes* Revisited," *The Atlantic Monthly*, December 1993, 129–133.

2. "An expert could tell you": Quoted in Kirstein, "Ballet Alphabet," 354.

3. Edwin Denby, "About Toe Dancing," in *Dance Writings*, eds. Robert Cornfield and William Mackay (New York: Alfred A. Knopf, 1986), 143–144.

4. Lincoln Kirstein, *Movement and Metaphor* (New York: Praeger Publishers, 1970), 82.

5. Carlo Blasis, *The Code of Terpsichore* (1828; repr. Alton: Dance Books, 2008), 53.

6. Théophile Gautier, *The Romantic Ballet as Seen by Théophile Gautier, 1837–1848*, trans. Cyril W. Beaumont (New York: Books for Libraries, 1980), 73.

7. Volynsky, "The Book of Exaltations," 136.

8. Ibid., 136–137.

9. Avelin A. Malyango, *A Re-examination of the Functional Relationships of the Olduvai Hominid (OH) 8 Foot from Olduvai Gorge, Tanzania* (MA thesis, New York University, 1996). The *Homo habilis* OH 8 foot, 1.8 million years old, is the earliest foot fossil to show a longitudinal arch as well as the structural changes that stabilized the ankle and aligned the toes.

Chapter Three: Reading the Program: A Glossary

1. Homans, *Apollo's Angels*, 112–113.

2. "There always was": Jerome Robbins, "Jerome Robbins: Something to Dance About," *American Masters*, directed by Judy Kinberg (February 18, 2009; New York: PBS), TV; "This is very interesting": Christine Conrad, *Jerome Robbins: That Broadway Man, That Ballet Man* (London: Booth-Clibborn Editions, 2000), 177.

3. Roland John Wiley, *Tchaikovsky's Ballets: "Swan Lake," "Sleeping Beauty," "Nutcracker"* (New York: Oxford University Press, 1985), 373.

4. *American Ballet Theatre: A Close-Up in Time*, documentary, directed by Jerome Schnur (1973; New York: Thirteen/WNET), TV.

5. "Rudolf Nureyev and Margot Fonteyn, The Perfect Partnership," Rudolf Nureyev Foundation, n.d., www.nureyev.org/rudolf-nureyev -biography-margot-fonteyn/.

Chapter Four: Tchaikovsky, Godfather of Ballet

1. Hans Hofmann, "The Search for the Real in the Visual Arts," in *Search for the Real and Other Essays*, revised ed., ed. Sara T. Weeks and Bartlett H. Hayes Jr. (Cambridge, MA: MIT Press, 1967), 45.

2. "too capricious": Review in the *St. Petersburg News*, quoted in Roland John Wiley, *Tchaikovsky* (New York: Oxford University Press, 2009), 101; Nikolay Kashkin is quoted in Wiley, *Tchaikovsky*, 102; "Had I known": Tchaikovsky's appraisal of Léo Delibes's ballet *Sylvia*, a score that bowled him over and made him doubt his own *Swan Lake*, was a sentiment he expressed in writing to many friends, including Kashkin

and Nadezhda von Meck. See Wikipedia, s.v. "Léo Delibes," last modified October 9, 2017, 14:25, https://en.wikipedia.org/wiki/L%C3%A9o_Delibes; see also Wikipedia, s.v. "Sylvia (ballet)," last modified September 15, 2017, 10:41, https://en.wikipedia.org/wiki/Sylvia_(ballet).

3. Wiley, *Tchaikovsky*, 346.

4. Ivanov is quoted in ibid., 371.

5. Quoted in Solomon Volkov, *Balanchine's Tchaikovsky: Interviews with George Balanchine* (New York: Simon & Schuster, 1985), 131.

6. Alexander Poznansky, *Tchaikovsky: The Quest for the Inner Man* (New York: Schirmer Books, 1991), 57.

7. Ralph Waldo Emerson, "VIII. Beauty," in *The Conduct of Life*, paragraph 13, www.bartleby.com/90/0608.html.

8. Poznansky, *Tchaikovsky: The Quest for the Inner Man*, 107.

9. "*is* the tree": Balanchine is quoted in Nancy Reynolds, *Repertory in Review: 40 Years of the New York City Ballet* (New York: Dial Press, 1977), 157; "All the soarings": Rainer Maria Rilke, *Letters of Rainer Maria Rilke, 1910–1926*, trans. Jane Bannard Greene and M. D. Herter Norton (New York: W. W. Norton & Company, 1947), 255.

Chapter Five: Arabesque, Above All

1. Volynsky, "The Book of Exaltations," 191.

2. Rollo Myers, *Erik Satie* (London: Dobson, 1948), 71.

3. Sir Frederick Ashton, "A Night at the Joffrey," *Great Performances: Dance in America*, produced and directed by Judy Kinberg and Thomas Grimm (April 28, 1989; New York: WNET and Danmarks Radio), TV, https://www.youtube.com/watch?v=j0ppAEMpaVQ.

4. Ibid.

5. Alexander Simmons, *Erik Satie's Trois Gnossiennes in the French Fin de Siècle* (PhD diss., University of Birmingham, 2013), 79–81.

6. Jann Pasler, *Composing the Citizen: Music as Public Utility in Third Republic France* (Berkeley: University of California Press, 2009), 541–543.

7. T. E. Lawrence to Eric Kennington (letter dated October 27, 1922), T. E. Lawrence Studies, http://www.telstudies.org/writings/letters/1922/221027_kennington.shtml.

Notes

Chapter Six: Thoughts on Perfection

1. Homans, *Apollo's Angels*, 6.
2. Interview with the author, New York City, 2015.
3. Interview with the author, New York City, December 16, 2014.
4. Interview with the author, New York City, January 6, 2015.
5. Interview with the author, New York City, May 19, 2016. The ballerina Tanaquil Le Clercq (1929–2000) was the last wife of George Balanchine. An exemplar of his emerging neoclassical style, she was known for her sophistication and wit. Le Clercq's performing career was cut short by polio in 1956. She went on to teach and coach ballet.
6. Interview with the author, New York City, July 19, 2017.
7. Interview with the author, New York City, February 18, 2017.
8. Randall Jarrell, "Some Lines from Whitman," accessed November 17, 2017, http://www.english.upenn.edu/~perelman/classes/english088/rj_somelinesfromwhitman.html.

Chapter Seven: She's Alive!

1. Adam is quoted in Cyril W. Beaumont, *The Ballet Called Giselle* (1944; repr. Hampshire, UK: Dance Books, Ltd., 2011), 23.
2. Ibid.,103.
3. Heine is quoted in Violette Verdy, *Giselle: A Role for a Lifetime* (New York: Marcel Dekker, Inc., 1977), 73.
4. Quoted in Bessel van der Kolk, *The Body Keeps the Score* (New York: Penguin Books, 2015), 183. Lincoln Kirstein, on page 23 of the book *Portrait of Mr. B: Photographs of George Balanchine* (New York: Viking Press, 1984), makes a fascinating observation about the female corps and the uses of Wili-like anger. "As much as half the force and efficiency of a supporting corps is fueled as much by resentment as by ambition," he writes. "Fury at failure to advance or achieve a desired status is not negligible as a source of negative energy."
5. "Fantômes" is quoted in Beaumont, *The Ballet Called Giselle*, 20.

232

6. We know that Charlotte Brontë knew something of ballet. She gives Rochester a former mistress, Céline Varens, who is described as "a French opera-dancer."

7. Laura Jacobs, "To Be Giselle," *Stagebill*, May 1998, 12.

8. Akim Volynsky, "Reviews and Articles," in *Ballet's Magic Kingdom*, 56.

9. Gennady Smakov, *The Great Russian Dancers* (New York: Alfred A. Knopf, 1984), 154.

Chapter Eight: Round and Round

1. Kirstein, *Movement and Metaphor* (New York: Praeger Publishers, 1970), 29.

2. Michael Langlois, "A Conversation with Gillian Murphy," *Ballet Review* 44, no. 2 (Summer 2016), 44–56.

3. Volynsky, "The Book of Exaltations," 191.

Chapter Nine: Sex and the Single Girl

1. Stark Young, "Note on Nijinsky and Robert Edmond Jones," in *Nijinsky: An Illustrated Monograph*, ed. Paul Magriel (New York: Henry Holt and Company, 1946), 65.

2. Quoted in Sjeng Scheijen, *Diaghilev: A Life* (New York: Oxford, 2009), 170.

3. S. L. Grigoriev, *The Diaghilev Ballet: 1909–1929* (1953; repr. London: Penguin Books, 1960), 89; Cyril W. Beaumont, *Vaslav Nijinsky* (London: Wyman and Sons, 1932), 19.

4. Charles M. Joseph, *Stravinsky's Ballets* (New Haven, CT: Yale University Press, 2011), 80.

5. Igor Stravinsky and Robert Craft, *Expositions and Developments* (1962; repr. Berkeley: University of California Press, 1981), 147–148.

6. Count Harry Kessler, *Journey to the Abyss: The Diaries of Count Harry Kessler, 1880–1918*, ed. and trans. Laird M. Easton (New York: Alfred A. Knopf, 2011), 619.

7. "the tyranny of this rhythm": Quoted in Minna Lederman, ed., *Stravinsky in the Theatre* (1949; repr. New York: Da Capo Press, Inc., 1975), 31; "The composer has written": Quoted in Morris Eksteins, *Rites of Spring* (1989; repr. Boston/New York: Mariner Books, 2000), 52; "a biological ballet": Quoted in Richard Buckle, *Nijinsky: A Life of Genius and Madness* (1971; repr. New York: Pegasus Books, 2012), 356.

8. Vaslav Nijinsky, *The Diary of Vaslav Nijinsky: Unexpurgated Edition*, ed. Joan Acocella, trans. Kyril FitzLyon (New York: Farrar, Straus and Giroux, 1999), 170.

9. *American Ballet Theatre: A Close-Up in Time.*

10. Wikipedia, s.v. "Jackson Pollock," last modified November 15, 2017, 16:08, https://en.wikipedia.org/wiki/Jackson_Pollock.

11. "Lucia Davidova," in *I Remember Balanchine*, ed. Francis Mason (New York: Doubleday, 1991), 132.

12. George Bernard Shaw, *Pygmalion* (1913), act V, line 254.

Chapter Ten: Ballet Is Woman—But Look at Its Men!

1. "Balanchine was fascinated": Suki Schorer, "Profile: The School of American Ballet," NYC-ARTS (May 17, 2012; New York: Thirteen/WNET), TV; "Ballet is woman": In an article titled "Balanchine Said" in *The New Yorker* (January 26, 2009), the dance critic Arlene Croce discusses the sources of some of Balanchine's most famous sayings.

2. Quoted in Arlene Croce, *Going to the Dance* (New York: Alfred A. Knopf, 1982), 60.

3. "jump from place to place": Beaumont, *The Ballet Called Giselle*, 28–29.

4. Beaumont, *Vaslav Nijinsky*, 28.

5. Quoted in Smakov, *The Great Russian Dancers*, 212.

6. Quoted in Scheijen, *Diaghilev: A Life*, 235.

7. Carl Van Vechten, "The Russian Ballet and Nijinsky," in *Nijinsky: An Illustrated Monograph*, ed. Paul Magriel (New York: Henry Holt and Company, 1946), 7–9.

8. Quoted in Smakov, *The Great Russian Dancers*, 214.

9. Edwin Denby, "Notes on Nijinsky Photographs," in *Nijinsky: An Illustrated Monograph*, 18.

10. Quoted in Julie Kavanagh, *Nureyev: The Life* (New York: Pantheon Books, 2007), 122.

11. Walter Terry, *Great Male Dancers of the Ballet* (New York: Anchor Press/Doubleday, 1978), 35.

12. "I wanted to be *everything* onstage": Kavanagh, *Nureyev: The Life*, 15; "I will be the number one": Rudolf Nureyev, "Nureyev: The Russian Years," *Great Performances*, produced by John Bridcut (August 29, 2007; New York: BBC in association with Thirteen/WNET), TV.

13. Quoted in Barbara Rowes, "Baryshnikov Has the Publicity," *People*, May 21, 1979.

Chapter Twelve: Ballerina: Civilization in a Tutu

1. Alastair Macauley, "All-American Goddesses," *New York Times*, July 5, 2013.

2. *La Danse: Le Ballet de L'Opera de Paris*, documentary, directed by Frederick Wiseman (2009; Cambridge, MA: Zipporah Films), film.

3. Natalia Makarova and Antony Tudor, "Program 1: Body and Soul," *Ballerina*, documentary, directed by Derek Bailey (1987; Great Britain: BBC-TV), TV.

4. Mary Clarke and Clement Crisp, *Ballerina: The Art of Women in Classical Ballet* (Princeton, NJ: Princeton Book Company Publishers, 1988), 49.

5. "an important factor": Quoted in ibid., 9.

6. Quoted in Smakov, *The Great Russian Dancers*, 28.

7. Cecil Beaton, *The Face of the World* (London: Weidenfeld and Nicolson, 1957), 159.

8. Quoted in Meredith Daneman, *Margot Fonteyn: A Life* (New York: Penguin Books, 2004), 1.

9. "I always remember" and "one of the most beautiful things": Quoted in ibid., 283.

10. Kirstein, *Thirty Years*, 106.

11. Interview with the author, New York City, August 18, 2014.

12. Gautier, *The Romantic Ballet*, 23.

13. Gillian Murphy, "A 'Ballerina' Is . . . ", *Pointe*, December 2013/ January 2014, 72.

14. Ralph Waldo Emerson, *Ralph Waldo Emerson: Selected Journals 1841–1877*, ed. Lawrence Rosenwald (New York: Library of America, 2010), 44.

BIBLIOGRAPHY

Balanchine, George, and Francis Mason. *Balanchine's Complete Stories of the Great Ballets*. 1954. Reprint. New York: Doubleday & Company, Inc., 1977.

Beaton, Cecil. *Ballet*. New York: Doubleday & Company Inc., 1951.

———. *The Face of the World*. London: Weidenfeld and Nicolson, 1957.

Beaumont, Cyril William. *The Ballet Called Giselle*. 1944. Reprint. Hampshire, UK: Dance Books, Ltd., 2011.

———. *Vaslav Nijinsky*. London: Wyman & Sons, Ltd., 1932.

Blasis, Carlo. *The Code of Terpsichore*. 1828. Reprint. Alton, UK: Dance Books Ltd, 2008.

Brophy, Brigid. *Mozart the Dramatist*. 1964. Reprint. New York: Da Capo Press, 1999.

Bruna, Denis, ed. *Fashioning the Body: An Intimate History of the Silhouette*. New Haven, CT: Yale University Press, 2015.

Buckle, Richard. *Nijinsky*. 1971. Reprint. New York: Pegasus Books, 2012.

Chazin-Bennahum, Judith. *The Ballets of Antony Tudor: Studies in Psyche and Satire*. New York: Oxford University Press, 1994.

Chujoy, Anatole, and P. W. Manchester. *The Dance Encyclopedia*. New York: Touchstone, 1967.

Bibliography

Clarke, Mary, and Clement Crisp. *Ballerina: The Art of Woman in Classical Ballet*. Princeton, NJ: Princeton Book Company Publishers, 1988.

Conrad, Christine. *Jerome Robbins: That Broadway Man, That Ballet Man*. London: Booth-Clibborn Editions, 2000.

Croce, Arlene. *Afterimages*. New York: Alfred A. Knopf, 1977.

———. *Going to the Dance*. New York: Alfred A. Knopf, 1982.

Daneman, Meredith. *Margot Fonteyn: A Life*. New York: Penguin Books, 2004.

de Mille, Agnes. *Dance to the Piper*. Boston: Little, Brown and Company, 1951.

Denby, Edwin. *Dance Writings*. Edited by Robert Cornfield and William Mackay. New York: Alfred A. Knopf, 1986.

Eksteins, Modris. *Rites of Spring: The Great War and the Birth of the Modern Age*. 1989. Reprint. Boston: Houghton Mifflin Company, 2000.

Emerson, Ralph Waldo. *Ralph Waldo Emerson: Selected Journals 1841–1877*. Edited by Lawrence Rosenwald. New York: Library of America, 2010.

Farrell, Suzanne. *Holding On to the Air*. New York: Summit Books, 1990.

Garafola, Lynn. *Diaghilev's Ballets Russes*. 1989. Reprint. New York: Da Capo Press, 1998.

Gautier, Théophile. *The Romantic Ballet as Seen by Théophile Gautier, 1837–1848*. Translated by Cyril W. Beaumont. New York: Books for Libraries, 1980.

Grant, Gail. *Technical Manual and Dictionary of Classical Ballet*. 1950. Reprint. New York: Dover Publications, Inc., 1967.

Haskell, Arnold. *Ballet: A Complete Guide to Appreciation*. Harmondsworth, Middlesex, UK: Penguin Books Limited, 1938.

———. *Prelude to Ballet*. London: Thomas Nelson & Sons Ltd., 1947.

Homans, Jennifer. *Apollo's Angels: A History of Ballet*. New York: Random House, 2010.

Joseph, Charles M. *Stravinsky's Ballets*. New Haven, CT: Yale University Press, 2011.

Kavanagh, Julie. *Nureyev: The Life*. New York: Pantheon Books, 2007.

Kendall, Elizabeth. *Balanchine and the Lost Muse: Revolution and the Making of a Choreographer*. New York: Oxford University Press, 2013.

————. *Where She Danced*. New York: Alfred A. Knopf, 1979.

Kessler, Count Harry. *Journey to the Abyss: The Diaries of Count Harry Kessler, 1880–1918*. Edited and translated by Laird M. Easton. New York: Alfred A. Knopf, 2011.

Kirkland, Gelsey, with Greg Lawrence. *Dancing on My Grave*. New York: Doubleday & Company, Inc., 1986.

Kirstein, Lincoln. *Ballet: Bias and Belief*. New York: Dance Horizons, 1983.

————. *Movement and Metaphor: Four Centuries of Ballet*. New York: Praeger Publishers, 1970.

————. *Portrait of Mr. B: Photographs of George Balanchine with an Essay by Lincoln Kirstein*. New York: The Viking Press, 1984.

————. *Thirty Years: Lincoln Kirstein's The New York City Ballet*. New York: Alfred A. Knopf, 1978.

Kirstein, Lincoln, and Muriel Stuart. *The Classic Ballet: Basic Technique and Terminology*. 1952. Reprint. New York: Alfred A. Knopf, 1973.

Lederman, Minna, ed. *Stravinsky in the Theatre*. 1949. Reprint. New York: Da Capo Press, 1975.

Levinson, André. *Marie Taglioni*. 1929. Translated by Cyril W. Beaumont, 1930. Reprint. Hampshire, UK: Noverre Press, 2014.

Lobenthal, Joel. *Alla Osipenko: Beauty and Resistance in Soviet Ballet*. New York: Oxford University Press, 2016.

Magriel, Paul, ed. *Nijinsky: An Illustrated Monograph*. New York: Henry Holt, 1946.

Markova, Alicia. *Giselle and I*. New York: Vanguard Press, Inc., 1960.

Mason, Francis, ed. *I Remember Balanchine: Recollections of the Ballet Master by Those Who Knew Him*. New York: Doubleday, 1991.

Myers, Rollo. *Erik Satie*. London: Dobson, 1948.

Nijinsky, Vaslav. *The Diary of Vaslav Nijinsky: Unexpurgated Edition*. Edited by Joan Acocella. Translated by Kyril Fitzlyon. New York: Farrar, Straus and Giroux, 1999.

Pasler, Jann. *Composing the Citizen: Music as Public Utility in Third Republic France*. Berkeley: University of California Press, 2009.

Poznansky, Alexander. *Tchaikovsky: The Quest for the Inner Man*. New York: Schirmer Books, 1991.

Bibliography

Rameau, Pierre. *The Dancing Master*. 1725. Translated by Cyril W. Beaumont, 1931. Reprint. Hampshire, UK: Dance Books, Ltd., 2003.

Reynolds, Nancy. *Repertory in Review: 40 Years of the New York City Ballet*. New York: Dial Press, 1977.

Scheijen, Sjeng, *Diaghilev: A Life*. New York: Oxford University Press, 2009.

Schonberg, Harold C. *The Lives of the Great Composers*. New York: W. W. Norton & Company, Inc., 1970.

Schorer, Suki. *Suki Schorer on Balanchine Technique*. New York: Alfred A. Knopf, 1999.

Smakov, Gennady. *The Great Russian Dancers*. New York: Alfred A. Knopf, 1984.

Tallchief, Maria, with Larry Kaplan. *Maria Tallchief: America's Prima Ballerina*. New York: Henry Holt, 1997.

Taper, Bernard. *Balanchine*. 1984. Reprint. Berkeley: University of California Press, 1996.

Terry, Walter. *Great Male Dancers of the Ballet*. New York: Anchor Books, 1978.

Vaganova, Agrippina. *Basic Principles of Classical Ballet: Russian Ballet Technique*. 1946. Reprint. New York: Dover Publications, Inc., 1969.

van der Kolk, Bessel. *The Body Keeps the Score*. New York: Penguin Books, 2015.

Verdy, Violette. *Giselle: A Role for a Lifetime*. New York: Marcel Dekker, Inc., 1977.

Villella, Edward, with Larry Kaplan. *Prodigal Son*. New York: Simon & Schuster, 1992.

Volkov, Solomon. *Balanchine's Tchaikovsky: Interviews with George Balanchine*. New York: Simon & Schuster, 1985.

Volynsky, Akim. *Ballet's Magic Kingdom: Selected Writings on Dance in Russia, 1911–1925*. Translated and edited by Stanley J. Rabinowitz. New Haven, CT: Yale University Press, 2008.

Wiley, Roland John. *Tchaikovsky*. New York: Oxford University Press, 2009.

———. *Tchaikovsky's Ballets: "Swan Lake," "Sleeping Beauty," "Nutcracker."* New York: Oxford University Press, 1985.

INDEX

Index

choreographers *(continued)*
 Taglioni, "Ballet of the Nuns,"
 132–133
 Taglioni, *La Sylphide*, 29, 35–39,
 67, 133, 134, 211
 Tchaikovsky, 80
 Tharp, *Push Comes to Shove*, 65,
 196
 Tudor, *Jardin aux Lilas* (Lilac
 Garden, 1936), 167–168
 Tudor, *Pillar of Fire* (1942),
 170–173
 Wheeldon, 176
 See also Balanchine, George;
 Fokine, Mikhail; Nijinsky,
 Vaslav
"Choreography" (Berlin), 63
Chosen Maiden, The *(Le Sacre du
 Printemps)*, 157–158, *159*,
 162–164
Chujoy, Anatole, 8, 11, 101
Clarke, Mary, 211
classical training, 2, 12–13,
 21–22, 91
classicism, 15, 113–114, 172, 194,
 214, 217
 American, 22, 214
 Le Sacre du Printemps breaks
 from, 157, 160, 164, 167
Cléopâtre (1909), 114
Clercq, Tanaquil Le, 124, 175,
 232n5
Code of Terpsichore, The (Blasis), 104
color, 28, 53, 78, 81
Conduct of Life, The (Emerson), 92
Copland, Aaron, 65, 174
Coppelia (Delibes), 82
Coralli, Jean, 138–140
 See also Giselle (1841)

Corella, Angel, 197
Cornejo, Herman, 197
corps de ballet, 51–56, *54*
 male dancers and, 181,
 197–198
Corsaire, Le (1856), 113
Così Fan Tutte (Mozart), 90
costumes, 67, 142
 for male dancers, 187–188, 190,
 192–194
 in *Monotones*, 110, 113
Crisp, Clement, 211
Cuba, 197

Dance Encyclopedia, The (Chujoy
 and Manchester), 8, 11, 101
Dance Journal, 64
Dance Theatre of Harlem, 28, 48
Dance to the Piper (de Mille), 2
Dancing Master, The (Rameau),
 3, 30
Dancing on My Grave (Kirkland), 74
Daneman, Meredith, 73, 217
Daniels, Don, 126
Danilova, Alexandra, 151, 175,
 228n12
Davidova, Lucia, 175
Debussy, Claude, 160
Degas, Edgar, 133, 207–208
Dehmel, Richard, 170
De l'Allemagne (Heine), 127, 142
de Mille, Agnes, 2, 29, 107,
 168–169
 Rodeo, 173–174, 218
de Mille, William C., 173
Delibes, Léo, 82
DeMille, Cecil B., 173
Denby, Edwin, 30, 41, 188
Denmark, 215

Index

Index

Index

Index

JAMES WOLCOTT

LAURA JACOBS is a contributing editor at *Vanity Fair* and the dance critic for the *New Criterion*, a position she has held since 1994. Called "our best dance critic" by the eminent dance editor and writer Francis Mason, Jacobs has also written about dance for the *Atlantic*, the *Washington Post*, and *London Review of Books*. She lives in New York City.